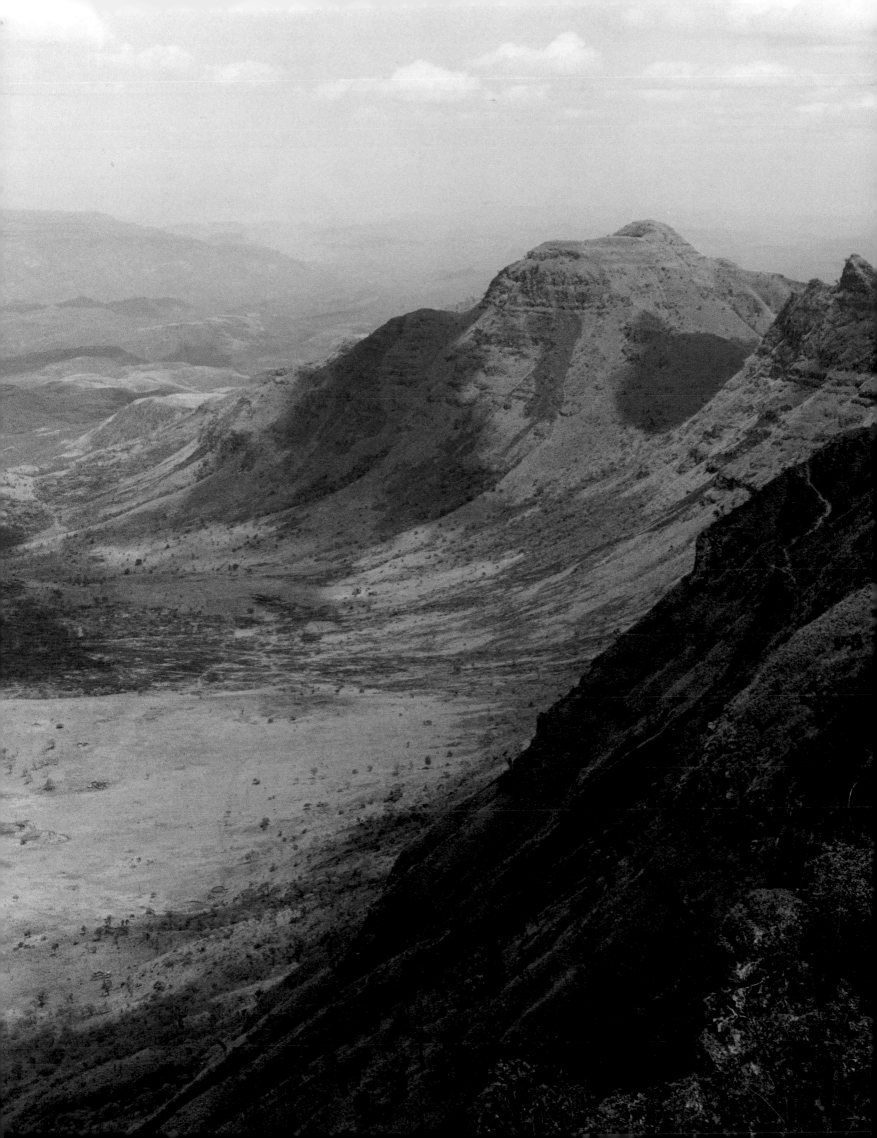

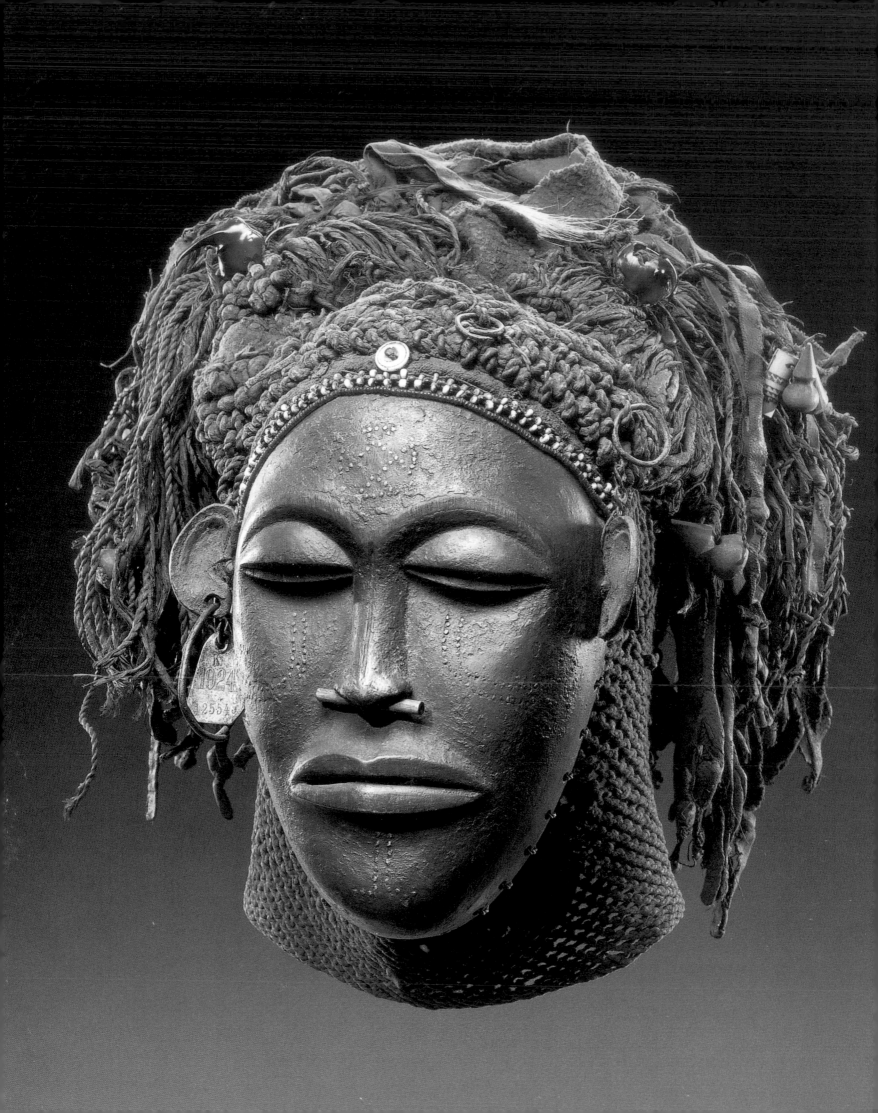

World Art

Africa

by Peter Stepan

Prestel

Munich · London · New York

World Art series editor: Peter Stepan

Front cover: Bronze head, Kingdom of Benin, Nigeria, 15th/16th century.
Ethnologisches Museum Berlin (photograph: Staatliche Museen zu Berlin,
Preußischer Kulturbesitz, Dietrich Graf)

Endpapers: Painted barkcloth (detail), Ituri foragers,
Democratic Republic of the Congo, ca. 1910–15. Private collection

Frontispiece: *Phwo* mask, Chokwe, southern Kasai,
Democratic Republic of the Congo, early 20th century.
Musée royal de l'Afrique centrale, Tervuren (photograph: Roger Asselberghs)

Landscape photographs:
p. 1: Northern Kenya (photograph: Andreas Wisniowski)
pp. 18/19: On the River Kabompo in northwest Zambia (photograph: Manuel Jordán)
pp. 44/45: Kenian landscape (photograph: Andreas Wisniowski)
pp. 62/63: Outside the Great Mosque in Djenne, Mali (photograph: Ilija Trojanow)
pp. 116/117: Landscape in eastern Anti-Atlas, Morocco (photograph: Kurt Rainer)

© Prestel Verlag, Munich · London · New York, 2001

Die Deutsche Bibliothek – CIP-Einheitsaufnahme data and
Library of Congress Cataloguing-in-Publication Data is available

Prestel Verlag
Mandlstrasse 26, 80802 Munich
Tel. +49 (89) 38 17 09-0
Fax +49 (89) 38 17 09-35

4 Bloomsbury Place, London WC1A 2QA
Tel. +44 (020) 7323-5004
Fax +44 (020) 7636-8004

175 Fifth Avenue, Suite 402
New York, NY 10010
Tel. +1 (212) 995-2720
Fax +1 (212) 995-2733

www.prestel.com

Prestel books are available worldwide.
Please contact your nearest bookseller
or one of the Prestel offices listed above
for details concerning your local distributor.

Translated from the German by John Gabriel, Worpswede (plate texts),
and Elizabeth Schwaiger, Toronto (introduction), with contributions by Stephen Telfer,
Edinburgh, and Paul Aston, Dorset.

Copy-edited by Michele Schons
Editorial direction: Christopher Wynne
Editorial assistance: Achim Wurm

Design and layout: Ulrike Schmidt
Cartography: Anneli Nau, Munich
Cover design: Atelier 59, Munich
Lithography: ReproLine, Munich
Printing and Binding: Graspo, Zlin

Printed in the Czech Republic on acid-free paper

ISBN 3-7913-2580-9

Contents

Foreword

African art had to travel a long road to recognition and appreciation in the West. Running counter to European "tastes" in so many ways, it was especially difficult for this form of art to be understood by cultures outside Africa. While some Western artists and a small circle of open-minded art-lovers recognized its significance early on, a wider public of art enthusiasts has become receptive to the message it bears only in recent times. Although the label "primitive art" is rarely used in its former derogatory sense today when speaking of African art, the implied sense of a lower order of aesthetics, backwardness or, at the very least, a "special role" continues to linger. The fatal Western ideal of progress is reflected in such terms as *arts prémiers* which has only recently resurfaced. The art of Africa is neither representative of the "dawn of humankind" nor of some primitive simplicity. It is sophisticated, ingenious, at times overly refined, but in each instance the product of a long aesthetic evolution.

Hierarchical thinking has also done its part to cloud Western perception of African culture. While China, Japan, Mexico and Egypt were accepted into the pantheon of "high" cultures early on, each acknowledged in disciplines devoted to the study of their history and art, Africa and Oceania were relegated to the sidelines for the longest time, under the pretext that their art seemed to be fashioned merely from such transient materials as wood or raffia. Accordingly, ethnology became the collective heading for the study of all those cultures that had been denied the status of "high".

This volume on the art of the African continent is the first in a series that opens a window onto the richness of world art in a selection of masterpieces. While a canon of major works has long since been established for some cultures, the criteria upon which such a selection for African art should be based are still hotly disputed, especially with regard to the choice of selecting individual works. What seems important to ethnologists seems secondary to art historians and vice versa. And collectors follow criteria of their own. Compared to the "icons" of Western or East Asian art, some of the most important masterpieces of African art are often familiar only to experts, although they are in no measure less significant either in status or in mastery than the *Charioteer of Delphi*, for example, or a sculpture by Donatello. This volume presents some proposals which range from well-known pieces to others that have rarely been seen.

A central concern in making this selection was to dispel the common prejudice that the African continent has produced art only in wood and to present as wide a spectrum as possible of techniques and materials: bronze, gold and iron, terracotta, cotton and raffia, as well as wood, beads, leather and ivory. Masks and carved figures have determined our view of African art for far too long, although they represent only a fraction of the art of this vast continent. In addition to carving, ancient traditions in metal-casting, weaving and embroidery have been cultivated, and these were greatly admired by European visitors as early as the 16th century.

Each plate is accompanied by a text that treats the subject, artistic character and uniqueness of the selected work, as well as establishing its place within the chronology of African art history. Together, these texts offer a broad overview of the themes, development and characteristics of African art. It is as varied as the societies that have produced it: kingdoms and feudal empires as well as agrarian societies and urban cultures—the opposite, in fact, to what the fixation on "tribes" would have us believe. Beyond symbolic interpretation, chronology and classifications, the primary focus is on the magnificent works of art themselves, whose creators were highly gifted artists with an impressive mastery of the materials with which they work.

Thanks are due in the first place to the museums and private collections who have allowed their treasures to be reproduced in this volume. I also owe a great debt of gratitude to friends and colleagues for their suggestions and invaluable input, which have contributed to the realization of this book: Armand Duchâteau, Dorothee Gruner, Lorenz Homberger, Manuel Jordán, Marcel and Annette Korolnik-Andersch, Maria Kecskési, Karl-Ferdinand Schaedler, Klaus Schneider, Christine Stelzig, Karl Heinz Striedter, Miklós Szalay, Gary van Wyk and Lisa Brittan as well as Manfred A. Zirngibl. Hans-Joachim Koloss kindly offered to review the manuscript, for which I am extremely grateful, as well as Hans-Joachim Mattke and Heidi Violand-Hobi. I should also like to thank Gillian Auld, Gert Chesi, Pierre Dartevelle, Burkhard Gottschalk, Jacques Kerchache, Kathrin and Andreas Lindner, Laurence Mattet, Hansjörg Mayer and Marrlies Tschäppät for their kind cooperation.

Historical and Cultural Events

7th millennium BC	Pottery in Tibesti (Sahara region of Chad)
6000 BC	Cattle breeding and farming in the Nubian desert.
	Beginning of the Neolithic Period in the Sahara
5000–3500 BC	Lakes in the Sahara dry up and disappear
3000–1000 BC	Expansion of Bantu peoples from the highlands of the border region
	between present-day Nigeria and Cameroon into Central and East Africa
ca. 2000 BC	Migration of southern Kushitic-speaking peoples into the area of modern-day Tanzania.
	The original Khoisan-speaking population is driven out or assimilated
2nd millennium BC	Native Berber population in Morocco
From 15th cent. BC	Invasion of Mediterranean groups from the northeast into Central Sahara:
	use of horses spreads
From ca. 7th cent. BC	Nok culture (Nigeria)
From 6th cent. BC	Use of camels slowly spreads from Egypt across the Sahara
300–100 BC	Sokoto culture (Nigeria)
146 BC	Destruction of Carthage by the Romans. The Maghreb becomes the province of Mauretania
1st–7th cent. AD	Kingdom of Aksum (Ethiopia). Christian from 4th century
From ca. 2nd cent.	Settlement of Kenya and Natal by the Bantu. Early Iron Age in southern Africa
From 3rd cent.	Southeast Asian influence on East Africa
5th cent.	Conquest of Tangiers by the Vandals
ca. 550	Arab influence on East Africa
7th/8th cent.	Arab armies vanquish the Berbers in Morocco
ca. 800	Founding of Ife (Nigeria)
	Spread of Islam along East African coast. Swahili culture develops.
	Influences of Malayo-Polynesian culture sweeps across Madagascar from East Africa
ca. 900	First dynasty of the later kings of Benin
900–1800	Kingdom of the Luba
10th	Founding of Igbo-Ukwu (Nigeria)
10th–13th cent.	West African Empire of Ghana with its capital at Kumbi Saleh (Mauretania)
11th/12th cent.	Almoravids rule North Africa. Areas of West Africa south of Sahara
	converted to Islam
ca. 1100	Founding of Kingdom of Benin
12th–16th cent.	Songhai Empire with capital at Gao (Mali)
13th–15th cent.	Mali Empire with its capital in Niani (Guinea, Mali)
14th/15th– mid 17th cent.	Kingdom of Kongo
ca. 1400–1700	Kingdom of Owo (Nigeria)
15th/16th cent.	Expansion of Benin (Edo) under the warrior kings
1481	Founding of Portuguese Fort São Jorge in Elmina (Ghana)
1482	Portuguese caravels land at the mouth of the Congo
1486	Portuguese received at the royal court of Benin (contacts since 1472).
	An oba delegate visits Portugal in return. Pepper and ivory trade flourishes
1497/98	Vasco da Gama sails round Cape of Good Hope and reaches the East Coast
From 1500	Portuguese sugar cane plantations on the island of São Tomé.
	From ca. 1540, plantations in Brazil as well. Establishment of the Luba Empire
1512	Afonso, King of the Kongo (reigned 1506–43), converts to Christianity
1515–40	First missionary phase in Benin
To 1525	76,000 slaves are sent to other regions of Africa and Europe
1533	French attack Portuguese ships in the Bight of Benin
1591	Conquest of Timbuktu (Mali) by Moroccan king Ahmed al-Mansur
17th cent.	Kuba Kingdom established under Shyaam-a-Mbul (ca. 1600–20)
	and his successor
From 1620	Black slaves begin to be sent to North America
After 1665	Decline of Kingdom of Kongo
Early 18th cent.	Osei Tutu (1695–1731) founds the Ashanti Kingdom. The Makonde migrate
	from the area south of Lake Nyasa, Malawi, to their present territory
Mid 18th cent.	Establishment of the Kingdoms of the Cameroon Grasslands
18th cent.	Luba Empire at the height of its power and influence
1807	Slave trade abolished in Great Britain
1830	French conquer Algeria. Morocco follows in 1844
1851	Britain occupies Lagos. Southern Gold Coast (Ghana) annexed in 1864
1873–74	First British war against the Ashanti. Kumasi plundered
1878	Zulu Wars with Britain. Anti-colonial uprising in Basutoland (Lesotho)
1884–85	Congo conference in Berlin: partition of Africa among the European colonial powers
1897	British troops plunder Benin
1904	Herero uprising in German SW Africa ruthlessly suppressed
1912–56	French protectorate in Morocco. Rif Kabyles revolt against French and
	Spanish colonial powers 1921–25
1957	Gold Coast becomes independent Ghana. Other African countries follow suit

Works of Art

ca. 25 000 BC	First rock paintings in southern Africa
9000–8000 BC	First rock paintings in the Sahara
Up to 6000 BC	Hunter period, Sahara rock paintings
7000–6000 BC	Round head period
6000–1500 BC	Cattle period

1500 BC–beginning of 1st century AD Horse period
Male Figure with Shield and Headdress (plate p. 115)
Seated Male Figure, Nok Culture (plate p. 65)

Male Figure, Sokoto (plate p. 67)

From first century AD Dromedary period, Sahara rock paintings
Lydenburg Head (plate p. 57)

Head of an Ooni, Ife (plate p. 69); *Seated Figure,* Ife (plate p. 71)

12th century Rock churches in Lalibela (Ethiopia)
13th to 15th century Architecture and bird statues
of Great Zimbabwe
cf. *Seated Male Figure,* Segou (plate p. 103)
Mpu Cap, Kongo (plate p. 27)
Mid 14th century Brass and bronze foundry techniques
reach Benin from Ife
Court Dwarf, Benin (plate p. 73); *Ornamental Mask,* Benin (plate p. 75);
Relief Plaque, Benin (plate p. 77)

cf. *Saltcellar,* Sapi (plate p. 79)

cf. Ndop *Figure of King,* Kuba (plate p. 29)

cf. Goldsmith work, Ashanti (plate p. 89)
cf. *Ndimu Mask,* Makonde (plate p. 53)
cf. *Throne Figure/Female Memorial Figure* (plates p. 85/p. 87)
cf. *Royal Figure of Chibinda Ilunga,* Chokwe (plate p. 33)

1850 Discovery of the rock paintings in Fezzan

Art in Africa: The Post-Colonial Perspective

Looking at foreign cultures with an impartial eye is an art in itself. And it may be downright utopian to expect that anyone could perceive other cultures without preconceptions, to believe that one could suspend one's own cultural experience and heritage. If cultures meet on an equal footing, there is every chance that the dignity and beauty of the foreign culture will be recognized. In any era characterized by an unequal distribution of power and economic wealth, one side is bound to view itself in a position of superiority and judgment, and the other in a position of helplessness and being judged. During European imperial expansion, which culminated in colonialism, the conditions for an unprejudiced approach to Africa as a continent and to its art were, needless to say, extremely poor.

Even after nearly half a century of African independence, Western ethnologists and students of Africa continue to be conscious of the degree to which their own culture and history stand in the way of looking at African art without crass distortions. The "dark" continent has always seemed an ideal place into which European desires, yearnings and fears might be projected. The psychological mechanisms of this collective process are still at work.

Surprisingly, negative preconceived ideas are as common as positive ones. An image of eeriness, associated in the European fairy-tale tradition since time immemorial with darkness and blackness, was projected onto Africa just as was the desire for an alternative to Western intellectualism, "sicklied o'er with the pale cast of thought." The former produced a chimera of Africa —a haunted place, ruled by magic, sorcerers and witchcraft, with snakes, danger and disease lurking around every corner; the latter has shrouded the continent in a veil of mystery full of imaginative symbolism and complex cosmology. Africa promised salvation from the European deficit of sun, air and movement in idealized images of half-naked dancers with glorious physiques. Applied to art, these preconceptions gave rise to a distorted image of an expressionism drawing on inexhaustible sources of vitality, or to a kind of short-hand interpretation centered on drums, dance and masks.

While these and similar projections are relatively easy to "unmask," far more perfidious mechanisms are at work in other instances. Thus the contrast between "civilization" on the one hand and "primitiveness" or "unspoiled nature" on the other is based on wishful thinking, which originates either in cultural chauvinism or in European weariness of modern civilization, depending upon one's point of view. Real differences do indeed exist between industrial and agrarian societies. Firstly, however, even within Western cultures, differences exist between urban, technically advanced and rural regions. Secondly, the model is misleading, for it denies Africans the claim to having a "civilization" and insists upon viewing them as having "primeval cultures." The entire premise of "native peoples" is based precisely on this 19th-century evolutionary construct. The term is a veiled insult, a presumption that there is a lack of culture.

In truth, African cultures—as indeed all cultures—are the product of developments that span long periods of evolutionary history. Far from representing a kind of primordial condition, they are subject to the dynamic of change, as all systems are, and are at best "works in progress."

To regard Africa as a synonym of a culturally homogeneous entity with an undifferentiated uniform population is as wrong as throwing Hungarians, Catalans and Englishmen all into one pot, or like treating the Celts, the Early Renaissance in Tuscany and the Flemish Baroque as one and the same thing. Instead, Africa is home to a multitude of different cultural landscapes, each with its own history, social structure and hierarchy as well as strongly defined, individual arts. The kingdoms of the Luba, Kuba, Kongo, Ashanti and the Cameroon Grasslands, each distinct in their own way, are altogether different in cultural physiognomy from the farming cultures of the Bamana, Lobi or Senufo, which differ from the Dogon or other agrarian societies. These, in turn, must be distinguished from the nomadic cultures of the Tuareg, Peul or Massai. Merely from an anthropological point of view, these peoples are entirely different, their languages belonging to the most diverse language groups. Moreover the influence of Islamic and Christian cultures requires even further distinctions to be made today. Sociologically, too, this spectrum creates an intricate mosaic, all the more colorful when one considers the historic profile of these societies. The area now occupied by the Dogon (see p. 104ff.) was previously settled by the Tellem, and some 2,000 years ago by the Toloy, a population possibly composed of various groups that had been driven south

by the desiccation of the Sahara. Our knowledge is more extensive in the case of Nigeria. There, at least three cultures are known to have existed in the first millennium BC: the Nok (see illus. p. 8), Sokoto and Katsina (see p. 64ff.). They were superseded by Ife (see p. 68ff.), Igbo-Ukwu and Benin (see p. 72ff.). A large part of the region has been occupied for a long time by the Yoruba, who can lay claim to a lively and multifarious culture (see p. 80).

"Africa, the 'kinderland,' beyond the day of self-conscious history, is enveloped in the dark mantle of Night," was how the German philosopher Georg Wilhelm Friedrich Hegel (1770-1831) mistakenly dismissed a whole continent. For him, Africa "is no historical part of the World; it has no movement or development to exhibit. ... What we properly understand by Africa, is the Unhistorical, Undeveloped Spirit, still involved in the conditions of mere Nature ... on the threshold of the World's History." Hegel's historic error was a clumsy attempt to present the long and checkered history of the Occident in a significant light by making reference to the timelessness of Africa. Already the Romans had equated a lack of history with cultural underdevelopment. Patrician families possessed genealogies that reached far into the distant past, and there was no greater posthumous threat to the reputation of a citizen or an emperor than the damnatio memoriae, wiping his name from collective memory. To deny an entire continent its history was more than an historic error. The philosopher condemned Africa as a place unfit for civilized human beings.

The charge of a lack of history was later echoed in the equally indiscriminate pronouncement that African art has failed to undergo a development, that its forms have simply reproduced themselves time and again. Artistic stagnation over the course of centuries: an abstruse idea of stasis that would be revealed as entirely erroneous. The Enlightenment in particular contributed much to the demonization of Africa and it is largely to blame for the darkness=irrationality=backwardness equation. Named in the same breath as the Middle Ages in Europe with its superstitious beliefs, the continent was thought to be the very antithesis of intellectual prowess laced with rationality.

Africa not only has its own distinct history, it also has a unique tradition of handing down historical information. In the absence of the written word and historic manuscripts, the strong oral tradition plays an important role. In Francophone areas of West Africa, for example, the griots are a hereditary caste whose function it is to preserve the genealogy of its patron and his clan in elaborate ballads. These recitations are in the style of an oral tradition of the heroic epic, commemorating great battles, celebrated kings and the rise and fall of empires, etc. History is experienced through remembering great personalities and extraordinary events. It has been established that, in the Oku Kingdom in Cameroon, the memory of chieftains was kept alive by including their names in prayers (Koloss, 2000). Such genealogies also found expression in art. Like the Kongo, the Kuba look back on a dynasty of kings, whose names are known and whose memories are preserved in statues of seated figures (see p. 29). The Luba are renowned for their culture of memory: in a secret society that practices several stages of initiations, "traditionalists" ensure that historical norms are adhered to (see pp. 10, 38).

As is well known, the cultures south of the Sahara have no tradition of writing or script of their own. We can therefore safely assume that individual memory performance is much more highly developed there, especially in view of the fact that each group has specialists whose task it is to preserve memory. Cultures that rely on the written word no longer need to cultivate memory to the same degree. Instead, the accumulated archive of documents and chronicles becomes the material embodiment of "history." The memory kept alive in cultures with their own script is possibly quite different from the memory preserved in cultures without it. When an old man dies in Africa, it is said that an entire library perishes with him.

Ancestor worship, so important in many regions of Africa, also has an historic dimension. The cult of ancestors is devoted to charismatic individuals who were highly regarded. The health and well-being of the community is seen in direct relation to the goodwill of the ancestors, which is why they are venerated and feared. To ensure their benevolence, the living perform a variety of precautionary rituals. As time passes, the subjects of devotion become less defined, they grow both more anonymous and more

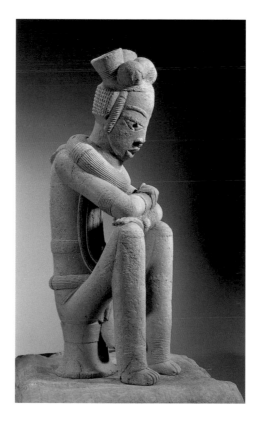

Seated male figure, Nok culture, Nigeria, 5th century BC, height: 81 cm. Private collection.

powerful (in other regions, however, their influence can also wane). In this context, too, we can see that historic memory is strongly linked to the individual.

A Continent of Tribes?

It is a European penchant to reduce Africa's anthropological and social richness to a simple common denominator. "The African" is a stereotype that projects a false image of continental uniformity. The refusal to grant the African an individuality of his or her own seems no more than a logical consequence. In as much as "individuality" is recognized at all, it is done so in collective form: the tribe. To speak of the tribe is to assume the absence of individuality. Those devoid of individuality merge anonymously into the community of the tribe. For generations, the West has held on to an idée fixe of Africans that ignores their individuality and acknowledges merely their right to exist as a herding creature. The kinship to zoology is only too obvious: Africa as a continent of animal herds and natives. The zoological tone in our image of Africans is further unmasked when we take a closer look at the system of tribe classification. Valentin Mudimbe (1988) rightly pointed out the analogy to insect classification. It is one of the most deplorable "achievements" of Western colonialism to have employed a metaphor of this kind, virtually equating the population of the world's second-largest continent with the animal kingdom: the African as an inhabitant of the great Serengeti National Park of Western anthropology.

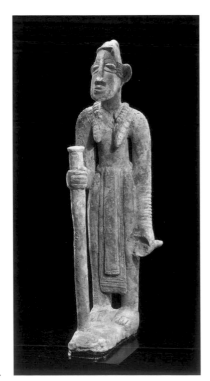

Standing female figure, Djenne, Mali, ca. 12th-13th century, height: 63 cm. Private collection.

It may be understandable that the theories of evolution and race employ some of the same methods as zoology and biology. But it certainly is questionable when categories of physical anthropology are indiscriminately applied to art historical inquiry. Ethnology and the study of art history are then infiltrated by a biologism that inevitably clouds our image of non-European cultures. The perception of African art is distorted by a multitude of concepts derived from this misunderstanding— among others the idea that the tribe is the very foundation of African art and that the individual sculptor has no significance. (Until recently, the preferred terminology in the West was to speak of "carvers" rather than sculptors.) This deprives the artist of his individuality—he works merely as a representative of the tribe—and avoids elevating him to the same status granted to Western artists. He is "just" a mere craftsman.

The supposed collective nature of African art blinds us to the individual characteristics of a particular work. Instead of discovering deviations from the "norm," we see only a typical expression of the tribal tradition. This way of looking at things completely ignores, for example, the fact that some sculptors worked not only for members of their own clan, but also for neighbors who had different ethnic roots. An outstanding artist had the opportunity to go beyond his immediate environment and work for other clients. Famous itinerant artists and masters were known to work for several ethnic groups simultaneously. This resulted most likely not only in stylistic adaptation, but also in amalgamation (see p. 100). Yet more than one ethnic group was in possession of specific visual traditions. In the case of societies with pronounced hierarchical structures, the question arises moreover whether nobility, for example, was not more closely linked across ethnic boundaries than various classes or castes might have been within one and the same ethnic group. An exchange of aesthetic preferences would have been the result. It would also be helpful to apply the European model of "task-based art history" to Africa. Style, in that model, does not interpret form as a continuum encompassing all genres, techniques and materials; instead, it is applied only to specific groups of objects. A certain type of figure, for example, or special objects would have required a departure from the stylistic pattern.

The homogeneity of "tribal styles" is a fiction. This is supported by countless examples of blended or transitional styles or exponents that defy classification to this day. From a methodological perspective, the tribal interpretation leads to a hermeneutic circle: because every object is deemed typical of a certain tribe, the ethnic roots of style are reinforced anew. This model is based on an inflexible concept that ignores migration and any other form of travel.

The Blinders of Innovationism

The ideology of tribalism is not alone responsible for the denigration of the achievements of African artists. The concept of tradition has been used as additional ammunition in the attack to diminish their art. Since it is assumed that African artists simply follow traditional patterns and styles, their creative ingenuity has been less valued from the outset. Where innovation and originality are evidently unimportant, even undesired, one must surely question whether one is dealing with art at all. No debate in the arts during the past decades has been as superfluous and tedious as this, and in a number of countries it has been pursued with particular tenacity.

One cannot overlook that the speed of innovation, the challenge to produce ever-new inventions, indeed the hysteria associated with advancement—typical aspects of the industrial society—have imperceptibly been projected onto aesthetic values. The dizzying carousel of "isms" in the art of the 19th and 20th centuries is paralleled in the accelerated pace of progress in technology. To expect the same of other cultures, with a different sense of time and a different aesthetic evolution, and to judge their art against the yardstick of the Western drive for innovation is to overlook their unique characteristics. It has been observed time and again that African sculptors were expected to improve upon and "update" their approach. The supposedly prescribed patterns would not be so full of life were they mere repetitions. Alone the speed at which such innovations occur reflects a different concept of time.

Here, too, Africa was an ideal foil. The African carver is stylized into the antithesis of the Western artist. While the former is said to remain anonymous and content with repeating patterns that are only too well known and dictated to him by his own tradition, the European artist dazzles by virtue of his originality and inventiveness. Since the Renaissance a favorite of Apollo and the muses, the European has long since transcended mere artisanship.

Another legacy of the Western philosophical and sociological preoccupation with art plays a major role in this context: the overstraining of the notion of art. But the more recent European distinction between high art and low art, between "fine art" and "applied art," has little relevance in Africa. In Italy, the 16th-century discussion on disegno was the starting point for separating the fine arts from the association of trades (artes), leading to a gradual liberation of the creative idea from its execution. French academicism, German idealism and the Romantic notion of the genius were way stations on the artist's path toward autonomy that set him apart from the rest of society, culminating in the privileged outsider role, which evolved in the 19th and 20th centuries. In European and American cultural circles, art begins where purpose ends. In Africa, by contrast, art and craft were never divorced, but remaining one.

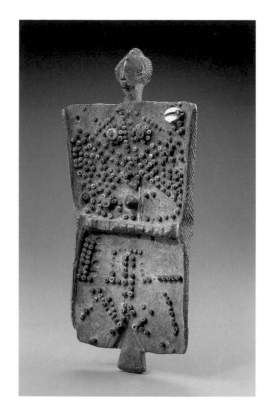

Mnemonic board (*lukasa*), Luba, Dem. Republic of Congo. Private collection.

"Independence of purpose" is not considered a category that endows an activity with greater value or accords it special status.

The process of classifying African art into groups based on stylistic criteria and ascribing them to different masters began some time ago. The "Master of Buli" is the first invented name given to an unknown artist, to whom some 20 figures and caryatid stools have been attributed. Only recently has it been suggested that his oeuvre was actually the work of three artists, the most important of which is called the "Master of Katéba" (see p. 36). Similar research efforts have established a close link between previously unconnected works. This method represents an important step for both art ethnology and art history: it hones the eye for individual characteristics, where a numinous uniformity of style was previously presumed to prevail. Bernard de Grunne compiled an impressive index comprising 300 names of African sculptors largely already known, not including those anonymous artists who were given invented names: a veritable manifesto on African individualism (de Grunne, 2001).

Africa and Europe as unequal brothers: this is how Europeans view themselves and their neighboring continent to the south. Mechanisms of collective psychology are at work here. Perfectly happy to grant their own artists the freedom to indulge in a veritable cult of their own person, Europeans have in the past denied artist status to Africans whose body of work was simply labeled "tribal art." Boasting of themselves as the great avant-garde, they viewed their "brothers" as rooted in tradition. One could stretch to cast a positive light on this contrast: as tradition

dissolves in the West, Africa—purportedly a continent of farmers, hunters and gatherers—becomes a Garden of Eden that offers a nostalgic journey into the past. Ever since technology and industrialization have followed the relentless road to progress, beginning in the last third of the 19th century, the European eye has sought respite in the picturesque of African artisanship.

The Age of San Salvador

The psychograph of the cultural misjudgment of Africa by its neighbors to the north reveals many bizarre traits. A historic overview is necessary to understand how this came about. The discovery and exploration of Africa's west coast from the 15th century onward can be divided roughly into four periods: the period of bilateral trade, the age of transatlantic slave trade, the colonial and postcolonial eras. Peter Mark and Ezio Bassani have reconstructed the first European contact with Africa in great detail and were able to demonstrate that this early phase was marked by a surprisingly positive European image of Africa (Bassani and Fagg, 1988). Olfert Dapper's account (1668) expresses respect and awe for the African civilization. The exploration of the West African coast in the 15th century, from Cape Bojador (now western Sahara) to the Cape of Good Hope, stretched over many decades and the Portuguese gained influence in a similarly gradual manner. The trade that developed between the Portuguese and the Sapi in what is now Liberia, with the Fante and Ashanti on the Gold Coast, with the kings of Benin and the Kongo Kingdom in the estuary of the eponymous river, was equally advantageous to both parties. The export of goods, such as ivory or pepper, particularly sought after by Europeans in Benin, was controlled by the kings of that region. African-Portuguese ivories bear witness to this harmonious economic exchange (see p. 79). These so-called saltcellars were considered such a luxury that they found their place on the tables of the nobility and the moneyed aristocracy of Europe. European influence was particularly strong in the Kongo Kingdom, where King Afonso I converted to Christianity. From 1512 onward, it was reorganized into a Christian kingdom under the patronage of Emanuel I of Portugal. Thus the Congo became the first model of a European-African civilization. Henry, the son of Afonso I, had been educated in Lisbon together with the sons of Kongolese noble families. Raffia was one of the most important trade goods in the Congo, purchased by the Europeans to use in bartering for slaves further south in what today is Angola (see illus. p. 26). Altogether some 76,000 slaves were shipped to Europe between 1415 and 1525. By comparison to this human freight, the goods originally transported in the caravels, such as ivory, spices and gold, were less profitable, especially once the slave trade grew even more lucrative, with expansion into Brazil, the Caribbean and North America.

The shift in European trade in Africa from goods to slaves naturally also had an influence on how Africans were viewed. In the 15th and 16th centuries Africa was still seen as the home of the "noble Black." Many images of the Adoration of the Magi depict one of the Three Kings as a black man with noble features and sumptuous robes. Thus personified, "Africa" bows to the central figure of European faith; accordingly, the representatives of the continent were equally respected among Europeans. With the gradual erosion of African sovereignty, the flooding of the continent with European goods and its depopulation as a result of the slave trade, there followed a period of decline in fortunes and independence that culminated in the colonial era. Blacks became subjects and domestics, a situation that would endure for many generations. It is hardly surprising that the ethnological focus on African art grew roughly at the same time as African nations gained their independence, for the perception and appreciation of a people's cultural goods are closely linked to its freedom.

Christian missionary work as a vehicle to impose a different worldview was indispensable to economic and political colonialization. Priests played an important role in the destabilization of a social and cultural infrastructure that had endured for centuries. Ultimately, however, the religious conversion was never entirely successful. Even during the time of the Christian-African Kongo Kingdom, religious syncretism seems to have outweighed other forms. The religious syncretism of a country like Benin (formerly Dahomey) is today the rule in Africa rather than the exception. As the artist Romuald Hazoumé notes, people happily attend church in that country as long as things are going well. As soon as difficulties arise, however, people beat a path back to the shrines of the 'tried and tested' voodoo gods.

Physical anthropology was another piece of the ideological baggage of colonialization. It provided scientific justification for Africans to be treated as underprivileged and second-class citizens in their own countries. Euphemisms to replace terms such as "native peoples" soothed the bad conscience of the white establishment, which designated itself as the "master race." When Africa was divided among the colonial powers like so many pieces of a pie at the Berlin Conference in 1884/85, no consideration was given to the original settlement areas of its peoples. In order to give a proportionate slice to each colonial power, new borders were drawn straight through the Sahara, the savannas and the rain forests. Many ethnic groups were separated by these borders, and passport laws ensured that visiting relatives on the other side meant traveling into a foreign country.

Art and Function

This brief historic excursion is an attempt to reconstruct the background against which the distorted European view of African art has emerged. In light of the enormous propaganda efforts required to justify how Europeans treated Africans, it would be surprising indeed if one had drawn the line at their cultural identity. Just as school children in French Sudan learned little about the history of their ancestors, instructed instead to memorize the names of France's royal dynasties, so indigenous art was denigrated. Its status was nullified in the face of the cultural achievements of European civilization. If it received any recognition at all, then as a craft on the lower level of folklore and exotic curiosities.

The colonial view of African art still has a hold on the Western mind, although African independence has been a fact for nearly half a century. First the discipline of art ethnology had to liberate itself from ethnology, which viewed itself as a social science. The art of Africa, like that of other continents, is a magnificent reflection of the feelings and thoughts of the people who created it; it is an expression of social and personal values, similarly collective or individual. It stands at the intersection between earth and heaven; the living and the dead are its themes as well as nature spirits and deities. It is both profane and religious.

To accord African art the high status it deserves is to recognize its unique characteristics. Instead of subsuming it into a single type, one must study the changing forms and creative conditions from region to region as well as individual characteristics. Forms that are externally similar may well signify different "meanings" in different locations. At the same time there are common elements that even link objects from distant regions. One such element is function. All the objects presented in this volume were utilized at one time: be it for ancestor worship or covering the body, repelling enemies (as with a shield) or invoking divine protection against evil spirits (as with a magical figure, see pp. 25, 35). The objects had to fulfill a task and if they failed to do so they were withdrawn from circulation. A broken clay vessel was just as useless as a wooden statue that had failed to protect its owner from misfortune. A "village fetish" was even exposed to public insult if it did not live up to the performance expected of it (see p. 25). Such "failure" often meant that figures were simply given away to ethnologists and antique dealers (who also profited from weather or termite damage or the overzealousness of missionaries). In Africa, special status was not accorded based on the unique artistic character of a figure, but on its utility. The most "beautiful" figures—the "masterpieces" to the Western eye—were not necessarily the most powerful; these were often rather inconspicuous, even artless objects and symbols (although functionality in no way diminishes their artistic quality).

African figures are instruments capable of performing a specific service in the hands of the experts and the initiated. It would be wrong to assume that such figures were always dedicated to worship, prayer or practices of the kind we associate with Catholicism or Buddhism. At least this kind of reception is not the rule. The potential of a statue was not necessarily activated by the adoration of the believers. While people believed in these figures, their faith was dynamic: they sensed the spiritual entity concealed within them. Hence the use of such objects could vary greatly.

Charged Objects

In Africa, this is closely linked to a completely different relationship with the notion of portraying a likeness. Masks or figures carved by African artists are not attempts to render the features of the being they represent—an impossible feat, at any rate, when dealing with invisible beings—but to embody a particular spirit. The figures are sites where beings reside; they are vessels, containers. Therefore the qualification of the artist lies in giving the figure formal expression, irrespective of taste or beauty, that enables it to incorporate the forces of the relevant spirits. Often it is not the figure itself that is important (no matter how well it is carved), but its "activation" by a ritual expert: magical substances are added to the figure, thereby creating the "charge" required for it to be effective. The performance of a masked dancer is usually in the service of the embodied beings and spirits, which have taken possession of him. A Shango priestess in Nigeria is only then considered ready for her task when she has reached a level of identifying with the god to such an extent that she is no longer herself, but possessed by him (see p. 80). Works of art, too, are regarded as fulfilling a role at this threshold between the real and the spirit world. It is often taken for granted that they will mediate between the two spheres.

The representation of a person's features can thus not be the focus of the creative interest. The entire cultural effort is directed toward appealing to metaphysical beings to prevent misfortune or, in the best scenario, to bring health and wealth to the living. Even the embodiment of ancestors does not strive for portrait-like resemblance, since what is important is the power of the ancestors, their blessing for the descendents. Their presence and goodwill is not ensured with an attempt at capturing individual features, but by invoking their charisma.

In view of the forces with which African sculptures are brought into context, it may seem surprising at first that we are seldom faced with figures of dramatic movement, full of pathos and baroque exuberance. On the contrary: African cultic sculpture is predominantly static and severe in symmetry (e.g., the reliefs and narrative depictions on Chokwe stools). Deviations from this fundamental rule are so rare as to be readily notice-

able. There are virtually no dancing figures (see p. 87). The contradiction between the spiritual "charge" of the figures, the intensity of their imaginary inner life and their appearance could not be more striking. Africans experienced the liveliness of their figurative objects precisely through the hieratic severity of their physical appearance. The high degree of inner concentration would conflict with extroverted movement or animation. To demonstrate this inner force, sculptors suspended the motor ability of the figures and every square centimeter of the wooden surface was suffused with tension. Many figures are depicted with eyes closed to further enhance the sense of reflection. When they are open, the gaze is usually one of great intensity. With rare exceptions, these figures are distinguished by one aspect above all else: the gravity of their countenance.

But not all figures were mere vessels for spirits. For some ethnic groups, the figures themselves were living beings. In his field studies among the Lobi in the south of Burkina Faso, Piet Meyer remarked: "For the Lobi, statues are neither works of art nor simple wooden, metal or shaped clay objects but living beings who can see and communicate with one another, who can move and—this is one of their tasks—can ward off witches and black magicians" (Meyer, 1981, p. 52). Similar observations have been made with regard to masks. It was thus possible to prove that, for the onlookers, a masked dancer *is* in actual fact a particular forest spirit (Fischer/Himmelheber, 1976). For Hans-Joachim Koloss the masks in the Cameroon Grasslands are less embodiments of ancestors or spirits than autonomous, unpredictable beings, "even though they owe their powers ultimately to the ancestors or spirits and are thus a medium of magic medicine" (Koloss, 1999, pp. 16, 19). The best-known example of treating figures like living beings are the *ibedji* figures of the Yoruba in Nigeria. They are carved whenever twins are born. Should one of the children die, one figure takes on the role of the dead child, and it is fed and put to bed along with the surviving twin.

All in all one can note that there are fluid transitions between the concept of embodiment and that of figures or masks leading a life of their own. The idea of representation, however, known in the West as "mimesis," is foreign to Africa. The most telling indicator of this is the total absence of portraits. The majority of anthropomorphic images adhere to a formal canon that reflects the style of a region or ethnic group and is supra-individual and anonymous in nature. Every now and then a figure "refers" to a specific person, identifying the individual with the help of certain attributes or symbols; but such examples are not portraits in the Western sense. What interests an African viewer in the depiction of an ancestor is the typical, that which transcends the individual, and not recognizability.

Realism is not an African invention. Where faces appear "realistic," and such instances are rare enough, one can often trace European influences (see illus. p. 24) or discover that the motivation was to create a trophy (see p. 83). Ife sculptures are borderline cases in this regard (see pp. 69, 71). The figures occasionally appear to have a portrait-like quality simply because their human features have been rendered in a realistic manner. The seated figure of a Kuba king is a portrait only in this narrow sense (see p. 29). Even in Europe, portraits did not always play an important role. Although more decisive in Roman art than in that of the Greeks, portraits disappeared almost altogether in the Middle Ages, experiencing a revival only with the "discovery of the individual" in the Renaissance. Nevertheless, the archetype of the European portrait originates in Africa: in the Faiyum portraits of Egypt.

Against the background of magic ritual, evil spirits and the struggle to defend against them, portrait-like verisimilitude may be more problematic than an art historical perspective at first reveals. To have an image of someone also means, at least in part, to be able to exercise power over that person. This is perhaps one of the reasons why the portrait is such a problematic topic for African cultures. When Africans saw photographic portraits of themselves for the first time in the 19th century, their deep-seated reservations on the subject of portraits was openly expressed.

Metamorphoses

If there was little demand for creating a visual document of the individual features of a person, this circumstance greatly benefited another category: abstraction. African art is traditionally characterized by a high degree of abstraction and knows many forms of objects and symbols that could be described as abstract. Western artists discovered abstraction only very late, in the first decade of the 20th century, liberating themselves from the constraints of Realism and Empiricism. Naturalism had never been firmly established in Africa, for there was no fertile ground for it to grow into an obsession. African art was suddenly cast in the role of catalyst to facilitate and accelerate the separation from the dictum of empirical reality. It provided decisive inspiration for Modernism in Europe, since it had followed a conceptual direction for centuries. The high degree of abstraction in anthropomorphic and zoomorphic depictions, the freedom in the rendering of anatomical details—be it by means of exaggeration, "distortion" or omission—all that seemed surprisingly "modern" to the Western eye. While the proportional ratio between body and head is 7 : 1 in the human body, African art more commonly subscribes to a ratio of 4 : 1 or even 3 : 1, e.g., in Nok terracotta from the first millennium BC (see p. 65). This did not develop into a dogma in Africa, where many figures display impressively self-willed definitions of the human physique (see pp. 49, 107).

It is fascinating to observe how each chapter of modernism in the 20th century reveals a receptivity to different aspects of

African art—where they had always existed. Today, we are familiar with many more facets of African art than the generation of Picasso, Kirchner or Derain. The "Cubist" character of African art was the slogan of the day (and soon threatened to become yet another cliché); this was also the time when the fixation on sculpture and masks began. It took the visual education and expanded perception of Dada, Arte Povera, Land Art, Conceptual Art and artistic strategies employing archaeological and reconstructive methods to sensitize the West to the complexity and variety of African art: its richness in materials, themes and purposes, its spectrum of material transitions and syntheses as well as the cosmos of its forms. Studded wooden figures (see p. 25) are, one might claim, a paradigm for Process Art or for the assemblages of an artist like Arman. The relief-like emblems of the *ngbe* leopard spirit society of the Ejagham are convincing precursors to the assemblages and multiples of artists ranging from Pablo Picasso to Daniel Spoerri. Masked dances embody many of the elements found in 'modern' performances.

The abundance of forms and meanings in African art resists categorical interpretation and repeatedly poses a challenge to the European-American cultural circle. If African artists take the middle path between realism and abstraction, the reason is above all this: openness to form. Clarity is abandoned in favor of complexity and multidimensionality. When looking at African works of art, many observers notice that the forms allow several levels of reading, that they are often simultaneously anthropomorphic and zoomorphic. Metamorphosis seems to be one of the central achievements of African invention of form. Georg Baselitz observed: "They are not animals, nor legendary creatures, nor spirits, either; but somehow they resemble human beings more than not" (Szalay, 1995). He succinctly expressed the dilemma with which every viewer of African art is confronted. At the same time it alludes to a wealth of form, exponentially multiplied through ambivalence, ambiguities and overlapping layers of meaning. This does not, however, merely refer to the formal game of metamorphosis, but also conveys something: the human, animal and spirit world are present in equal measure. It is this oscillating universe, virtually inexhaustible in formal inventiveness, that captivates anyone who has ever discovered the fascination that is African art.

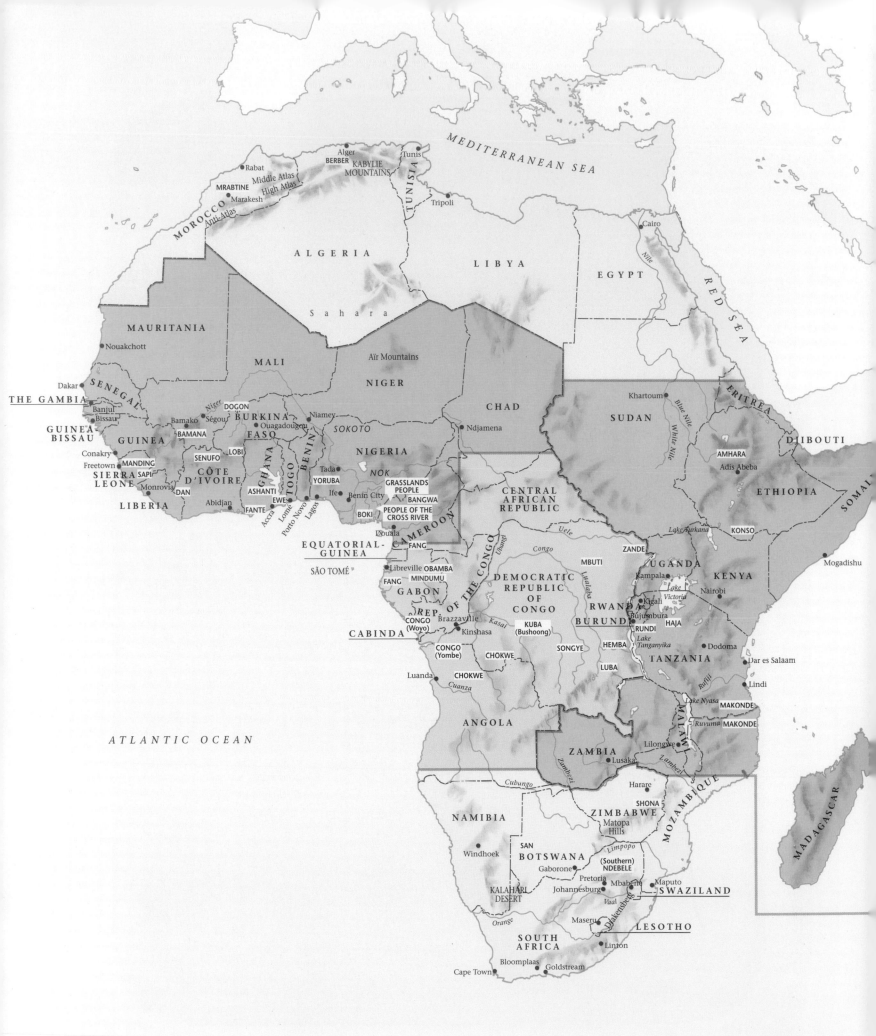

MEDITERRANEAN SEA

Alger
BERBER KABYLIE
MOUNTAINS
Tunis

Rabat
Middle Atlas
MRABTINE High Atlas
Marakesh
Anti-Atlas

Tripoli

Cairo

MOROCCO

ALGERIA

LIBYA

EGYPT

S a h a r a

MAURITANIA

Nouakchott

MALI

Aïr Mountains

NIGER

CHAD

SUDAN

Khartoum

ERITREA

DJIBOUTI

Dakar

SENEGAL

THE GAMBIA

Banjul
Bissau

GUINEA-
BISSAU

Conakry
Freetown

SIERRA
LEONE

Monrovia

LIBERIA

GUINEA

MANDING
SAPI

DAN

Abidjan

BAMANA

Bamako Ségou

SENUFO

CÔTE
D'IVOIRE

LOBI

GHANA

ASHANTI

FANTE

Accra

Niger

DOGON

BURKINA
FASO

Ouagadougou

TOGO

EWE

Lomé

BENIN

Porto Novo

Niamey

SOKOTO

NIGERIA

Tada
YORUBA
Ife

Benin City
NOK

Lagos

BOKI

Ndjamena

**GRASSLANDS
PEOPLE**
BANGWA

**PEOPLE OF THE
CROSS RIVER**

Douala

CAMEROON

FANG

EQUATORIAL-
GUINEA

SÃO TOMÉ

Libreville **OBAMBA**

FANG **MINDUMU**

GABON

REP.
CONGO
(Woyo)

CABINDA

Brazzaville

Kinshasa

CONGO
(Yombe)

Luanda

CHOKWE

CHOKWE

Cuanza

ANGOLA

CENTRAL
AFRICAN
REPUBLIC

Uele

Ubangi

Congo

MBUTI

ZANDE

DEMOCRATIC
REPUBLIC
OF
CONGO

Lualaba

KUBA
(Bushoong)

SONGYE

HEMBA

LUBA

Kasai

AMHARA

Adis Abeba

ETHIOPIA

KONSO

Blue Nile

White Nile

Nile

RED SEA

SOMALI

Lake Turkana

Mogadishu

UGANDA

KENYA

Kampala

Nairobi

Lake
Victoria

Kigali

RWANDA

Bujumbura

BURUNDI

RUNDI

HAJA

Lake
Tanganyika

Dodoma

TANZANIA

Dar es Salaam

Lindi

Rufiji

Lake Nyasa

MAKONDE

Ruvuma **MAKONDE**

MALAWI

Lilongwe

ATLANTIC OCEAN

ZAMBIA

Lusaka

Zambezi

Cubungo

Harare

SHONA

ZIMBABWE

Matopa
Hills

MOZAMBIQUE

Maputo

MADAGASCAR

NAMIBIA

Windhoek

SAN

BOTSWANA

Gaborone

Limpopo

(Southern)
NDEBELE

Pretoria
Johannesburg

Mbabane

SWAZILAND

KALAHARI
DESERT

Vaal

Maseru

LESOTHO

Linton

SOUTH
AFRICA

Cape Town

Bloomplaas

Goldstream

Orange

Drakensberg

INDIAN OCEAN

Plates

Central Africa

This region in the heart of Africa stretches from the Atlantic to the great lakes in the east, and from southern Chad in the north to Angola and the southernmost tip of the Congo in the south (see map on p. 16). Whereas a large part of Central Africa is covered by tropical rain forests (Gabon and the two Congo states), in the north of Angola, the Central African Republic and the south of Chad subtropical savanna is mainly prevalent. With its numerous tributaries, such as the Ubangi, Lualaba, Lomami, Sankuru, Kasai, Kwilu and Kwango, Africa's largest river, the Congo, dominates the area like a giant fan, wending its way westward. Owing to the dense rain forests, the population of Central Africa has remained relatively sparse. Numerous Pygmy groups are found in the forest regions between the Atlantic and Lake Tanganyika. It was not until relatively late, from the second millennium BC onward, that Bantu tribes migrated to Equatorial Africa from the north.

Central Africa is home to numerous kingdoms, including those of the Kongo, Chokwe, Kuba, Songye, Luba, Hemba and Mangbetu. Their monarchies, which are often characterized by their sacred character, are largely of a relatively recent date. The migrations of the Hemba, for example, can be traced back to the 16th and 17th centuries, and the Kuba rulers consolidated their power as late as ca. 1600, by which time they had absorbed the aboriginal Pygmies and subjected neighboring groups to the ruling clan of the Bushoong.

In 1482, the Portuguese landed at the mouth of the Congo and founded the first Christian kingdom on African soil. The influence of Europeans on the art of Central Africa was far-reaching, but their effect on African society, culture and religion was even more decisive. The coastal regions soon had to contend with the problem of depopulation as a result of the slave trade, but the eastern regions long remained relatively intact.

Unlike in West African kingdoms, where gold and bronze were of great importance in representational art, metallurgy played only a marginal role in Central Africa. Instead, extravagant quantities of cowry shells and glass beads are used in the ceremonial robes of the Kuba kings, whereas royal statues and regalia are made of wood. The reliquaries of the peoples living in eastern Gabon, which are lavishly decorated with metal mounts, constitute an exception.

Also characteristic of Central Africa is *nkisi*, which encompasses soothsaying, healing, magic and counter-magic. This involves a wealth of figures that serve as instruments or, if suitable in size, are used as "village fetishes" in communal matters. Such "nail figures" have virtually become synonymous with the art of Central Africa.

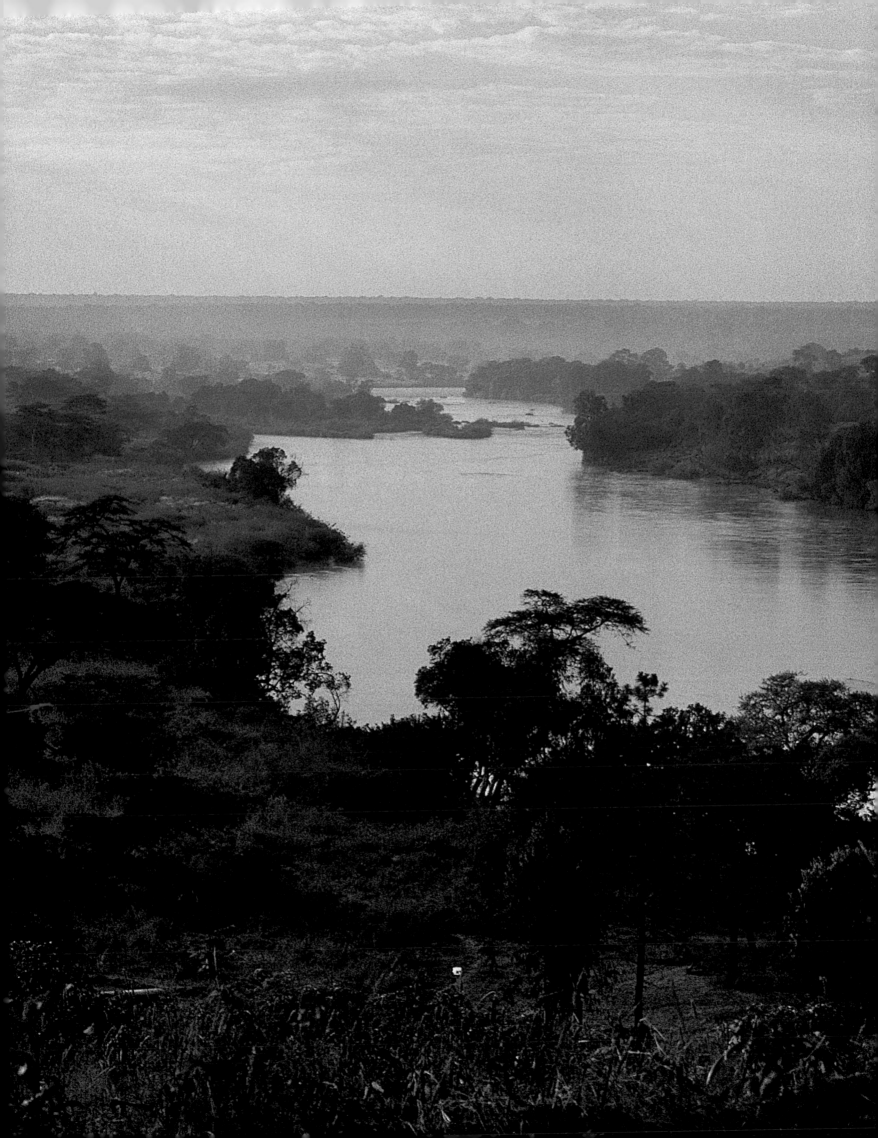

Ngil Face Mask

Fang, Gabon, 19th century
Wood, kaolin and brass nails; height 66 cm
Musée du Quai Branly (Dépôt Musée de l'Homme), Paris

**This white mask belonged to a men's society known as
ngil. It is a masterpiece of geometric abstraction that conveys
an impression of aloof dignity. Over twice as high as the
wearer's head, its size alone inspires awe.**

The extremely elongated face apparently reflects the shape of the
tree trunk from which the carver hewed the block. The trunk's
natural curve was retained in the convex forehead. This convexi-
ty is replied to by a concave, heart-shaped face in which eye slits
have been carved. The long nose and arched brows represent the
ridges that remained after the face was hollowed out. The carver,
wonderfully aware that less can be more, has composed the
mask with merely a few sweeping planes. Thin, incised lines are
used to accentuate the mouth, brows and hairline, which is fur-
ther marked by a line of nail heads. The three vertical lines run-
ning over the forehead and leading to a comblike crest on the
head represent a scarification pattern. As field photographs and
coiffures preserved in museums indicate, the Fang wore very
elaborate headdresses, to which the crest and the line of nails
allude. The two U-shaped incisions below the hairline might
either be stylized representations of the loops on such headdress-
es, or of scarifications. Those depicted here—including the rows
of notches under the eyes—are part of the astonishingly large
repertoire of Fang motifs, as recorded by the eminent scholar of
this ethnic group, Günter Tessmann. The mask's noble impres-
sion is increased by its finish of kaolin wash, which is associated
with the dead.

The great aesthetic impact the mask has on a contemporary
observer stands in sharp contrast to that which it once had on
the Fang people themselves. Yet, since the traditions with which
these masks were associated died out in the early 20th century,
very little is known about their purpose. The *ngil* men's society
apparently used such masks in initiation ceremonies, as well
as during their often quite merciless persecution of people sus-
pected of witchcraft and various other crimes. Members of this
society reputedly appeared in a village in the dead of night, car-
rying torches, whose flickering light increased the frightening
aspect of their masks, which instilled fear and trembling in all
who saw them.

The mask's mouth seems oddly closed, and indeed some com-
parable masks in other collections have mouths that are merely
suggested by an incision. Evidently the spirit it embodies can
convey its message without resorting to many words, and its
eyes seem to be caught in a vacant stare—indications of the
supreme metaphysical power of the being that dwells within.

Bibliography: Tessmann, 1913; Perrois, 1985; Laburthe-Tolra and Falgayrettes-
Leveau, 1991; Bouloré, in: Kerchache, 2000, pp. 169–72

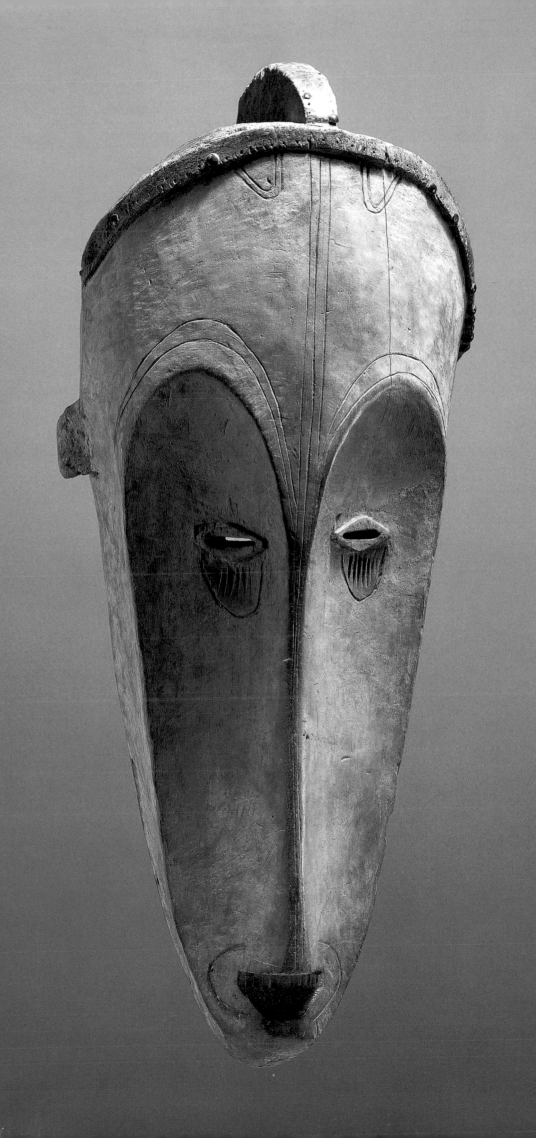

Mbulu Ngulu Reliquary Guardian Figure

Obamba/Mindumu, Gabon, 19th century
Wood, brass and copper; height 41 cm
Musée Barbier-Mueller, Geneva

The reliquary figures of the Kota and Mahongwe of eastern Gabon, and of neighboring groups, the Obamba and Mindumu, exhibit some of the most striking forms in African art. They originally served to protect the bones of deceased notables, and were inserted into the lids of the baskets in which these were kept. Among the Fang to the west, this purpose was served by carvings of heads (see illus.) or entire figures.

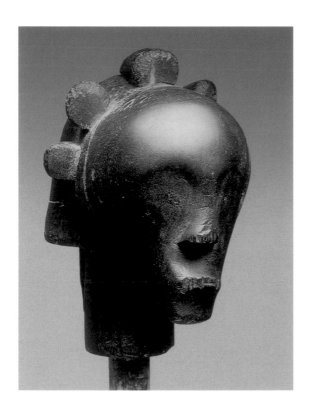

Reliquary guardian figure, Fang, Gabon, Private collection

Such figures were placed on the lids of bark boxes containing ancestors' relics. With the Kota and Obamba, the figures were so radically abstracted that in many cases they were no longer recognizable as such.

The diamond shape at the bottom of the present piece can be read as legs drawn up with knees spread, a formally striking device. Too flat to serve as masks and too masklike to be considered sculptures, such reliquary figures represent a hybrid form of the two genres. Many of their well-nigh abstract details recall certain features of the Fang reliquary figures just mentioned, which, however, are treated more in the round and figuratively, and whose meaning is thus easier to interpret.

The most striking feature of these reliquary figures is their overlay of metal, in this case brass and copper. The valuable metal was not employed in solid form but in thin, hammered sheets spread over a wooden core (front only, in the present piece). Unlike that of the guardian figures of the northern Kota or Mahongwe, the sheathing was applied not in the form of overlapping strips but as a continuous sheet. And while the former tend to have an almost abstract spoon shape, the Obamba and Mindumu figures have clearly articulated facial features.

There is no other known reliquary figure whose gaze is so hypnotic in effect, and this despite the fact that the eyes are mere flattened cylinders. Their purpose was to ward off evil influences. Reflecting the predominant style in Gabon, they lie in broad circular hollows that come together at the nose to form a narrow projection. The wide forehead is crowned by a sort of diadem, with a toothed pattern that extends down to the temples. The faces of many such guardian figures are set off by surrounding sickle-like shapes, sometimes large in scale. A particularity of the present guardian figure is the way these shapes are brought together to form a continuous contour, creating the impression of a coiffure with a gently undulating silhouette. The outside edges are decorated with a double row of round indentations, which merge with a triple row at the bottom.

There are holes on the reverse that, according to Louis Perrois, originally served to hold an ornamental tuft of feathers. Perrois has also classified the existing reliquaries in seven groups, and placed the present figure in the fifth of these. Their predominantly oval-shaped heads are characterized by shorter flanking plates that end in volutes.

Bibliography: Perrois, 1985

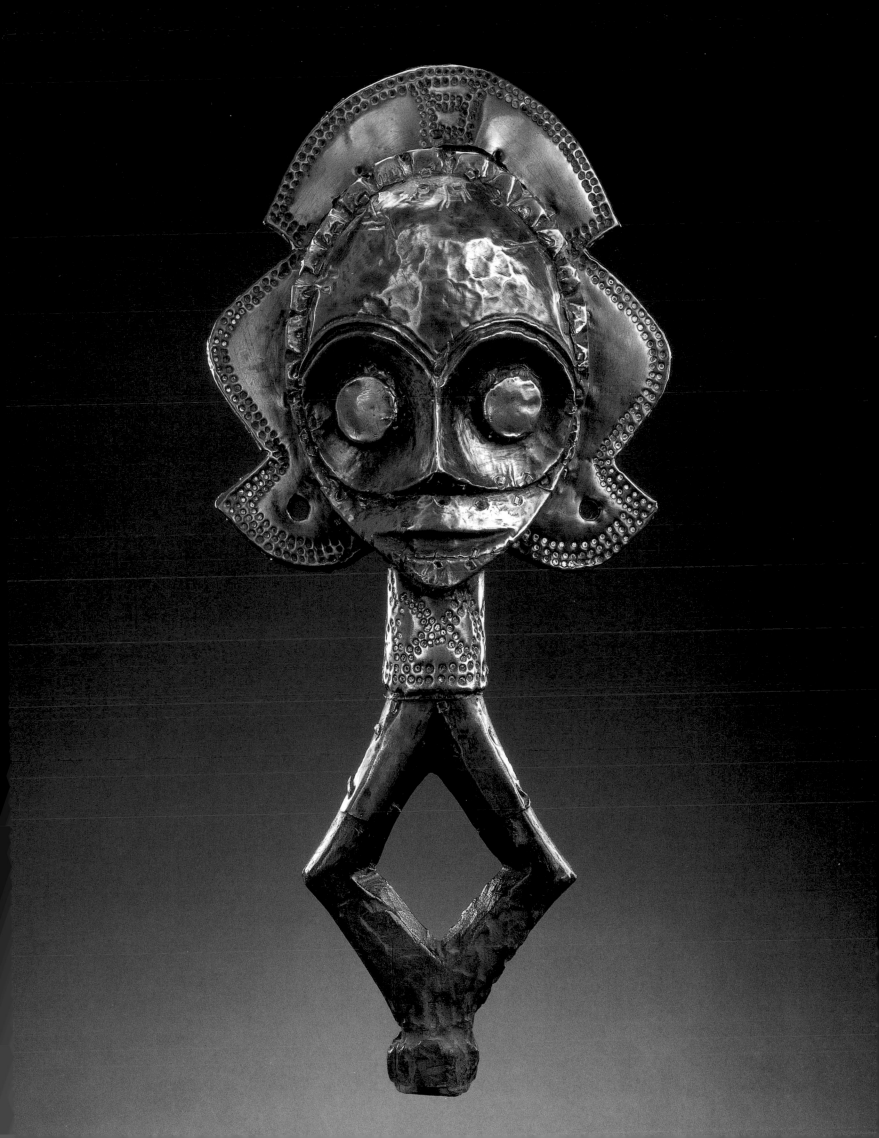

Nkisi Nkondi Figure

Yombe, Democratic Republic of the Congo, 19th century
Wood, metal and shells; height 117 cm
Detroit Institute of Arts, Founders Society Purchase,
Eleanor Clay Ford Fund for African Art

This figure was once called the "Apollo of Africa," and indeed it is not only the most outstanding piece of its type but one of the most impressive and compelling sculptures in all African art. With hands resting on hips (*pakalala*), the pose of this youthful figure reflects great self-confidence. Its body is suffused with tension, but thanks to its strict symmetry and frontality its potential energy finds release through the wide-open eyes and mouth with bared teeth. Since the figure was used as a "weapon" in the context of magical practices, its facial features were designed to convey just this effect. The overlarge eyes, accentuated by pieces of shell, have a look that can kill, and the formerly white teeth between the full, sensual lips were a clear signal to beware of so much readiness to defend the good.

Yet, in the eyes of the Yombe, a subgroup of the Kongo, it was not so much the figure's appearance, for which the carver was responsible, as the additions of the *féticheur* that ensured that a *nkisi nkondi* would fulfill its purpose. *Nkondi* means "nail," and the figure's torso is studded up to the teeth with nails and blades of iron driven into it. Above the navel is a cylinder containing powerful, magical substances, covered by a magnificent cowry shell, which recalls a navel or vulva. The term *nkisi* denotes an extremely manifold complex that includes healing rites, protective magic and even customs relating to the conclusion of contractual agreements. Objects and figures also played a role in such rituals, although they do not seem to have been necessary generally. Smaller figures of this type served the *nganga*, the

medicine man and soothsayer, to assist individuals seeking help. A *nkisi* as large as this one, however, must surely have stood in the service of an entire village. As a "village fetish," it was a "grand oath-taking and healing image" (Thompson) and probably used in the context of making peace treaties between villages, reaching judicial agreements or resolving political issues that affected the entire community. This collective function explains why the figure wears a chief's cap (*mpu*, see p. 27). To seal a contract or reach a decision, a nail was driven into the wood. As a rule, this act signified a certain activation of the powers slumbering within the figure, which might ensure spiritual protection, or lead to the launching of an attack.

The carver basically provided no more than a wooden core on which the medicine man and his client performed their ritual practices. In addition to pieces of metal, such figures could be embellished with a cloth or fur skirt, or a headdress made from cloth or feathers. Besides a beard, the present figure originally wore a cloth skirt, which explains its lack of a male member. While many such pieces were treated rather cursorily for this reason, this one exhibits remarkable sculptural care, especially in the head area. The elaborate head covering and fine facial features are painstakingly rendered. In its realism the head recalls Yombe masks (see illus. on this page), which may reflect the long economic, cultural and religious influence of Europeans on the coastal regions of Central Africa.

The nails and blades had no aesthetic significance for the Yombe themselves. Yet it is precisely this feature, so strange to Western eyes, that has long put such figures in great demand among collectors who view them in strictly aesthetic terms.

Bibliography: Thompson, 1978 and 1981, p. 16f., 38f.; Thompson, in Koloss, 1999, p. 214f.; MacGaffey, 1991; MacGaffey and Harris, 1993; Kan and Sieber, 1995, cat. no. 58

Face mask, Yombe.
Royal Museum
of Central Africa,
Tervuren.

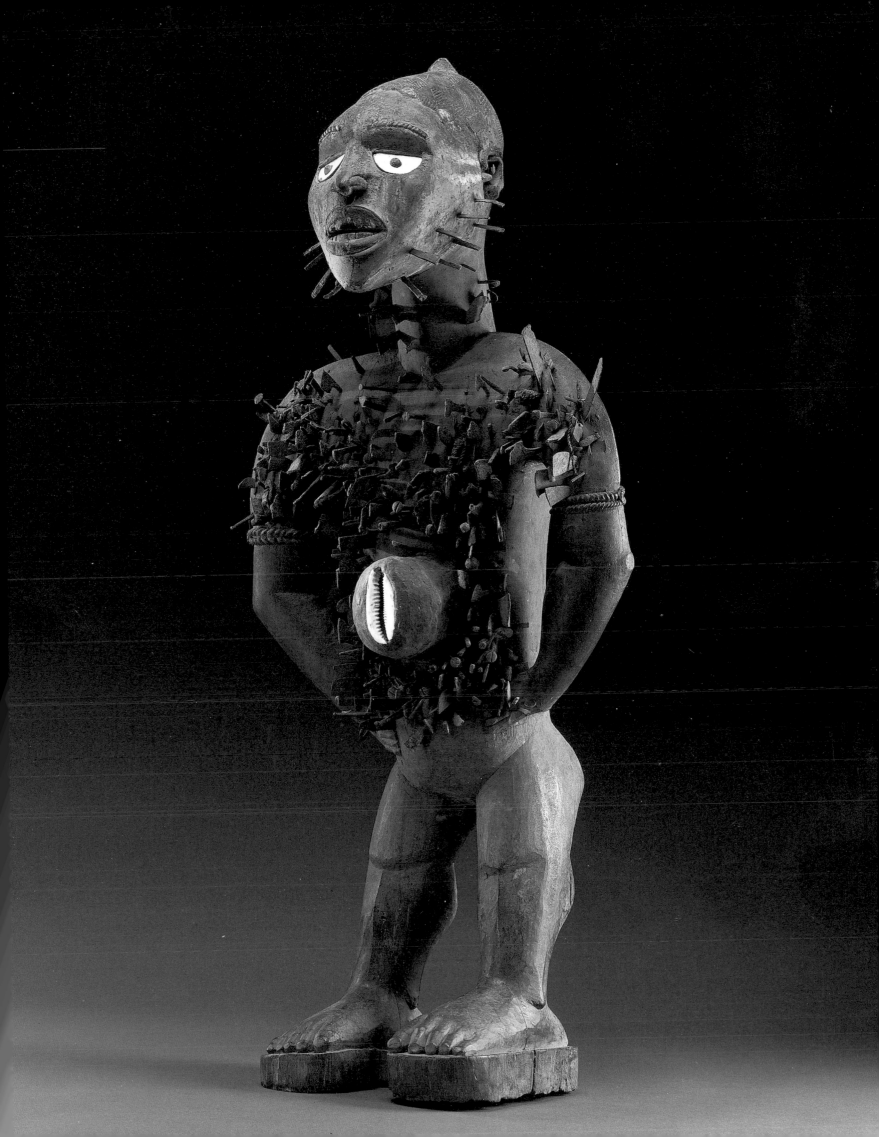

Mpu Cap

Kongo, Angola/Democratic Republic of the Congo,
first half of 17th century
Raffia or pineapple fibers; height 18 cm
National Museum, Copenhagen

As early as the start of the 16th century, the Portuguese traveler Duarte Pacheco Pereira enthused over the woven fabrics of the Kingdom of the Kongo, where "they produce cloth from palm fibers with velvet-like decoration, of such beauty that better ones are not made in Italy. In no other part of Guinea is there a land in which they are able to weave clothes as in the Kongo Kingdom."

The patterns of Kongo textiles are among the finest geometric designs in African art. Lying in low relief on the surface, they combine diamonds, rectangles and triangles to form highly elaborate configurations. In some cases certain areas were left blank on the cloth, and then filled in with woven band patterns; in others the cloth was covered with a braidlike weave or sweeping meander patterns. Traditionally the beige tones of the raffia palm predominate, though these are occasionally supplemented with black.

The raw material used to make these textiles (see illus. below) was won from the raffia palm, bast of the bamboo palm, or from pineapple plants. The creation of elaborate, cut-pile raffia cloths is complex. These are made by drawing raffia between warp and woof of the original cloth and cutting them off at a height of 2–3 millimeters. Not knotted, these threads are then roughened to form a pile surface. The high density of the embroidery produces a velvety effect, and makes the material highly durable.

Much sought-after by Europeans ever since they first visited the Congo coast, these textiles have also been made for export for centuries. They entered European curiosity cabinets as early as the 17th century, where, together with Afro-Portuguese ivories (see p. 79), they formed the nucleus of the African collections of subsequent ethnographic museums. The Danish National Museum has a wonderful collection of old Kongo plushes. One of the most valuable pieces in what was once the Danish Royal Art Collection is the cap of raffia or pineapple fibers illustrated here, which found its way to Europe at an early date, between 1651 and 1700. The person who created this work of art marshaled all available skills, employing a wide range of textile techniques in this single object. A right-angled meander is used to create contrasts in texture and relief between the bands, edgings and interstices. The most elaborate feature are the fillings of two parallel crocheted braids woven into bands. Four so-called

potent crosses, embroidered in high relief, reflect a possible European influence on the art of the Christian Kongo Kingdom. This may have partly extended even to the patterns themselves, which could have been modeled on European clothing or liturgical garments and textiles, but the ornamentation itself is clearly of African origin. Caps of this type were made by specialized "hatmakers" and were limited exclusively to courtly use.

At the time, Europeans purchased such textiles directly from Kongo weavers who lived in the coastal region, to exchange them for slaves in Angola farther south. They were apparently not originally made farther inland, though the center of production did in fact shift there with time. At present the Shoowa, a subgroup of the Kuba, are considered masters of this craft, which lost importance among the Kongo long ago. Within the strictly hierarchical structure of the kingdom of the Kongo and Kuba, plushes presented a textile equivalent of the different social classes through their extensive repertoire of ornamentation. Not everyone was permitted to wear such textiles. Elaborate weaves and certain patterns were restricted to courtly use, and Kuba weavers were forbidden, on pain of death, to sell such royal textiles elsewhere. The cloth was not only made into clothing, cushions and bags but also formed an essential part of the grave goods of important personalities. Plushes were so highly valued that they even served as a means of barter.

Bibliography: Stritzl, 1971[1] and 1971[2]; Gibson and McGurk, 1977; Dam-Mikkelsen and Lundbæk, 1980, pp. 55, EDc 123; 52, EDc 108; Mack, 1980; Bassani, 1983; Meurant, 1986 and 1995; Schaedler, 1987, pp. 33f., 65f., 366f.; Bassani and Fagg, 1988, pp. 202–7; Cornet and van Braeckel, in: Phillips, 1995, p. 275 (with bibliography); Bassani, 2000, p. 9f. (nos. 51, 529, 567, 669; 38), Kongo Art, pp. 277–84

Raffia plush with geometric decoration, Kongo,
17th century, 57 x 54 cm. National Museum, Copenhagen

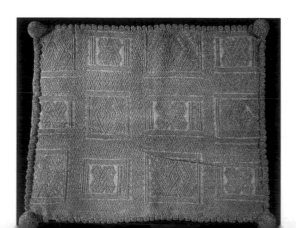

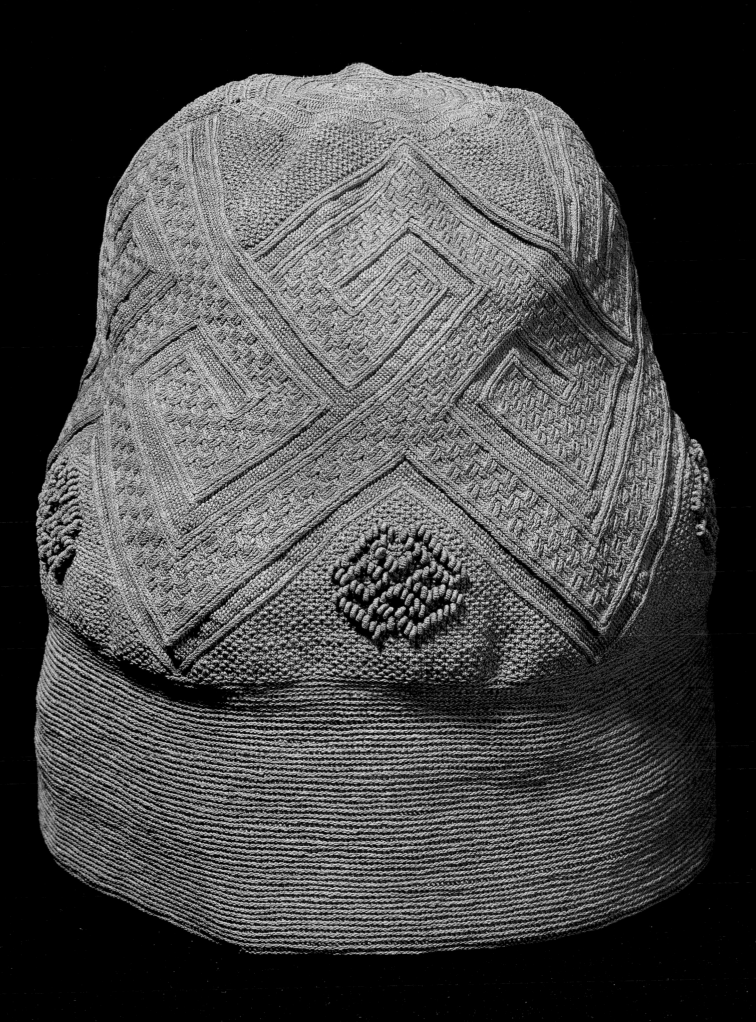

Ndop Figure of a King

Kuba (Bushoong), Nshyeeng, Democratic Republic of the
Congo, 18th–19th century
Hardwood and fibers; height 51 cm
Royal Museum of Central Africa, Tervuren

Not all African kingdoms cultivated a tradition of depicting
their rulers. Among the Kuba, however, this genre is highly
developed. The genealogy of their statues of kings is the
most impressive in all of Black Africa. In the course of their
over 300-year rule, the kings of the Kuba time and again
employed artists at their court in the capital of Nshyeeng to
produce works serving the purpose of official representation.
Their depictions of kings approach more closely than any
other type of African sculpture the European notion of a
"portrait." Still, they are never individual portraits in the
Western sense of the word. The facial features always remain
generalized and seem scarcely to go beyond the stylistic
canon of Kuba art. Instead of depicting the physiognomy of
a person "realistically," sculptors were satisfied to employ
distinctive symbols and attributes. In this way, the resulting
figure unmistakably "represented" a certain person in the
eyes of contemporaneous observers.

Such royal statues served the widows of deceased kings (*nyim*)
as memorial figures and, according to J. Cornet, were commis-
sioned by their immediate successors. J. Vansina claims that a
new figure was carved for each king on the occasion of his coro-
nation. It represented the ruler, also when he was absent from
court for long periods, and was thought to be capable of easing
women's birth pangs. Thus the statue served as a doppelgänger
of the king throughout his lifetime. When the king died the
sculpture became a memorial figure, or, rather, the embodiment
of the king, whose charisma was then transferred to his succes-
sor after going into seclusion for several days.

Like this piece, the few *ndop* known to us show the monarch,
with legs crossed, enthroned on a rectangular stool. An embodi-
ment of dignity, he is depicted in a frontal, symmetrical pose.
The eyes in the disproportionately large head are closed, signal-
ing unapproachability, detachment, and communication with
the world beyond. On his close-shorn head he wears a boardlike
royal cap, embellished with depictions of cowry shells, which
projects out over the forehead. In front of the king, holding a
sword in his left hand, is his most significant insignia, a richly
ornamented royal drum. Strings of cowries around the stomach
and upper arms, and bands around the shoulders and joints,
complete his ornament. The front of the pedestal bears depic-
tions of an anvil, a fly whisk and a board game (*mankala*). Based
on the personalized drum, or *ibol*, Cornet believes the figure can
most likely be identified as representing King Kot a-Ntshey, who
lived in the first half of the 18th century. The worn relief work is
possibly due to generations of rubbing the figure with redwood
powder (*tukula*). Presumably even sculptures such as this, made
from an extremely resistant hardwood, were occasionally
replaced and copied, so that only in exceptional cases are we
actually looking at original pieces.

Bibliography: Vansina, 1972; Rosenwald, 1974; Cornet, 1982; Adams, 1988;
Borgatti and Brilliant, 1990, p. 50f.; Burssens, in: Verswijver et al., 1998, cat.
no. 70

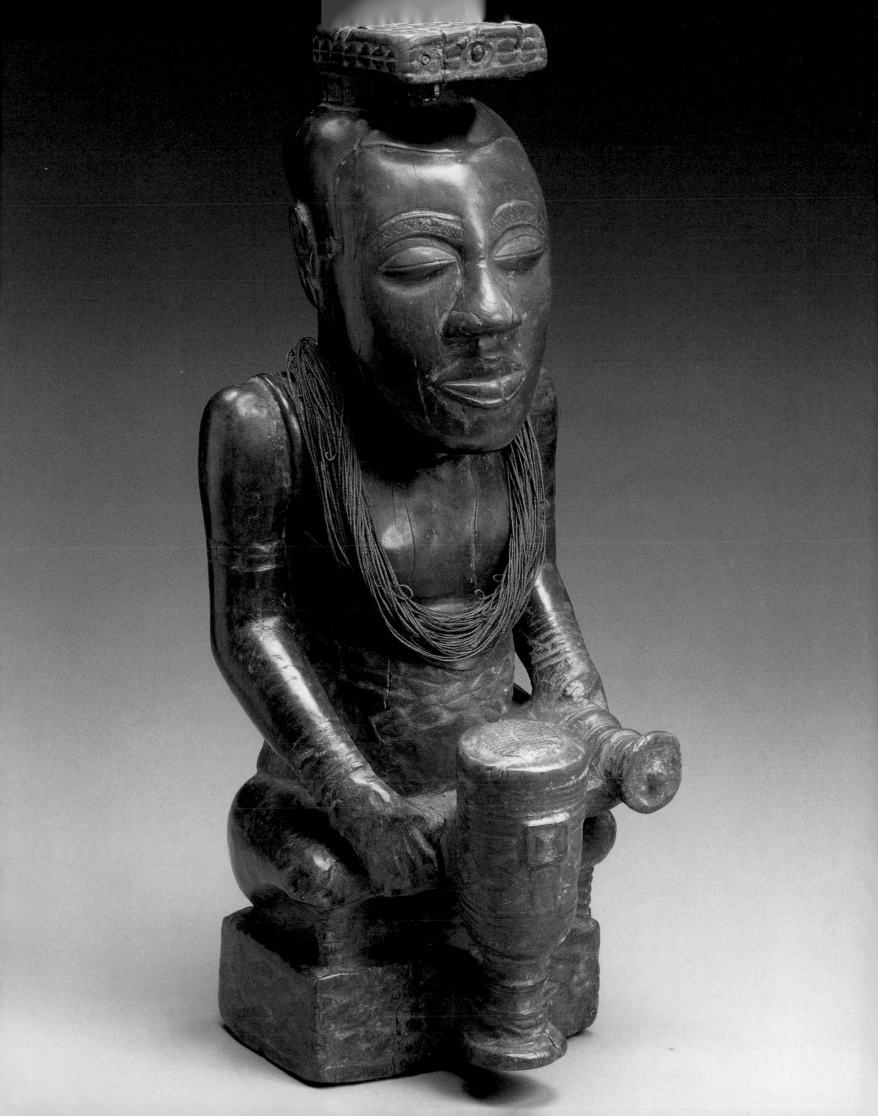

Bwoom Helmet Mask

Kuba, Democratic Republic of the Congo, end of 19th century
Wood, black paint, brass, raffia, cowry shells and glass beads,
among other materials; height 36 cm
Völkerkundemuseum, University of Zurich

Alone the exclusive materials used to make this helmet mask indicate that it was no ordinary object. As brass and other metals were extremely precious, in many parts of Africa only court artists were permitted to work with them. Cowry shells were so highly valued that they served as money. Only kings and notables could afford glass beads imported from Bohemia or Venice. Its sheer material value made this object a "Rolls Royce" among Kuba masks, as befits the mask of a king.

Carved palm wine cups clearly show the facial type favored by the Kuba: eyes ranging from almond shapes to mere slits, pronounced eyebrows, a short, broad nose and a mouth projecting like a relief. Often heavy scarification lines run diagonally across the cheeks from the lower eyelids. The polished forehead on the cups is ennobled on the mask by the sheen of the brass fittings, heightening its imposing aspect. The mouth and an ornamental crescent-shaped scarification design across the cheeks are also accentuated in brass. Bands of dark blue beads represent scarifications on the forehead, and a light blue-and-white striped band runs from the bridge of the nose to the upper lip. The sides of the nostrils and ears are likewise covered with blue beads. Rows of beads and cowry shells as well as a frayed border frame the face below, while this is achieved by a single row of beads above. Only the cheeks of the black, wooden mask have been left uncovered.

Female *ngady a mwaash* Kuba masks are often decorated with paint and the mouth is frequently covered by a vertical band of beads that runs down the bridge of the nose. In the present *bwoom* mask a white, stepped band of beads runs horizontally across the eyes, concealing them from the viewer (the eyes were therefore not elaborated by the carver). Consequently, the dancer who wore the mask had to tilt it slightly backward to see through its drilled nostrils. The broad ornamental band hanging from the chin is decorated with diamond-shaped, cowry shell patterns and glass beads, serving to cover the wearer's face.

The mask's facial features combine with its embellishments to create a striking mosaic of decoration, to which individual motifs are subordinated. Like their colors, the textures of the various materials offset each other to fine effect, engendering a maximum of contrast.

Ethnological interpretations of the *bwoom* mask are contradictory: they range from a presumed influence of the Pygmies, who are neighbors of the Kuba, to its identification as a hydrocephalous prince. All we know for certain is that the male *bwoom* mask is one of the three main types of Kuba mask. In addition to the aforementioned female *ngady a mwaash* mask, the triad is complete with the male *mosh' ambooy* mask (see illus. below). All three masks represent royal personages and are connected with performances of the creation myth of the Kuba, which involves the incestuous relationship between the primeval ancestor Woot and his sister-wife Mweel. Accordingly, the *mosh' ambooy* mask represents the king, Woot, the *ngady a mwaash* mask Mweel and the *bwoom* mask the king's brother, who contested the king's right to the throne and his consort without avail.

Bibliography: Vansina, 1978; Cornet, 1982, pp. 256–71; Szalay,1995, p. 178f.; Burssens, in: Verswijver et al., 1998, cat. no. 71 (with bibliography)

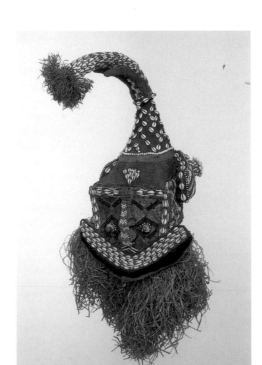

Mosh' ambooy mask, Kuba, end of 19th century, Völkerkundemuseum, University of Zurich

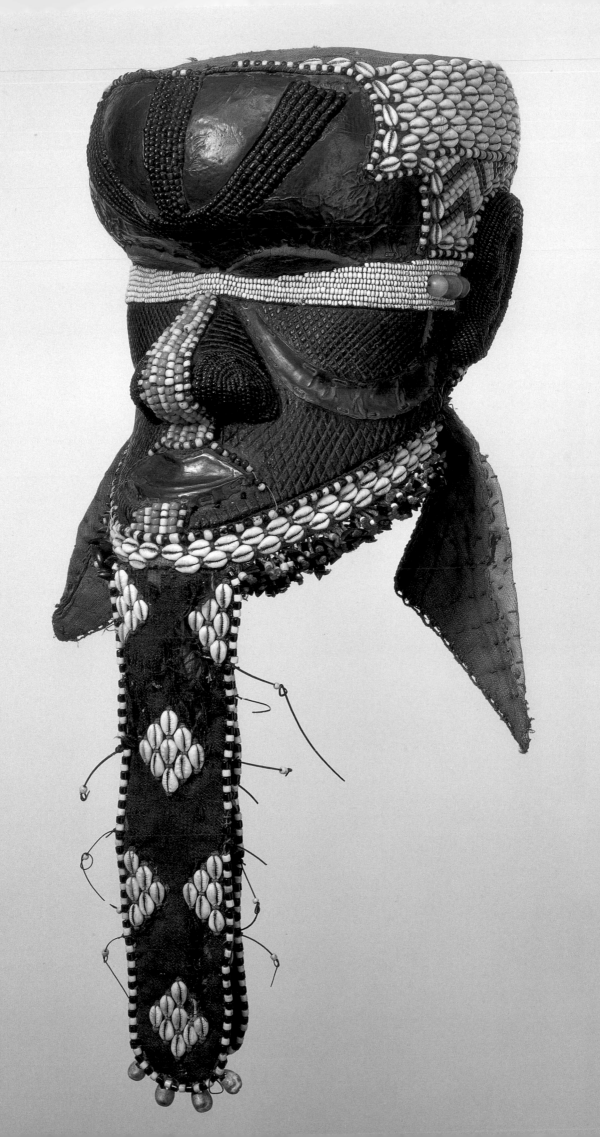

Royal Figure
of Chibinda Ilunga

Chokwe, Angola, 19th century
Wood, cloth, hair, plant fibers and glass bead; height 39 cm
Ethnologisches Museum, Berlin

Figures representing this mythological culture hero of the Chokwe, a people concentrated in northern Angola and the southern Congo, are rare and correspondingly valued. Chibinda Ilunga was a passionate and brave Luba huntsman of royal birth who left his homeland centuries ago, appeared one day among the Lunda and took their princess, Lweji, to be his wife (for more on the Luba, see pp. 36–39). Before Chibinda's arrival, Lweji had ruled her people with a group of chieftains. Later their son Mwata Yamvo, became the first king of the Lunda and the representative of a sacred monarchy introduced by him. Various ruling houses, including that of the Chokwe, derived from the Lunda dynasty. Whereas the deeds of this ancestral couple were continuously praised in their songs, in contrast to the Lunda the more artistically gifted Chokwe produced no narrative descriptions of this central African love story . Yet they did feel a special reverence for Chibinda Ilunga, which found expression in figures of this ancestor, which were earlier kept in the palaces.

Individual traits of the hero play no role in this sculpture, nor could they be expected to, since the myths relating to the founding of the Lunda Empire evidently date back to the period around 1600. The key features of the depiction of Chibinda Ilunga are his attributes, which establish his identity in Chokwe eyes and for whose representation particular attention was paid. Among the ruler's physical features are a muscular stature and powerful hands and feet that illustrate his might and stamina—his ability to "stand his ground," as it were. Moreover, the crown (*cipenya mutwe*) is so large that his head seems pressed into his shoulders by its weight. Its bizarre shape derives from elaborate

headdresses of the type familiar from many Chokwe masks, which consist of a headpiece made of bark cloth, stretched over a frame made of interwoven twigs. A "winged crown" of this type is seen in a surviving photograph of the Chokwe chief Chauto (A. da Fonseca Cardoso, 1903 and 1919). In addition, Chibinda Ilunga carries "all the indispensable hunting gear: a muzzle-loading rifle with cartridge belt, a knife, a calabash and objects endowed with magical powers to ensure a good hunt, such as a staff, a tortoise shell and an antelope horn. Further, the king is surrounded by small figures who serve as protective spirits during the hunt" (Marie-Louise Bastin).

The figure's face is smoothly modeled and lacks the geometric abstraction characteristic of other Chokwe figures and mask types. The mouth extends almost the entire width of the face, and the eyes are correspondingly elongated and overarched by curving brows carved in low relief. The smooth, beautifully rounded forehead provides an effective contrast to the hatching on the crown. The beard, carefully bound and adorned with a large glass bead, is worthy of a monarch. Rather than setting out to create a historical depiction of the hero, the carver of this masterpiece embraced the iconography of the period used in representations of royal personages. If we disregard the hunter's attributes for a moment, we see an ideal image of a sacred king of the Chokwe in this sculpture. He held the title of *Mwanangana*, which might be translated as "lord over the land."

Bibliography: Bastin, 1965, 1978, 1982, 1989 and 1999, p. 127f.; Bastin, in: Koloss, 1999, cat. no. 123; Bastin, in: Phillips, 1995, p. 266; Jordán, 1998; Cuononoca in: Mack, 2000, p. 138f.; Petridis, in: Falgayrettes-Leveau 2000, p. 297f.

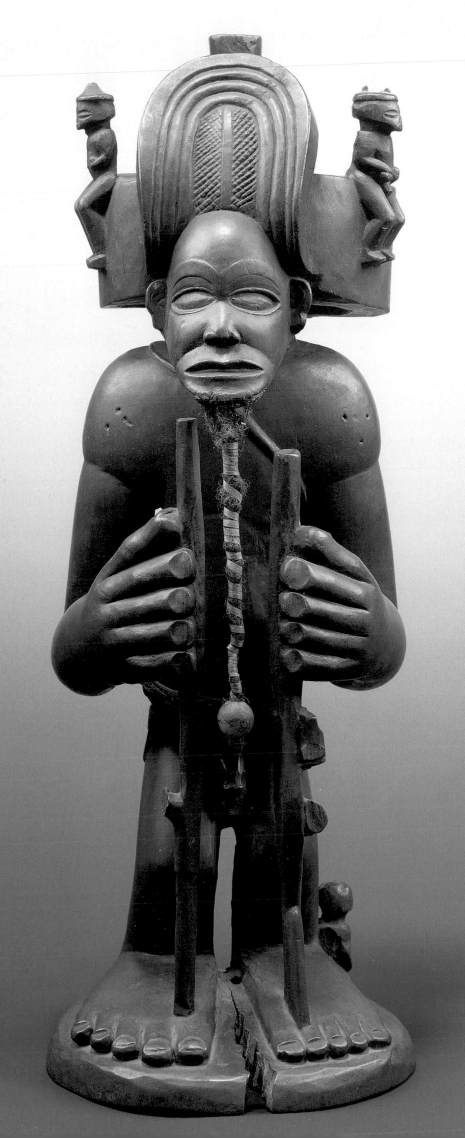

Nkisi Figure

Songye, Democratic Republic of the Congo,
19th–20th century
Wood, metal, teeth, fur and bast fibers; height 78 cm
Collection of P. Dartvelle, Brussels

Like the Yombe figure on page 25, this sculpture served the purpose of *nkisi*—healing, divination and magic-making—which the Songye associated even more closely with such statues than the Yombe. The underlying idea behind the two figures is very similar: their active powers are underscored by a standing pose (the Songye figure's bast skirt conceals short, powerful legs), their hands are pressed against their abdomens and they both contain magical substances that were crucial to their effect. While in the case of the Yombe figure, these substances were placed by a *nganga*, or medicine man, in a small container above the navel, here the *nganga* or a priestess concealed them in a hollow behind the figure's navel and probably sealed them with a piece of mirror. An additional medicinal bundle was placed in the mouth. Yet there is a decisive difference between the two figures, for the one illustrated here was never activated by driving nails or iron blades into it. Instead, the head was given a permanent cover of metal, attached with upholstery tacks (other figures of this type have only patterns formed with such tacks). Still, an analogous intention may be assumed in both cases: to potentiate the power and efficacy of the figure.

In contrast to the Yombe figure, the head of this Songye *nkisi* is anything but "classical" in style, eschewing every trait conventionally associated with physical beauty. In accordance with the Songye style, the eyes are not sunken but strongly protruding. They are represented on a plane with the eyebrows, above deeply hollowed cheeks, from which nose and mouth in turn protrude. The bands of the symmetrical metal applications meet at the bridge of the nose, run across the lower eyelids, forehead and cheeks, and completely cover nose, lips and chin. The eyes, which appear closed, are left free. The fur used to represent hair and the goatee lends the sculpture a touch of naturalism. Comparable figures occasionally had one or more horns containing magical substances mounted on their head. While smaller figures of this type were kept and consulted by individuals, larger

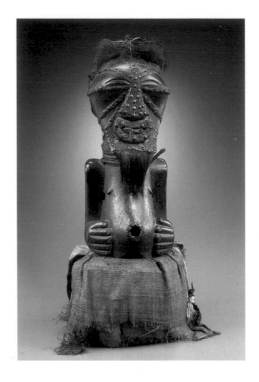

ones, like this figure, were responsible for ensuring the welfare of an entire community.

The Yombe practice of studding figures with nails has been associated with influences from European Catholicism. The harmonious face of the Yombe figure would indeed seem to provide proof of a long artistic influence of European sources. In sharp contrast to this stands the extremely threatening aspect of the Songye figure, produced by a people who originally migrated from the region of Uganda to settle in deepest Central Africa. As a result they were spared the incursions both of slave traders and of early missionaries, and thus the infiltration of their culture by a foreign one. This *nkisi* figure would therefore seem to bear a more authentic witness to ancient African customs and ritual imagemaking.

Bibliography: Hersak, 1986; Hersak, in: Verswijver et al., 1998, cat. nos. 80–81; Hersak, in: Mack, 2000, p. 149f.; Mack, in: Phillips, 1995, p. 283

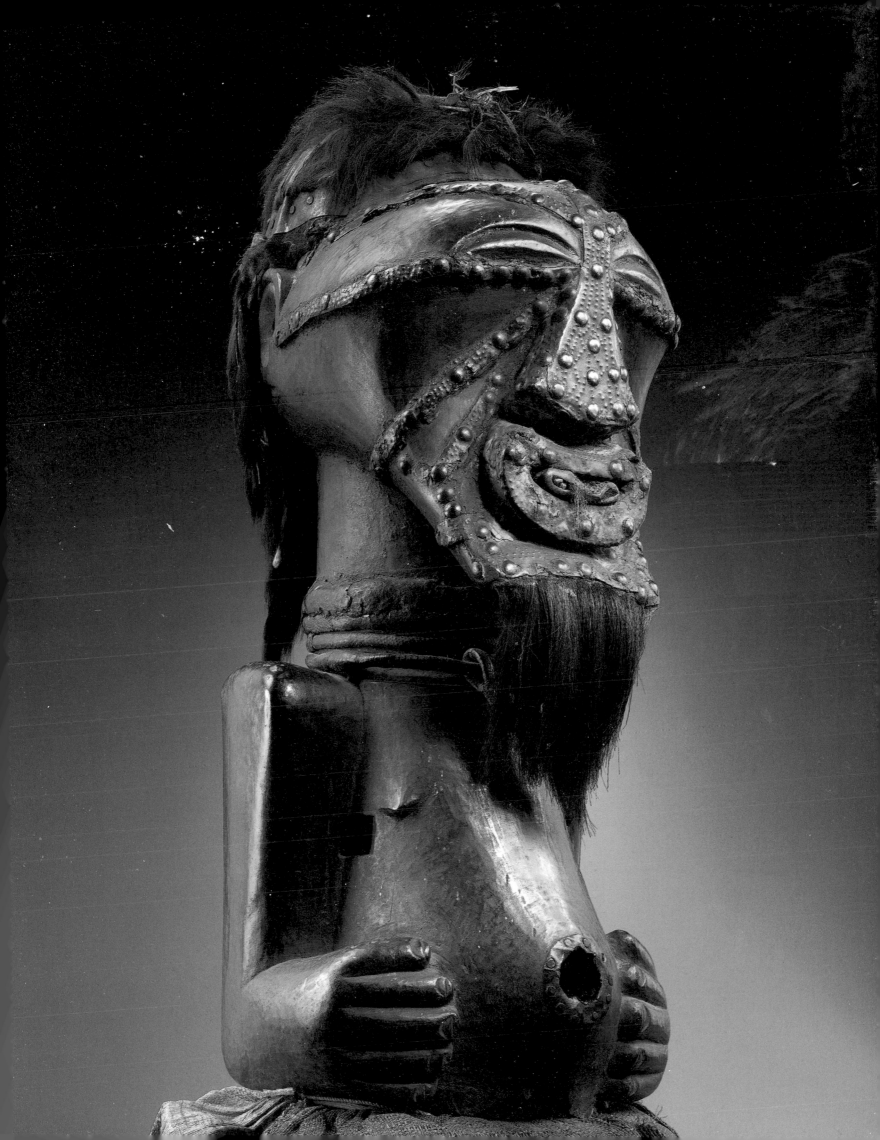

Female Figure Holding a Vessel

Luba-Hemba, Master of Katéba (former Master of Buli),
Democratic Republic of the Congo, 19th century
Wood; height 44 cm
Royal Museum of Central Africa, Tervuren

This figure is not only one of the most unusual in all African art, but enjoys a legendary reputation among ethnologists. At a period when the supposed collective character of African art made the question of artistic individuality seem irrelevant and tribal styles were considered immutable, the investigations of Frans M. Olbrechts beginning in the 1930s came as a revelation. Based on comparative stylistic criticism, Olbrechts succeeded for the first time ever in compiling a group of about twenty figures that must have been created by a master or his workshop in the latter half of the 19th century. In the absence of a signature, he named this artist "Master of Buli," after a town in the eastern Congo. It has recently been suggested that his oeuvre was in fact created by three artists: the "Master of Katéba," the "Master of Buli the Elder" and the "Master of Buli the Younger" (de Grunne, 2001). The Master of Katéba (active ca. 1820–60) is considered to have been the most important. In addition to the caryatid stools and two standing figures, the present female figure represents his *chef d'oeuvre*.

A similar crouching posture is found in the Master of Katéba's caryatid stools. Yet, whereas in these the head is raised and the arms are bent to carry the weight of the seat, here the hands hold a bowl. The head is lowered in humility or reverence, and the eyes are closed. Earlier this figure was erroneously identified as a beggar. Among the characteristics of the Master of Katéba's, as well as both of his successors' style are a gaunt, elongated face with accentuated cheekbones, highly raised eyebrows (which emphasize the closed upper eyelids) and narrow, protruding lips. The bodies of his figures likewise appear ascetic and the standing figures tall and slender. This figure does not represent a young person, as is customarily the case, but an old one.

Figures of this type are among the most important requisites of royal soothsayers, or *bilumbu*, who still play a key role in the daily lives of the Luba. During consultations such sculptures are placed to the left of the soothsayer, whose wife sits to his right. According to Mary Nooter Roberts and Allen F. Roberts, the bowl-bearer represents, among other things, the wife of the spirit who takes possession of the soothsayer when he enters a trance. Healing properties are attributed to such figures. The bowl may contain kaolin or white chalk, substances that are holy to the Luba and that the soothsayer also applies to his face and body in order to facilitate contact with the world beyond. In cases of medical treatment the soothsayer or healer removes the white powder and mixes it with therapeutic substances, then massages the patient with them. Such figures are believed to have still further supernatural powers, and are also found in royal residences, where they stand at the entrance and hold kaolin ready for use.

The bowl as such is also one of the crucial implements of Luba prophesying. Known as a *mboko*, it is usually a sacred pot fashioned from a calabash. The soothsayer uses it to keep various objects, both naturally occurring and specially fabricated, ranging from numerous tiny human figurines to miniature tools, magical bundles stuffed in antelope horns, cowry shells, teeth, seeds, birds' beaks, etc.—representing all aspects of reality. The aim of divination lies in calling upon the spirits to help find the right object for a particular client, and to interpret it convincingly in order to solve the problem that troubles him.

In this female figure by the Master of Katéba, the holding of a vessel becomes a veritably sacred act. The woman is unclad (and bears no scarifications) and wears a heavy, elaborate coiffure. Her meditative attitude would warrant viewing the figure as a female soothsayer (who were once in the majority) who has entered a trance and is receiving inspiration from her attendant spirits. A photograph of a soothsayer with eyes closed, seated on the ground with outstretched legs and holding a *mboko* bowl, taken some time between 1927 and 1935, has been interpreted as looking into the past, searching for advice for the future. Some authorities consider such figures of female bowl-bearers to be likenesses of Mijibu wa Kalenga, the primeval male soothsayer of the Luba, who in the hour of birth of the sacred kingdom helped its first king, Kalala Ilunga, achieve political success through his spiritual guidance. This made him patron and ancestor of all subsequent Luba soothsayers. His embodiment in a female figure would seem unproblematic in view of the special social role enjoyed by soothsayers of both sexes.

Bibliography: Olbrechts, 1959; Vogel, 1980; Neyt, 1993; Roberts and Roberts, 1996; Petit, in: Verswijver et al., 1996, cat. no. 97; Pirat, 1996; Roberts, 1999; Roberts, in: Mack, 2000, p. 132; de Grunne, 2001, pp. 185–90, cat. nos. 60–68

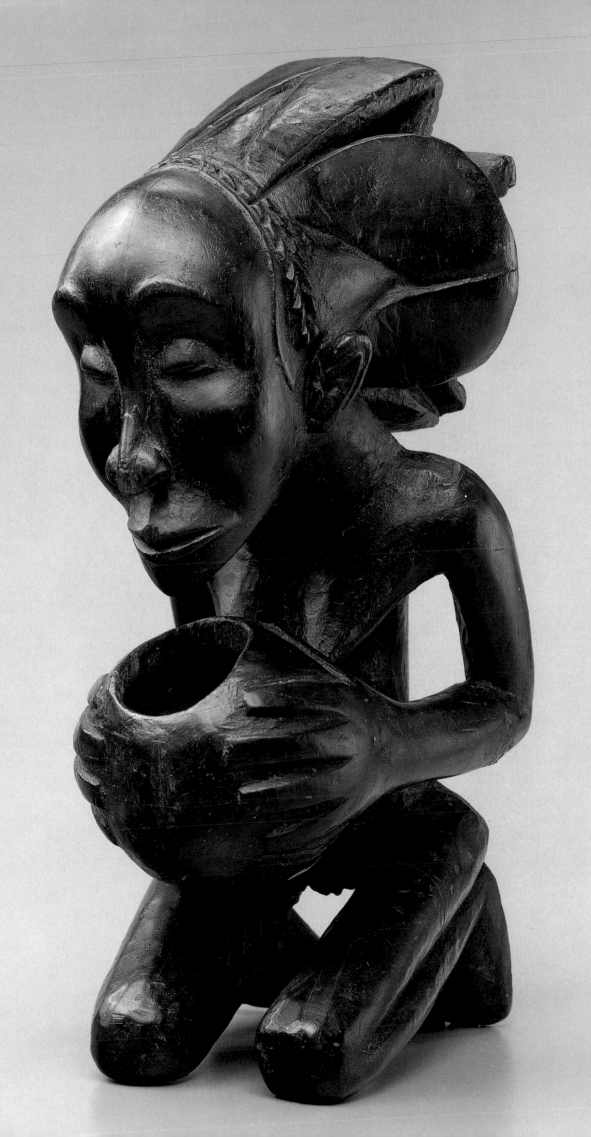

Lukasa Mnemonic Board

Luba, Democratic Republic of the Congo
Wood, beads and metal; height 27 cm
Private collection (formerly in the Felix Collection)

Although this gracefully shaped board adorned with bead-work has a great decorative effect, it was designed less for ornamental purposes than as a ritual object of great importance. For the Luba in the southeastern Congo, such *lukasas* served as means to keep their complex tradition alive. In cultures that passed their history down from one generation to the next without the aid of writing, the possession of an excellent memory was indispensable. The pandits of India or the *griots* of Africa were just such memory artists, who kept alive the memory of events from the far-distant past in their songs.

The Luba, whose empire reached its apex in the 18th and 19th centuries, had what might be termed an institutional form of historical transmission. According to Mary Nooter Roberts and Alan F. Roberts, one secret society's, or *mbudye*'s, purpose was to make certain that traditions were passed on. Its members, genealogists, court historians and "traditionalists," were entrusted with the task of watching over and ensuring political continuity. With the aid of ritual performances and didactic practices these "men of memory" attempted to keep an awareness of ancestors and events of Luba mythology alive. In their four-phase initiation, the *lukasa* represented the most difficult, fourth degree, which only very few were able to pass. The board associated with it served the instruction of the initiates. M. N. Roberts writes: "*Lukasa* boards evoke the heroes and exploits of the great Luba epic; the biographies of particular kings; the names, titles, and duties of all the court dignitaries; sacred loci in the landscape where particular named spirits reside; countless proverbs, maxims, and songs; and even the precise locations and contents of the royal treasuries." "During *mbudye* rituals a *lukasa* is used to teach neophytes sacred lore about culture heroes, clan migrations, and the introduction of sacred rule; to suggest the spatial positioning of activities and offices within the kingdom or inside a royal compound; and to order different officeholders' sacred prerogatives concerning contact with earth spirits and the exploitation of natural resources."

A simpler form of *lukasa* were wooden reliefs, whose "records" consisted of engraved lines and symbols. Incised motifs are found on this specimen as well, but more important are the raised bulges, iron hairpins and, especially, the clusters of beads attached with nails to form various patterns on the board. A single bead may stand for a king, and a bead within a circle of beads, a king at his residence. Lines may refer to migrations or ancient paths, and so on. An initiate would be quite aware of which Luba monarch is associated with each bead, whether Nkongolo Mwamba, the despot, Kalala Ilunga, the first, sacred king of the tribe, or another ruler. Many real and imagined places are also indicated on the board. Such *lukasas* might indeed be described as topographies of a memory space. Beyond their function as a mnemonic device, they retell the entire history of a clan or tribe in encoded form.

Bibliography: Roberts and Roberts, 1996; M.N. Roberts, 1998, p. 56

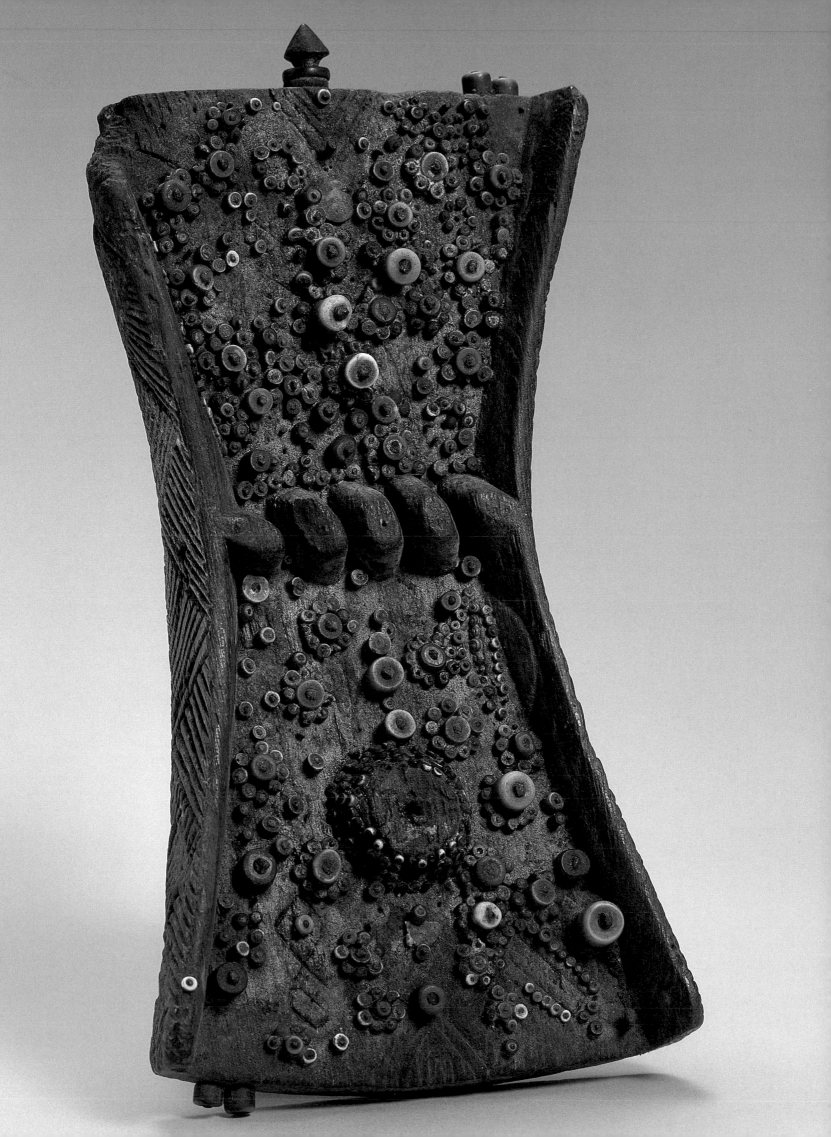

Pongo Barkcloth

Ituri foragers, Democratic Republic of the Congo, 20th century
Barkcloth and colored pigments; 82 x 65 cm
Private collection

Cloth made of bark, or bast, is one of the oldest types of textile known to mankind, and is found around the world (in Oceania it is called *tapas*). In Africa, it was produced and worn above all by the inhabitants of the northeastern rainforest region of the Congo, Pygmies named Ituri foragers after a tributary of the Congo River. Yet barkcloth was also known to their neighbors, the Mangbetu, the Makonde and the Baganda or Rundi of Burundi. The Ituri foragers (also known as Bambuti or Mbuti) lived, and in part still live, from hunting game and foraging for honey, fruits and nuts, roots, mushrooms and insects. These forest dwellers maintain contact with farming groups with whom they exchange their forage for grain, ceramics, salt, metal and other commodities.

The species of tree that provides the bark for the cloth is called *pongo* or *mulumba*. The inner bark layer is scraped off and the bast, or phloem (the tissue layer between the bark and core of a tree), is pounded with an ivory or bone mallet over a piece of wood for about two days until the material is soft and the sap has escaped. As P. Claes observed, the material is then dried in the sun for another five to six days. This work is performed primarily by men, whereas the subsequent decoration of the cloth is women's work. They usually fold a piece of barkcloth several times and lay it over their knee before beginning to paint. This folding explains the breaks or interruptions in the graphic pattern often observed, as in this specimen. The drawings consist principally of geometric shapes, and only rarely evince forms of a figurative character. Broader lines are applied to the cloth with a finger dipped in paint; finer ones by means of a twig or plant stem. The blackish-blue pigment consists of crushed charcoal, mixed with gardenia juice as a binding agent. Further colors are derived from various roots, plants and leaves. The material, with its beige tone, is occasionally tinted by impregnating it with some other color, such as the sumptuous reddish-brown of the present piece. The painted cloths may be up to 1.5 meters in length. Medium-sized pieces are worn by women as aprons (one piece, each front and back) and by men as loincloths. From a functional point of view these pieces are textiles, yet in aesthetic terms they represent works of graphic art. It might therefore not be going too far to term them "hip drawings."

Unlike woven African textiles, in which the texture of the long woven strips is often reflected in sequential, symmetrical designs, barkcloth enables a freer, more spontaneous composition. Only the rectangular shape establishes a kind of frame for the image. Mbuti women thus begin with a situation not unlike that faced by Western artists confronted with a white sheet of paper or an empty canvas. Apart from textile painting, the Mbuti also practice body painting, and the two genres evince a great similarity with regard to the motifs employed.

The design illustrated here is composed of fine, deep, black strokes across the surface that extend like a web (Meurant and Thompson, 1995, cat. no. 42). The graphic style of the upper and lower zones, as well as the left and right halves, are notably different, making each quarter distinct from the others. Yet dots at the intersections of lines, "asterisk" motifs and hatching occur in all four sections and lend the image cohesion. Its particular charm lies precisely in its insouciant disparity, an alternation between graphic compression and open space, between decorative pattern and freely rendered strokes. Like the four movements of a piece of music—in different keys and tempi and with variations on a basic theme—the four zones combine to form a vibrant whole.

Bibliography: Bailey, Claes, Fasel, Schmalenbach, 1990; Thompson and Bahuchet, 1991; Meurant and Thompson, 1995, cat. no. 42; Thompson, in: Phillips, 1995, p. 303f.; Schildkrout, in: Phillips, 1995, p. 305

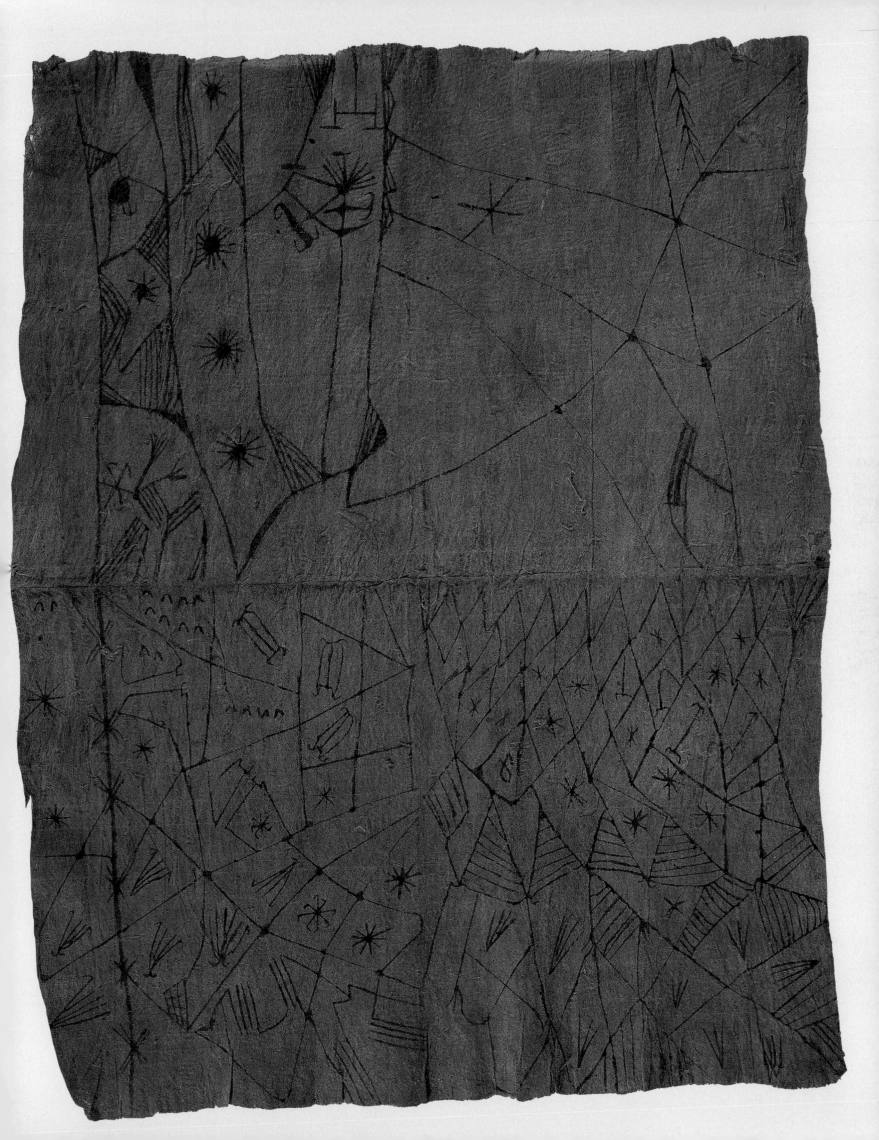

Anthropomorphic *Sanza* Lamellaphone

Zande, Democratic Republic of the Congo, prior to 1910
Wood and bamboo; height 61 cm
Royal Museum of Central Africa, Tervuren

Drums have become synonymous with Africa in the Western mind, which has resulted in a distorted image of African musical culture. There are African musical traditions in which drums play no special role at all, such as recitations by the *griots*, singers who recount the story of a clan bringing it vividly to mind. Moreover, from time immemorial the continent has produced an astonishing variety of musical instruments, used in regionally different combinations to produce a plethora of sounds. Harps and a range of other types of string instrument, xylophones, flutes, horns (of ivory or wood) and pipes are played on a variety of occasions. The use of bells, gongs, rattles and various forms of clappers has to this day remained a vital tradition, as it once was in Europe before the advent of reforms that "harmonized" the practice of music. Even drums, belonging to the membranophone family, evince a surprising range in terms both of their sound—such as from "talking drums"—and their appearance.

Equally various in shape and appearance are the lamellaphones, otherwise known as "thumb pianos" or *sanzas*, which are among the most ancient of African instruments. They are known to have existed as early as the first millennium BC. Their lamellae, or keys, were initially made of reed or bamboo. The anthropomorphic specimen illustrated here stands in this tradition, despite the fact that sheet iron keys replaced plant materials in many parts of Central Africa between the seventh to tenth centuries (G. Kubik). The female figure, her arms raised and her head thrown slightly back as if in a dance, is a veritable "resonating body," the hollow torso serving as a resonance chamber to amplify the vibration of the keys. Bound tightly over two bridges, the seven keys stand far enough above the instrument that they can be plucked from the underside. The *sanza* is tuned by pulling the keys out or pushing them in, which alters their pitch.

The present instrument was probably not made for everyday use but for festive occasions. *Sanzas* are played by a singer to accompany love ballads. In Africa, the strong, physically experienced link between music, song and dance gave rise to a preference for anthropomorphic forms. The Zande, in particular, who live in the border region between Sudan and the Congo, have made a fine art of lending their instruments human shape. In contrast to their neighbors to the southeast, the Mangbetu, for whom heads or figures merely adorn instruments, the instrument-makers of the Zande treat the entire corpus in an anthropomorphic fashion. Their predilection for female figures is surely due primarily to the fact that the instruments are played by men. In addition, the typically rounded female form was more appropriate to achieve the ample volume needed for good resonance (as, for instance, in barrel drums). The art of metamorphosis so typical of the African aesthetic is played out to the full here, for the plucking of the instrument takes on the sensual "undertone" of touching and caressing a woman's body. The figure's open mouth and extended arms may thus express a state of ecstasy, in more than one sense of the word.

Bibliography: Laurenty, 1962; Schmidt, 1989; Mack, 1990, p. 225f.; Schildkrout and Keim, 1990, pp. 194–215; Kubik, 1999

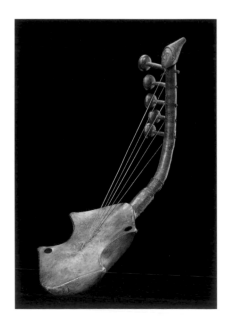

Kundi arched harp, Zande, prior to 1907, Royal Museum of Central Africa, Tervuren

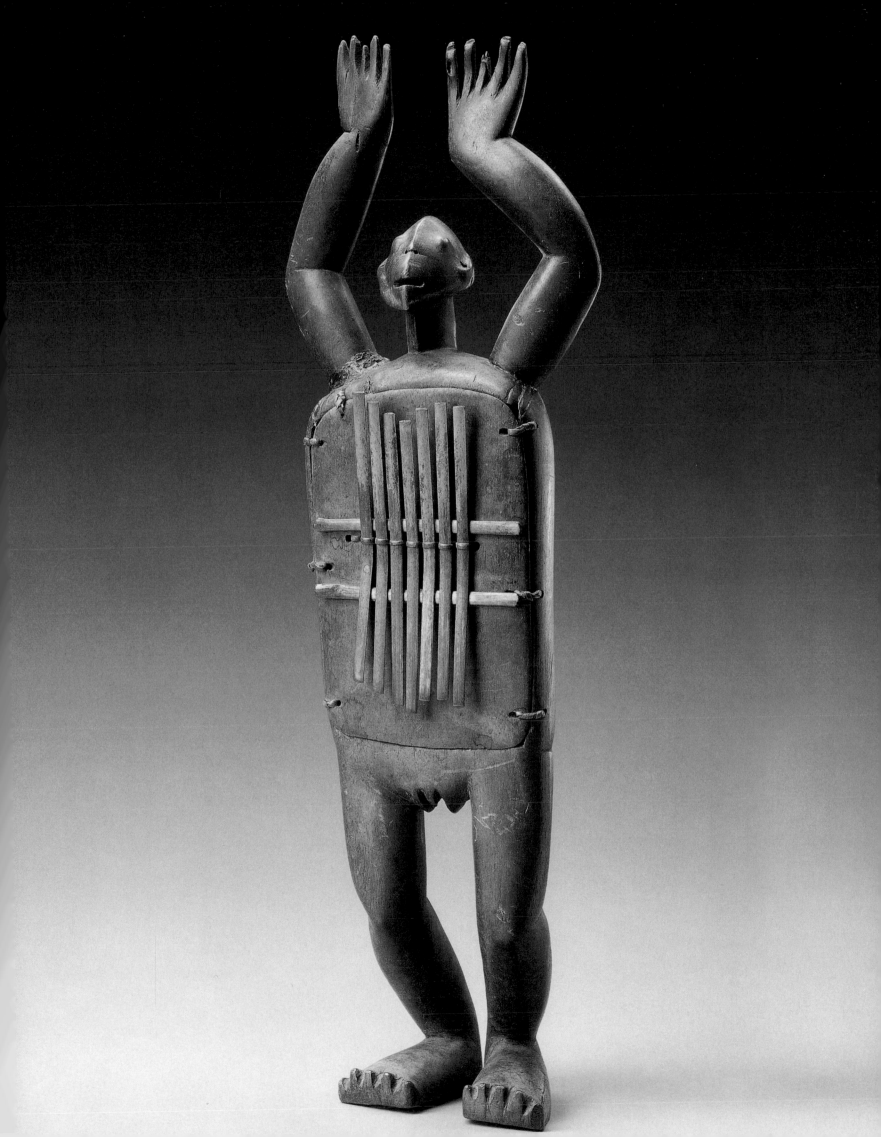

Eastern and Southern Africa

Art historians long took a rather disparaging view of East Africa. Many nomadic peoples are indigenous here so that little monumental art developed, yet even the copious artwork that did exist long failed to gain the recognition it deserves. A reason for this is the rougher character of East African sculpture, running counter to the "aesthetic quality" of West African art, which was for decades the benchmark for African art in the Western world. In East Africa, and still more markedly in southern Africa, art forms predominate that are more closely associated with the practicalities of everyday life. Public display and status are expressed even in simple objects, such as stools and headrests, woven baskets and bowls, sticks, pipes and tobacco containers.

Culturally, both East Africa and southern Africa are far less homogeneous than Central Africa. In Ethiopia, early forms of Christianity encountered indigenous religions and feudal societies mingled with tribal cultures. Further south, the Arab influence becomes more discernible. The Swahili culture on the East African coast, from Somalia to Mozambique, bears unmistakable Arab and Islamic features. When Vasco da Gama anchored here on his way to India in 1497/98, the markets were firmly in the hands of Arab merchants. To establish a trading base, the Portuguese destroyed the Arab trading settlements and built several forts.

It has been surmised that, prior to the Arab takeover, the East African coastal region was home to a culture of distinctively Malay or Polynesian character, now found only in Madagascar. Vestiges of this cultural heritage survive in the use of memorial posts. These stelae and figures are erected above graves among the Bongo of Sudan, the Konso of Ethiopia and the Giryama of Kenya, as well as the Vezo and Sakalava of Madagascar.

Southern Africa is famous for its rock art, which is found in Namibia and South Africa as well as Mozambique. Several thousand years old, these petroglyphs are associated in particular with the San (bushmen) and their forebears, who are reckoned to be the original inhabitants of the region. In the course of history they were marginalized by Bantu-speaking groups, immigrants reaching Kenya and Natal at the beginning of the first millennium.

The earliest surviving masks found on the continent come from South Africa. They are made of clay and date from the middle of the first millennium. When the beliefs of the Bantu living here underwent radical changes a few centuries later, the masks also disappeared, and have hardly returned to southern Africa since. In East Africa, it is primarily the Makonde who have made a name as mask carvers.

Calabash Covers

Haya from Bukoba, Tanzania; Rundi/Tutsi, Rwanda, Tanzania;
prior to 1913 (left), prior to 1920 (center), prior to 1922 (right)
Grass and strips of banana leaf sheaths; height 58 cm (right)
Staatliches Museum für Völkerkunde, Munich (left and center);
private collection (right)

**No longer used for their original purpose, namely to cover
long-necked vessels made of bottle gourds (calabashes) and
keep dust and insects out of the banana wine stored in them,
these covers have undergone a transformation into funnel-
shaped figures of enormous sculptural effect, varying be-
tween purely abstract objects and animal-like entities with
two horns.**

Technically speaking, these covers are half-weaves: strands of
plant fibers or grass are wrapped in thinly cut banana leaf
sheaths, forming a continuous coil that is wound steadily up-
ward in a spiral. The alternation of light brown and black bands
during the weaving process creates complex patterns. Many cal-
abash cover patterns follow the logic of the spiral coiling tech-
nique, displaying an alternation of light and dark horizontal
fields, as in the example depicted on the right. The decoration
is ingenious in the way the spiral runs upward while the zigzag
band runs optically downward like stairs. Other patterns defy
and even run counter to the spiral "weave" by using jagged
lines. Examples are the covers of the left and middle ones, with
broad zigzags that carve out sharp peaks and troughs. Still other
designs create an impression of decorative elements floating
freely across a neutral background. Calabash covers are made
by women, whose basketry is of legendary fame in the region
between the lakes (see illus. below).

Drinking banana wine is an important aspect of social gather-
ings among men in the region, and is ritualized by prescribed
rules of offering and consumption. The covers are lavishly de-
signed to underline the importance of the shared pleasure that
is derived from drinking. As these peoples live primarily from
cattle breeding and possessing large herds is a highly prestigious
matter, it is understandable that horn motifs figure so promi-
nently in their art.

Bibliography: Kandt, 1904, p. 339; Trowell and Wachsmann, 1935,
pp. 134f., 141f., 150; Kecskési, 1982 and 1999, cat. nos. 220–24; Kreuzer, 1991;
Stelzig, in: Eisenhofer, Hahner-Herzog, Stelzig, Stepan, 2000, p. 122f.

Igiseke lidded baskets,
Tutsi/Hutu, Rwanda/Burundi,
height 87 cm/65 cm,
Koenig Foundation, Landshut

Waaga Grave Figures

Konso, Ethiopia, 19th–20th century
Wood; height 213/174 cm
Both in private collections

The Konso live in the southwestern highlands of Ethiopia at an altitude of about 1,500 meters. Their most significant contribution to wood sculpture consists in memorial and grave posts of the kind illustrated here, many of which were commissioned during the lifetime of those concerned. This distinguishes them from their neighbors to the north, the Gato, who erect such posts only after a person has died. These symbols of honor were reserved for highly respected members of the community. One of the ways of obtaining the requisite prestige was by killing enemies—or, alternatively, wild animals—a phenomenon characteristic of many East African societies. Accordingly, a memorial post was frequently erected not only in honor of the "great hero" himself, but of any number of his fallen adversaries. Early field photographs show large groups of such statues standing shoulder to shoulder, with figures of the hero and his wives placed at the center and emphasized by additional emblems of honor, flanked by representations of those he had killed, which are recognizable by the absence of such emblems.

Rudimentarily carved tree trunks and branches were placed at the feet of the main figure and represented the animals that the deceased had slain, such as leopards, buffaloes and snakes. Monkeys were a status symbol and wealthy families kept them as pets. The lances with which enemies and wild animals had been killed were also represented. Moreover, according to C.R. Hallpike, stones arranged in front of such ensembles indicated the amount of land in the deceased's possession. Azaïs and Chambard interpret female figures as representing female killers, "placed to the right of their husbands, and the statue of the victim between her and him." The same authors maintain that grave figures were also made by Konso women carvers.

One of the most significant signs of honor associated with notables is a phallic ornament on the forehead, known as a *kalaacha*, donned by men when they enter the third rank of the four-phase age-class order of the *gada* system (northeastern Konso). This system subjects all Konso males to an 18-year cycle, prescribing the points in time for marriage and fatherhood, circumcision and sexual abstinence. Traditionally circumcision took place at the transition to the highest rank. According to A.E. Jensen, in recent times only six hereditary priests have been circumcised, "and only for them is the ban on associating with women still in force. They appear at the festival at which they are to be circumcised in women's clothing." Among the southwestern Konso one priest in each village is circumcised, and it is he who then wears the forehead ornament daily for a ten-year period.

The *kalaachas* of the figures shown here, like the figures themselves, are strongly weathered but still easily recognizable. Originally they consisted, if not simply of wood, of a disk of ivory with two attached metal bell shapes that projected out over the forehead. Also still visible are representations of elaborate necklaces, bands around upper and lower arms and the coiffures of "great men." The eyes were usually emphasized by disks of bone, and the teeth evoked with pieces of bone. The "great heroes" are depicted naked, with prominent penises. Apart from the general meanings associated with the phallic symbol—virility, fertility and an abundance of children—this feature surely had another significance for the Konso. Owing to the restrictions that used to be placed upon Konso men, which among the northeastern Konso in certain cases included a postponement of marriage until their thirty-fifth year and mandatory sexual abstinence in old age, the male member was a sign of special status and, in the *gada* system, explicitly associated with the privileges of the second and third rank.

The sculptural conception of the figures is quite plain. The slender bodies with their comparatively large heads and their arms pressed tightly against their sides have the form of a shaft, and the legs are merely suggested. No sculptored physical rendering was intended; the board-like impression has the upperhand, which makes the term "post" entirely apt. These figures owe their painterly appearance largely to the effects of the wind and the weather. Still, one must imagine how striking they must have been originally, standing in rows. Only prosperous members of the community were able to afford such funereal luxury.

Bibliography: Azaïs and Chambard, 1931, text vol., pp. 254f., 259; Atlas, plates 83–88; Jensen, 1954; Nowack, 1954; Hallpike, 1972, pp. 30, 137f., 158, 233

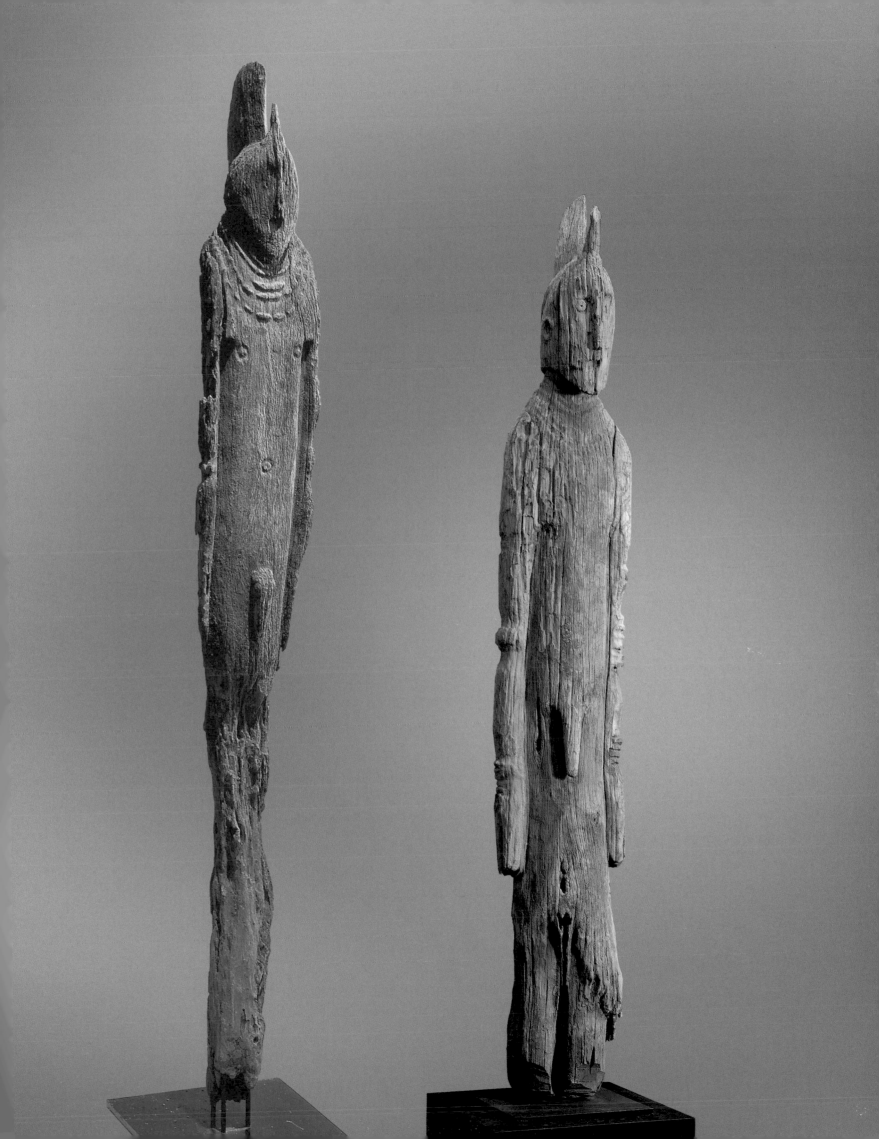

Tafa Parade Shield

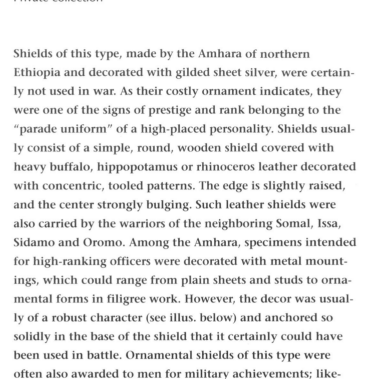

Amhara, Ethiopia, 19th century
Wood, leather, wire, thinly gilded sheet silver and velvet;
diameter 41.5 cm, depth 17.5 cm
Private collection

Shields of this type, made by the Amhara of northern Ethiopia and decorated with gilded sheet silver, were certainly not used in war. As their costly ornament indicates, they were one of the signs of prestige and rank belonging to the "parade uniform" of a high-placed personality. Shields usually consist of a simple, round, wooden shield covered with heavy buffalo, hippopotamus or rhinoceros leather decorated with concentric, tooled patterns. The edge is slightly raised, and the center strongly bulging. Such leather shields were also carried by the warriors of the neighboring Somal, Issa, Sidamo and Oromo. Among the Amhara, specimens intended for high-ranking officers were decorated with metal mountings, which could range from plain sheets and studs to ornamental forms in filigree work. However, the decor was usually of a robust character (see illus. below) and anchored so solidly in the base of the shield that it certainly could have been used in battle. Ornamental shields of this type were often also awarded to men for military achievements; likewise, kings conferred parade shields upon regional leaders as a sign of appreciation for their political loyalty.

The applications on the present shield, which has a metal body, were not made by a shieldmaker or armorer but by a master silversmith, whose actual profession was the manufacture of jewelry. The central convex section protrudes to such a degree that the elaborate decor can even be seen from the side. The decor of thin silver sheet extends across the surface like exquisite brocade, over a lining of purple velvet. The most striking elements are the ornaments surrounding the central projection. Their long middle sections are cut from chased silver, as is the broad band along the inside of the raised edge. These are flanked by volutes filled out in filigree technique. The ornaments have been squeezed so close together that the volutes overlap. Each ornament emerges from a trapezoid and ends in a lance-shaped point—a reminiscence of the sacred ornaments of Ethiopia. Especially elaborate is the decorative hub with its large rosette motif. The four floral-design hemispheres (located at the points where the shield grips are attached at the back) end in decorative blossoms, which are filled with red gems or glass stones.

Although its basic form clearly indicates an origin in tribal culture, the shield's decoration belies this impression. Both the silversmith's work and the velvet underlay would suggest Arabian sources. On the whole, this is an object in which African and Oriental influences merge—a synthesis characteristic of the art of East Africa in general and that of the Amhara in particular. The Amhara maintained a brisk trade with the Arabian countries, in commodities extending from ivory and gold to slaves. The latter were drawn primarily from the original inhabitants of the region, which was swallowed up in the course of the expansion of the Amhara Empire. Along the trade routes, artistic influences also found dissemination. Whether the ornamental silver on the present shield was imported from an Arabian country or made in Ethiopia on the basis of Arabian models must remain a matter of conjecture.

Although costly and elaborate, these shields, which were used by the Amhara during receptions and public appearances, were eclipsed by those presented as official Ethiopian state gifts to foreign leaders or ambassadors. Manufactured expressly for the purpose and therefore unused, they exhibit an ostentation that has little in common with the true tradition of armory. The two best-known examples are to be found in the Museum für Völkerkunde, Vienna, and at the Lords of the Admiralty, London.

Bibliography: Azaïs and Chambard, 1931, text vol., p. 63; Atlas, plate 16, 2; Plaschke and Zirngibl, 1992, p. 62f.; Spring, 1993; Benitez and Barbier, 2000, cat. no. 31f.

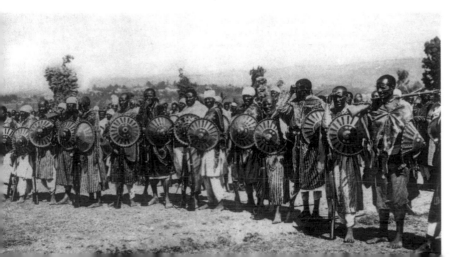

Amhara men dressed for a celebration,
with their parade shields, from: Sellasié 1930

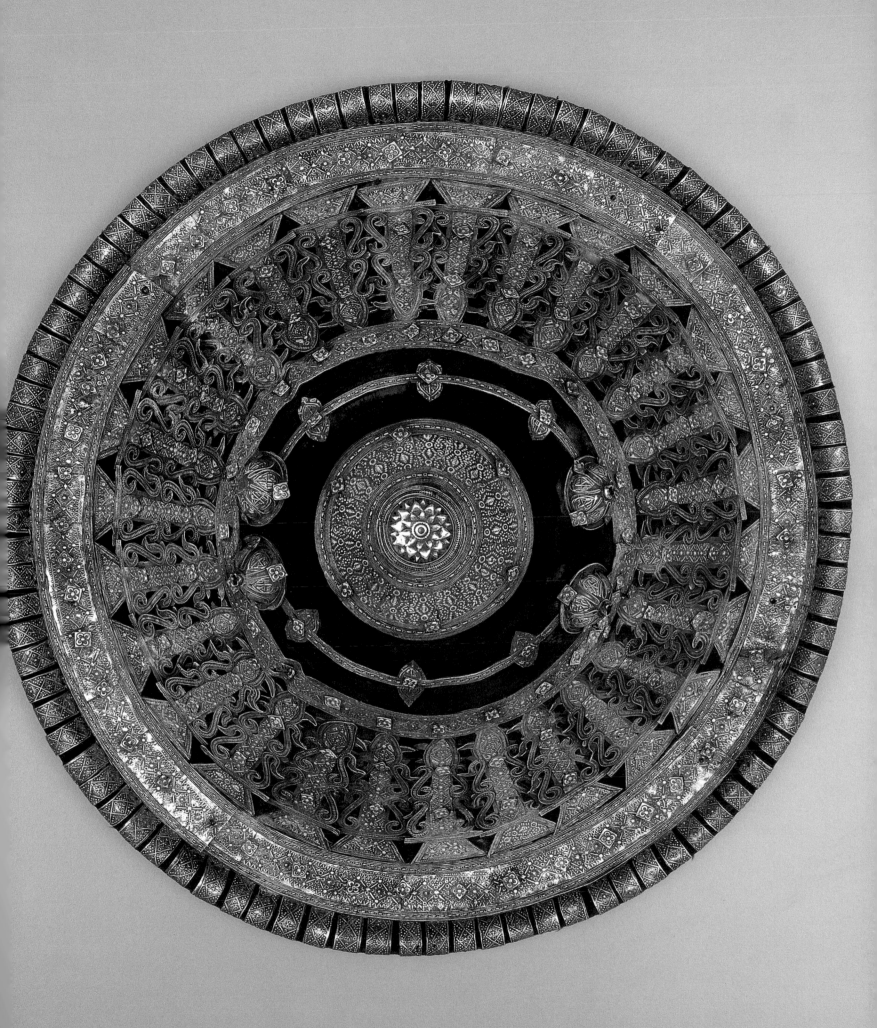

Ndimu Mask

Makonde, Tanzania, 19th century
Wood, hair, plant fiber and metal mounts; height 71.5 cm
Linden-Museum, Stuttgart

Large, smooth shapes with minimalist facial features—such would be the formula for describing the aesthetic secret of many masks of the Mwera and neighboring Makonde, who live in the border region between Tanzania and Mozambique. The restraint evident in the eyes and mouth of this hare mask lend the oval face its full three-dimensionality. Conversely, the simple geometrical shape of the mask, with the ears sticking up pertly like spatulas, makes the spartan details appear even smaller. This is bound up with a restrained naturalism, which to some extent accounts for the uncanny impact of such masks.

The upper lids of the beady eyes display hairs affixed with rubber, reminiscent less of human eyelashes than of animal fur. Additional features include bushy whiskers on the upper lip, budding fuzz below the narrow mouth and a straggly, forked beard made of knotted plant fibers, which forms a compositional counterpart to the long ears. Plant fibers inside the mouth represent teeth. Whereas a lip-piece indicates that a mask is female, the beard reveals this one to be male.

The dark ash gray of the face contrasts with the silvery tone of the metal inlays, which represent tattoos. Particularly striking are the scarification marks on the forehead, recalling vegetal shapes. According to old field notes about a Mwera mask in the Ethnologisches Museum in Berlin, which displays a similar tattoo above the bridge of the nose, this mask was known as *chingorombwe* and was worn by Mwera men and women alike (Krieger, p. 46). The motif is common mainly in female masks of both the Mwera and the Makonde (Krieger, cat. nos. 305, 308, 356, 366, 369, 378, 427, 431, 438, 453), and, like scarifications on other masks, usually consists of applied rubber or wax or, in rare cases, is incised. The technique used here of affixing narrow strips of sheet metal onto the surface of the wood constitutes an exception. Lines just above the eyes (right one lost), two vertical pairs of lines up to the temples, rectangles below and crescent motifs at the corners of the mouth complete the elaborate scarifications on the face. The fine linear patterns heighten the graphic character of the mask.

Most masks of the Makonde represent spirits (*midimu*), usually making their appearance toward the end of initiation ceremonies. Ritual and pedagogic functions combine seamlessly with the entertainment of spectators. Antelopes and hares are particularly common among the animal spirits. According to Szalay, E. Castelli held that hare masks with large, erect ears were reserved for the head of the bush school. While the ears of the present mask allude to the animal world, the face displays virtually no animal features. The whiskers on the upper lip and the tattoo pattern are human attributes. The special charm of this mask lies in its composite character; yet it is also an important piece in African sculpture, favoring a balance between human and animal references.

Bibliography: Weule, 1909; Wembah-Rashid, 1971; Krieger, 1990, cat. no. 305f.; Blesse, in: Jahn, 1994, p. 432f.; Szalay, 1995, p. 225; Dewey, in: Koloss, 1999, p. 234

Ndimu mask, Makonde, Tanzania, Museum für Völkerkunde, Leipzig

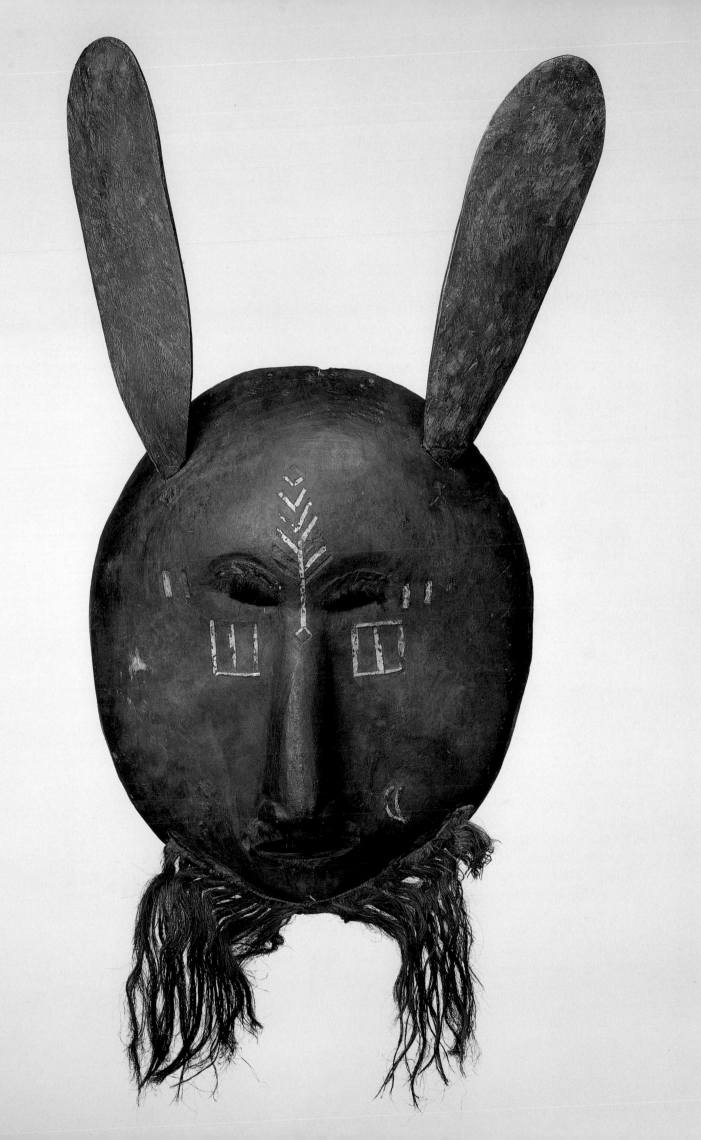

Mutsago Headrest

Central and eastern Shona (Zezuru, Manyika), Zimbabwe and
Mozambique, end of 19th century
Wood; height 19 cm
Völkerkundemuseum, University of Zurich

Called neck supports or headrests, these carved objects are
more prevalent in some parts of Africa than others. While
they are quite rare in West Africa, they are more common
in Central Africa, where they often assume the form of cary-
atid stools. The real homeland of headrests is East Africa,
however, where they are highly esteemed among the semi-
nomadic peoples of Uganda, Somalia, Kenya and Zimbabwe.

As the material culture of these peoples is not as diverse and rich
as those of regions further west, headrests and seats are impor-
tant status symbols. Primarily, however, they fulfill a very practi-
cal purpose: they are used to preserve the often lavish coiffures
of the peoples of these regions. Headrests are also reckoned to be
a means of conceiving vivid dreams, thus intensifying contact
with the ancestors. A chieftain in his function as a judge can
also receive important signs in cases that are difficult to resolve,
just as smiths who may also be sculptors, spiritual mediums or
poets receive inspiration in dreams. Every headrest remained the
property of one man for his entire life, either accompanying him
to the grave or handed down in the male line. If inherited, the
headrest could aid the new owner in contacting its previous
ones, i.e. the father, grandfather, great-grandfather, etc. These
objects therefore acquired a function that ancestral statues ful-
filled elsewhere.

Headrests were even used in ancient Egypt. Whereas those on
the Nile were worked in alabaster, ivory, terracotta, faience and
wood, in sub-Saharan Africa they are predominantly made of
the latter. Related in function to headrests, stools are larger and
designed to bear greater weight; headrests, on the other hand,
can have extremely graceful designs and, as in South Africa, take
on sophisticated shapes. The simplest headrests are carved from
a single tree trunk that forks three times, forming a natural sup-
port. Intricately carved, they are not only practical objects but
can also be superb works of art.

The present Shona headrest stands out for the clarity and in-
tensity of its ornamental forms. Between the rectangular, conical
base and the support, which forms a concave vault and displays
notches on the top left and right ends, are a double X and two
broad ovals, in which concentric circles appear. These are linked
by two horizontal lines, above and below, in which two zigzag
lines can be seen. Compared with the base and support, the
middle section is shallow, lending it a relief-like character. The
broad, deeply incised lines recall those in a woodcut block. No
element appears singly: diagonals and straight lines, concentric
and zigzags are all double, triple, quadruple or quintuple. Basic
geometric shapes are bundled together in a forceful visual inter-
play. The X-shapes resemble supporting braces with triangular
forms cut out of them. The ovals seem to tie together these brac-
es, fixing them with two "knots" or "clamps." The forms used
have clear anthropomorphic features as well. In comparable
examples, the two disc motifs are unmistakably shaped like
breasts, and, when seen from above, the base distinctly recalls a
figure eight: the front and rear incisions in the center are recog-
nizable as pudenda. The same is hinted at in the headrest shown
here. The patterns of such headrests also echo the scarification
marks of Shona women (*nyora*). It is this coquettish playfulness
that lends the ornamental forms their vivacity while eschewing
explicitness.

Bibliography: Dewey, 1993, in: Herreman, 2000, pp. 28–31; Homberger and
Meyer, 1995, p. 24f.; Becker, in: Phillips, 1995, p. 204 (with bibliography);
Dewey and Mvenge, in: Dewey and de Palmenaer, 1997, p. 208, cat. nos.
89–114

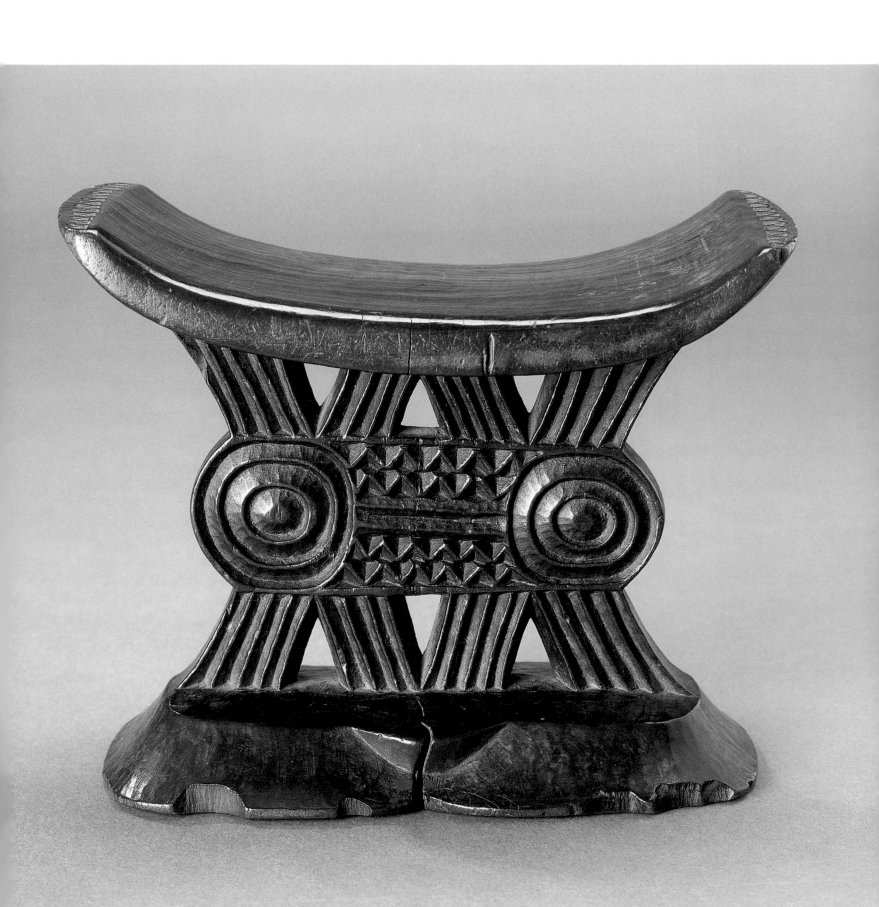

Lydenburg Head

South Africa, ca. 500–700 AD
Terracotta, white pigment, ferrous mineral, height 38 cm
South African Museum, Cape Town; University of Cape Town Collection

Seven terracotta heads, known as the "Lydenburg Heads" after the site where they were found, west of the Drakensberg mountains, are exceptional specimens of African sculpture. Originating in the early Iron Age, they represent the first artistic evidence of Bantu migration into southern Africa. Together with the rock art found in the region they are also the earliest known works of art to occur south of the equator. These sculptures differ from the art of contemporary South African ethnic groups, which is largely attuned to everyday needs, in that they are monumental representations in the round of the human face. Still, their great age probably precludes such comparisons, for it has by no means been established that the representatives of the civilization that produced these terracottas some 1,500 years ago are direct ancestors of the groups now living in the region.

The largest of the Lydenburg Heads, illustrated here, is hollow. Typologically speaking, its form seems to have developed naturally from another genre—ceramic vessels. If we were to imagine it turned upside down, it would strongly resemble a pot. The back view confirms this impression. There, the three bands of crude, diagonal hatching in alternate directions (herringbone pattern) that run entirely around the neck are supplemented by two further bands and variously hatched fields that extend up to the top of the head—all in all, a decor that is one of the most elementary in the art of pottery. Comparable finds of pottery for everyday use in fact exhibit the same patterns.

The facial features are little more than strings of clay applied in relief to the walls of the "vessel." Some of the other details are part of the familiar repertoire of many an African woman potter: little balls of clay that evoke hair and are set off from the forehead by a sweeping, raised line; notched lines in the shape of goggles that connect the eyes and brows with the temples, and which, like the curving diagonal over the forehead, probably represent scarifications. Only the narrow eyes, ears and mouth can be called specifically facial traits. The nose has been reduced to a mere tip with nostrils. On the whole, the piece has more the character of an anthropomorphic vessel than a figurative sculp-

ture, and there is nothing to indicate that it might not have been made by a potter. Admittedly, however, the piece is so masterly in design that the culture that produced it must have experienced a long development in the sculptural handling of clay.

An astonishing detail is the small figure on top of the head, apparently representing a four-legged animal of some kind. Another, relatively well-preserved head from Lydenburg—the only one with zoomorphic traits—likewise originally had such a surmounted figurine, as the surviving mount indicates. Indeed the heads might originally have been worn as helmet masks. According to Tim Maggs and Patricia Davison, both pieces are in fact large enough to have been slipped over the head. In addition, the eyes and mouths are open to the inside. The smaller heads have a hole on either side of the neck, suggesting that they may once have been attached to a pole or staff, or perhaps to a costume. Traces of white pigment and specularite (a ferrous mineral) indicate that the "masks" were originally painted. The smooth areas and facial features were white, and the incised lines were set off in a reddish color, which must have created a very dramatic effect.

Even more intriguing than the surely interesting question of what sort of performance these masks were used for and on what occasion is the evidence they seemingly provide of the origin of masks in Africa. Might they represent early forms of masks made of fired clay rather than wood? Could it be that a pot that someone once slipped over his head at a whim stood at the beginning of the entire African mask dancing tradition? Clay was certainly easier to work than wood, especially since the difference between such heads and a normal, decorated pot was not all that great. The carving of a mask required considerably greater skill and dexterity. Much evidence suggests that woodcarvers adopted the fully developed repertoire of clay masks at a much later date, and did so only because of the wood's lighter weight and greater resistance to breakage.

Bibliography: Inskeep and Maggs, 1975; Maggs and Davison, 1981

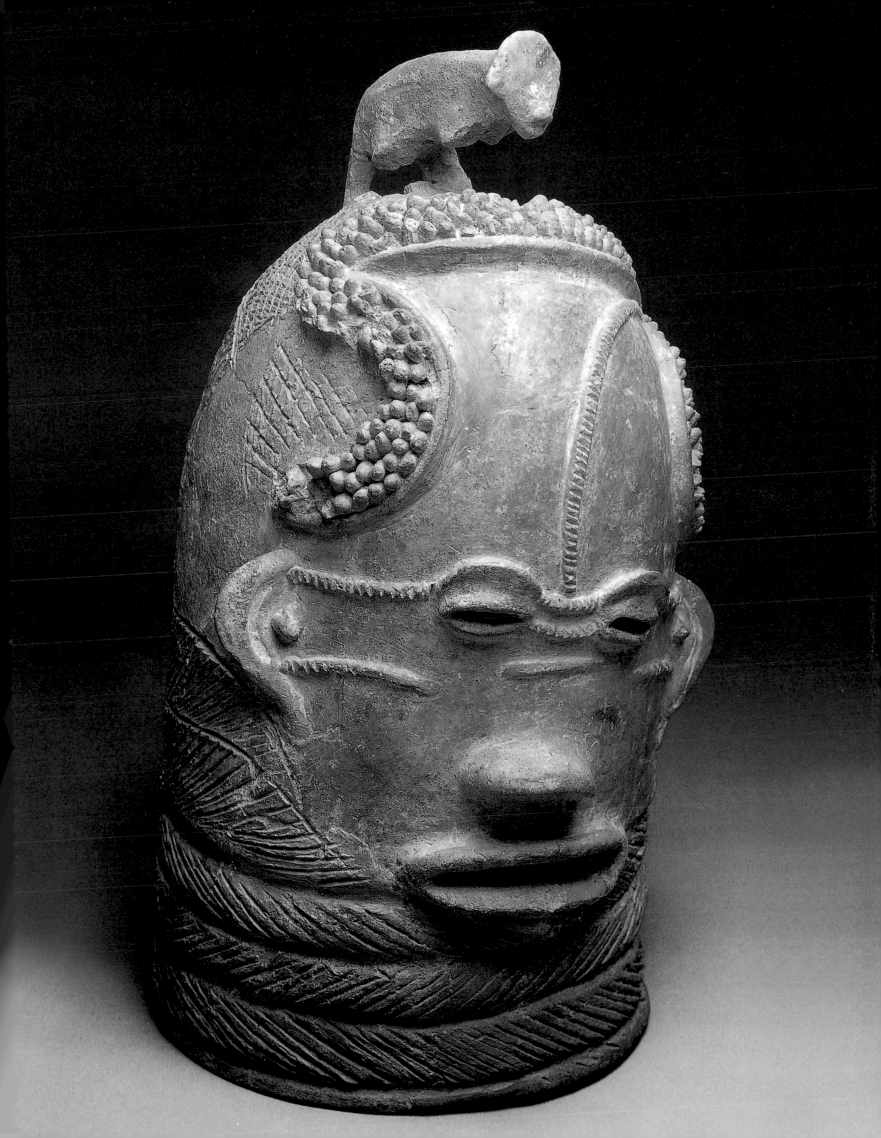

Linton-Panel

San, South Africa, 18th or 19th century
Stone, ocher and other pigments; 82 x 205 x 20 cm
South African Museum, Cape Town

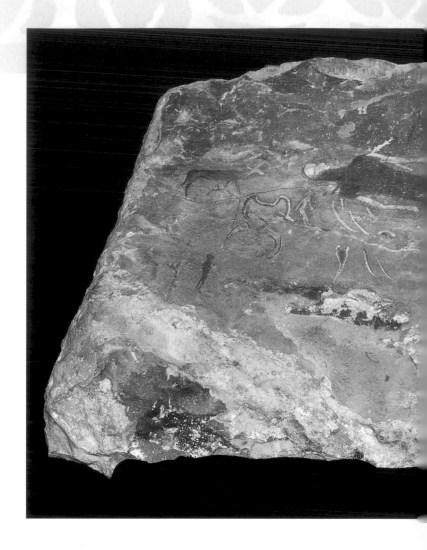

The rock paintings of the San (bushmen) are the heritage of a people who have been almost entirely decimated apart from a few remaining scattered enclaves. The pictographs that either they or their predecessors left behind in the course of their long history in present-day Namibia and South Africa are well-nigh innumerable. Some of the images are engraved in the stone (primarily animal depictions), others painted in colored pigments (primarily human figures). Unlike similar Stone Age paintings in Europe, they are located not in cave systems but under overhanging rock formations, in niches or simply on blocks of stone under the open sky. The locations are often topographically prominent, as on plateaus with vistas of the surrounding countryside, and frequently there is a natural water source nearby. "The paintings were summaries of the entire religion. In that sense they were not unlike the windows of Chartres" (Robert F. Thompson).

The paintings illustrated, which originate from a rock shelter in the southern Drakensberg mountains, are not the work of a single individual. Clearly they were built up, layer by layer, some superimposed on or even occasionally obscuring previous ones. The scale of the later depictions is not oriented to that of earlier ones, and different emphases of subject matter are evident as well. For instance, the group of four large eland does at the upper left is internally relatively consistent, yet it has been painted over a group of smaller animals accompanied by human figures, which extends to the right half of the panel. These were probably followed by the large reclining figures at the left and right edges. Another independent group is formed by the ocher-colored figures in the foreground, which includes a wonderful, large standing figure. Also of interest is the way in which the figures rendered in red hues are juxtaposed with both red-and-white and merely white ones. The white figures would appear to be the oldest among them.

When animals occur in connection with human figures in San art, or in that of their predecessors, it is not in a hunting scene. Here, however, a hunter does make an appearance. This is the relatively small figure whose legs are concealed by the lowermost of the four large antelopes, holding a bow in his extended right hand. Especially impressive is the man standing in the middle, a figure that represents a shaman. His legs and white

head are shown in profile, and his upper body from the back. Several rows of dots run across his broad shoulders and back. His buttocks and knees are likewise ornamentally accentuated by such marks—likely representing body paint or scarifications. Similar body adornment is seen on the figure at the top far right of the panel. The head of the standing figure is intersected by a branching, fine red line, again bordered by a dotted white line. "This line, a common motif in the region, is thought to represent the route of shamanic travel or . . . the supernatural potency that permeated the San universe and that San shamans harnessed in order to enter the spirit world (trance), control the movements of animals, heal the sick, make rain and go on extra-corporeal journeys in the form of animals. The southern San believed that this potency resided in certain large animals, chief of which was the eland . . ., an animal that had, for the San, multiple symbolic associations."

The author of this interpretation, J. D. Lewis-Williams, interviewed the San now living in the Kalahari Desert, gaining crucial insights into the religious worldview of their ancestors. One

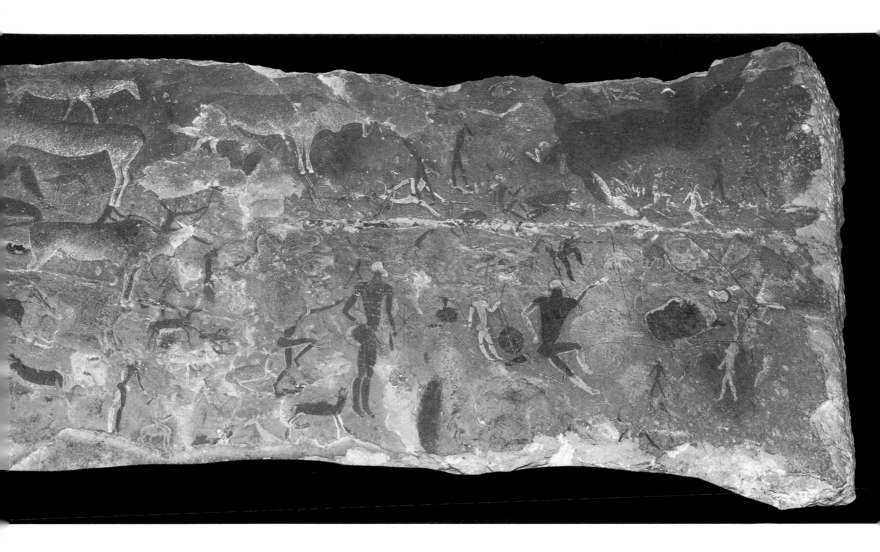

indication of a human-animal metamorphosis, for instance, is seen in the large supine figure at the left, whose arms end in animal legs and whose legs merge into cloven hooves. Lewis-Williams reads the stick above the left arm as a fly switch, which was used in the trance or medicine dance. The figure appears next to a buck-headed snake lying on its back and bleeding from the nose, and by eels, which symbolize the realm of water.

The flat space, devoid of lines of perspective, makes the figures seem to hover, and no attempt has been made to arrange them coherently. This free-flowing manner of depiction would seem metaphorically to stand for a consciousness that overcomes frontiers, strives to experience a continuum beyond the borderlines that separate man from animal, species from one another or the realms of earth, water and air. In the "underwater" experience of which shamans speak in describing the state of trance, the concept of time loses all validity. For the San, then, the process of painting over earlier depictions perhaps did not mean erasing the past but confirming and intensifying things that had proven their potency. Whether such imagery

served the visual instruction of laymen or novices, or was painted by shamans or specialized artists, must remain open.

No less impressive than the art itself is the historical dimension of the San rock paintings. If the most recent examples are a good century old, the earliest figures were apparently created over 25,000 years ago.

Bibliography: Lewis-Williams, 1983, 1985 and 1988; Thompson, 1993; Garlake, 1995; ibid. in Dewey/de Palmenaer, 1977, pp. 29–55; Lewis-Williams, in: Phillips, 1995 (with bibliography)

Ijogolo **Bridal Apron**

Ndebele, Mpumalanga, South Africa, ca. 1935
Glass beads, goatskin (?) and cotton thread; 70 x 50 cm
Collection of Dr. Gary van Wyk and Lisa Brittan, New York

Glass beads have long been a particularly popular Asian and European import article in Africa. The sheer quantity of Venetian and Bohemian beads sent there from the 17th century onwards is staggering, and by far the most of these went to South Africa. The principal customers were the Ndebele, whose beadwork became their most important artistic genre. Ndebele women appeared at festivals in elaborate beaded gala apparel, and fertility dolls and staffs were likewise adorned with beadwork. While in the 19th century the basic material—usually leather—was only partly covered with beaded patterns, the greater availability of beads in the 20th century encouraged the design of ornate, draped apparel.

Beadwork was a female province, and it was primarily women who wore the finished products. What beaded dresses they wore in public and how elaborate they were depended principally on age and status. Girls wore simple beaded aprons (*lighabi*), which were exchanged for larger ones as they grew older. When an adolescent girl reached marriageable age, her mother gave her a large apron (*isiphephetu*), which she wore with various accessories, including arm and foot bracelets that she had made herself. On her wedding day, when she was led to the house of her husband's family, the bride was dressed in beaded apparel from head to toe: a large beaded leather cloak (*linaga*), broad, beaded trains (*nyoga*), a beaded cap, leg and hip bands and a bridal apron of the type illustrated here (*ijogolo*). It was a part of her trousseau that she would continue to don on festive occasions in later years. After the birth of her first child, the young wife was also permitted to wear the married women's apron (*liphotu*), which was strictly rectangular and fringed with strings of beads along its lower edge.

Older pieces, whether bridal bands or aprons, are recognizable from a predominance of white beads, interspersed with restrained geometric designs in a limited range of colors. In the course of time, the proportion of colored beads increased. The present piece, made about the mid-1930s, evinces a comparatively spacious white ground with a highly contrasting pattern. After this period the relationship between ground and decor changed to the point that white beads served merely to frame or accentuate colored motifs. Figurative motifs, or even letters and numbers, were also occasionally included.

A characteristic feature of the *ijogolo*, which was made in part by the groom's grandmother, is the lower fringe, which consists of five strips, occasionally flanked by two narrower ones. According to Levinsohn, the latter were attached to the garment when it was not the groom's first wife. Moreover, the five large strips allude to the five head of cattle that were paid for the bride. Their shape is like that of a hand, distantly recalling Islamic silver amulets. The application of the beads generally followed a grid-like pattern into which the colored designs were worked, a technique that gave rise to the rigorously geometric ornament so typical of Ndebele beadwork. According to E.A. Schneider, no cosmological or religious references are detectable in these patterns, nor do their colors convey any particular symbolic meaning. A "language of beads" of the kind prevalent among the Zulus is unknown to the Ndebele. Motifs for beadwork and patterns painted on houses as decoration—an artistic activity that began in the 1940s and for which Ndebele women are likewise famous—draw from the same sources. Many cross-references exist between these two art forms.

Bibliography: Levinsohn, 1984, p. 113f.; Carey, 1986, p. 31f.; Powell, 1995, p. 108f.; Schneider, 1985; Jargstorf, 2001, pp. 56–128, 154–76

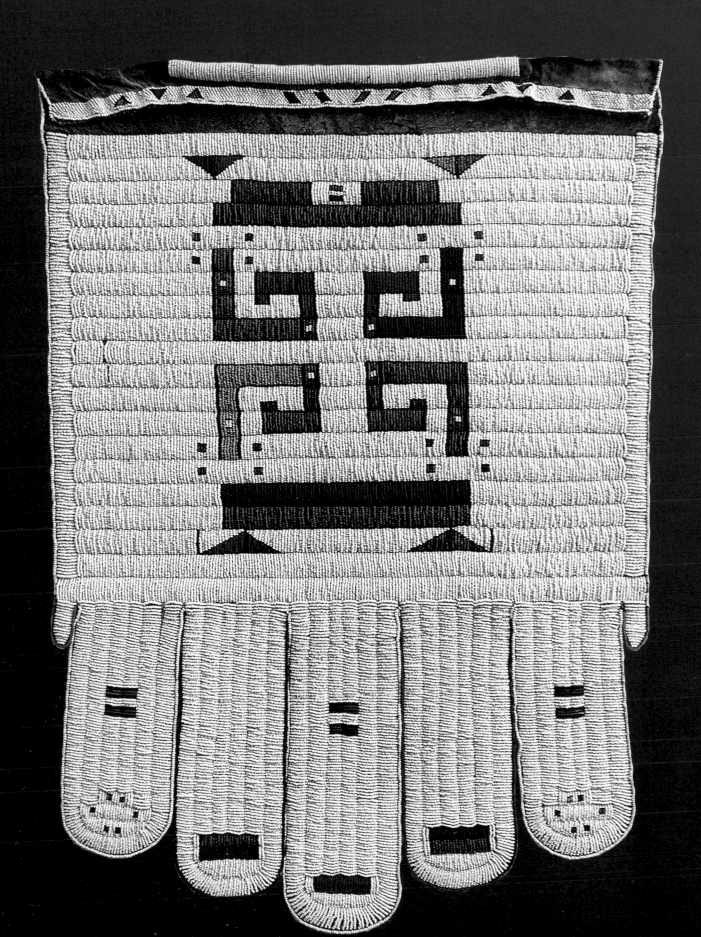

West Africa and the Guinea Coast

The coastal countries strung out like pearls on a chain between Senegal and Cameroon, as well as the landlocked countries of Mali, Burkina Faso and Niger, have, together with Central Africa, always been considered the heartland of African art. Bordered in the north by the Sahara, the region encompasses climatic zones ranging from semidesert and steppe to arid woodlands and subtropical savanna as one moves south. The coast, where not deforested, is fringed with tropical rain forests. Such a wide range of climates and landscapes has provided excellent conditions for diverse cultures to develop. If we include the rock art of the Sahara, the cultural beginnings of this region can be traced back to the ninth/eighth millennium BC. The earliest horizon that is archaeologically definable, the Nok culture in Nigeria, dates to the first millennium BC, followed by Sokoto and Katsina (ca. 300–100 BC), Ife and Igbo-Ukwu (from ca. AD 1000), Benin (from ca. 1200) and Owo (from ca. 1400). No other African country can boast of such a long and coherent cultural history.

West Africa was also home to the ancient empire of Ghana (in the modern border region between Mali and Mauritania) and the empires of Mali and Songhai. Many kingdoms have disappeared while others, such as the Ashanti in Ghana and Benin (Nigeria) or those of the Cameroon Grasslands, still exist. Despite severe conflicts with the colonial powers and the temporary suspension of the kings' rule, the continuity of their authority remained largely unbroken. From Kumasi to Benin, the royal residences offered an ideal stage for a courtly splendor involving all the arts to unfold. Gold, bronze, ivory, coral, glass beads and cowry shells were among the most precious materials, often constituting a king's privilege, therefore available only to court artists. Our picture of West African art in the second millennium is decisively shaped by the expertise of its metal founders and ivory carvers. Yet African antiquity, which came to a close with the Ife culture, was notable for its highly developed terracotta sculpture (the heyday of West African metalwork began in Ife). Associated with this tradition are the many artistic centers in the extraordinarily productive Niger delta and its area of influence.

Side by side with the centralized states, often run along authoritarian lines, West Africa also had its farmer cultures. These had no developed social hierarchy or even chieftains (acephaly). They were organized on the level of family groups, like the Senufo of the Ivory Coast, the Lobi of Burkina Faso or the ethnic groups in western Nigeria or southern Cameroon. The Dogon, one of the best-known groups in the region, are a farming people who live in villages and are ruled by village headmen. Owing to favorable conditions of preservation, their culture can be traced back more than a millennium without interruption. The art of these cultures is of an entirely different kind from court art. As it needs to serve no representational function, it is made of such unpretentious materials as wood, iron or bone. Urban cultures have also contributed to the diversity of the region. Islam has gained a foothold in such cities as Kano, Katsina and Djenne, and the art of textile production is flourishing.

West Africa is exemplary for its enormous ethnic variety, which is partly the result of large-scale migrations but also partly due to the steadfastness with which ethnic groups have preserved their own cultural identities. The religious heritage is correspondingly rich. The ancient animistic beliefs were to some extent superseded by Islam from the eighth century, but in many places the veneration of spirits and ancestors is still practiced. Christianity and, in its wake, Western-style materialism have been the cause of much greater devastation.

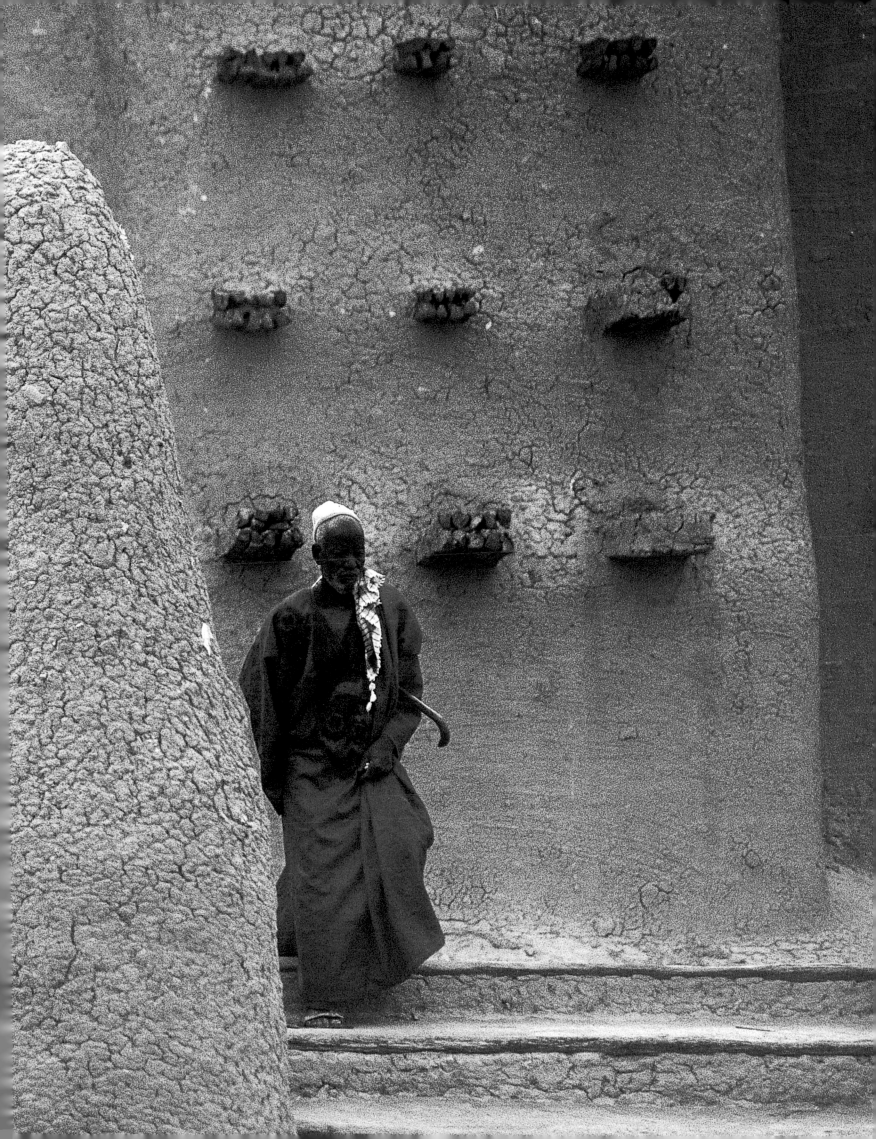

Seated Male Figure

Nok Culture, Nigeria, ca. third century BC
Terracotta; height 98 cm
Private collection

The complex of Nok terracottas represents the most ancient art of Africa south of the Sahara. Their archaeological discovery was like a fanfare that opened the art history of this region. These works were no tentative beginnings but represented a monumental art at the zenith of its development, which must have been preceded by centuries of intensive artistic activity. Nok art appears to have emerged over a long period beginning about the middle of the first millennium BC in quite constant conditions, because its style remained almost unchanged down to the first centuries of the Christian era. However, this continuity of formal language was by no means the exception in Africa.

Terracottas of the kind here illustrated are the sole artworks that bear witness to the Nok Culture. Our knowledge of it derives principally from these figures, many of which were accidentally discovered in tin mines, as well as from the results of a few scientific excavations made since the 1960s. The clay objects were found under sand and gravel sediments up to ten meters in thickness, but geological shifts had made it largely impossible to reconstruct their original embedding.

Named after a town on the Jos Plateau in the heart of present-day Nigeria, the Nok Culture had an extent of several hundred kilometers. Finds of iron objects and slag remnants, but also of stone tools, suggest that this civilization existed during the transition phase between the Stone Age and the African Iron Age. The 1990s witnessed a series of plunderings, both private and state-condoned, which explains why many of the figures that have since appeared on the market are so badly damaged. Based on hundreds and hundreds of finds, de Grunne was able to outline a typology of the figures' key poses. Disregarding secondary types, these were essentially four: a standing pose; a crouching pose with arms resting on drawn-up legs (including over a dozen variants in hand position); a further crouching pose in which the right leg only is raised; and finally, a kneeling pose in which the left leg is bent. As we may conclude from this, the Nok artists followed a strictly defined canon.

The figure shown here is unique in terms of its exceptionally undamaged state and its monumental proportions. Its overall unified form is masterly in its incorporation of numerous details. This sculpture is of the crouching type which includes figures squatting on a low stool. It is resting its chin on its arms which are folded across its knees. It is a relaxed posture with a mighty head towering over the body. The eyes, with their lower lids curving deeply downwards, are large and watchful. The power of its stare is increased by large, drilled pupils, the flat bridge of the nose, and tensely arched eyebrows. As is typical of Nok figures, the body is relatively slender compared to the head. A fundamental characteristic of the sculptural principle of such figures is their verticality that contributes to the impression of artistic stylization.

The man depicted was a high-ranking representative of the upper class, if not a prince, represented in a kind of parade dress. Considerable time and effort were invested in artfully tying his beard and arranging his hair, with its plaited locks at the temples and bombastic rolls behind. Multiple armbands, a neck ornament, and cords round off the finery. Whether some member of the nobility had himself portrayed in this sculpture during his lifetime or it was dedicated to him posthumously, whether it perhaps represents a clan ancestor dressed in the style of the period or not, we can only speculate. That the Nok figures were not grave goods may be inferred from the fact that no skeletal remains were found accompanying them. De Grunne suggests that they may originally have been placed in a sort of shrine.

Bibliography: Fagg, 1977; Eyo/Willett, 1980, cat. nos. 1–14; Bitiyong, in *Vallées du Niger*, pp. 393–415; Fagg-Rackham, in Phillips, 1995, pp. 526f.; Schaedler, 1997, pp. 195–211; Willett, 1997, p. 23f.; de Grunne, 1998 (with bibliography); Eyo, in Kerchache, 2000, pp. 114f.; Boullier, in Kerchache, 2000, pp. 118f.

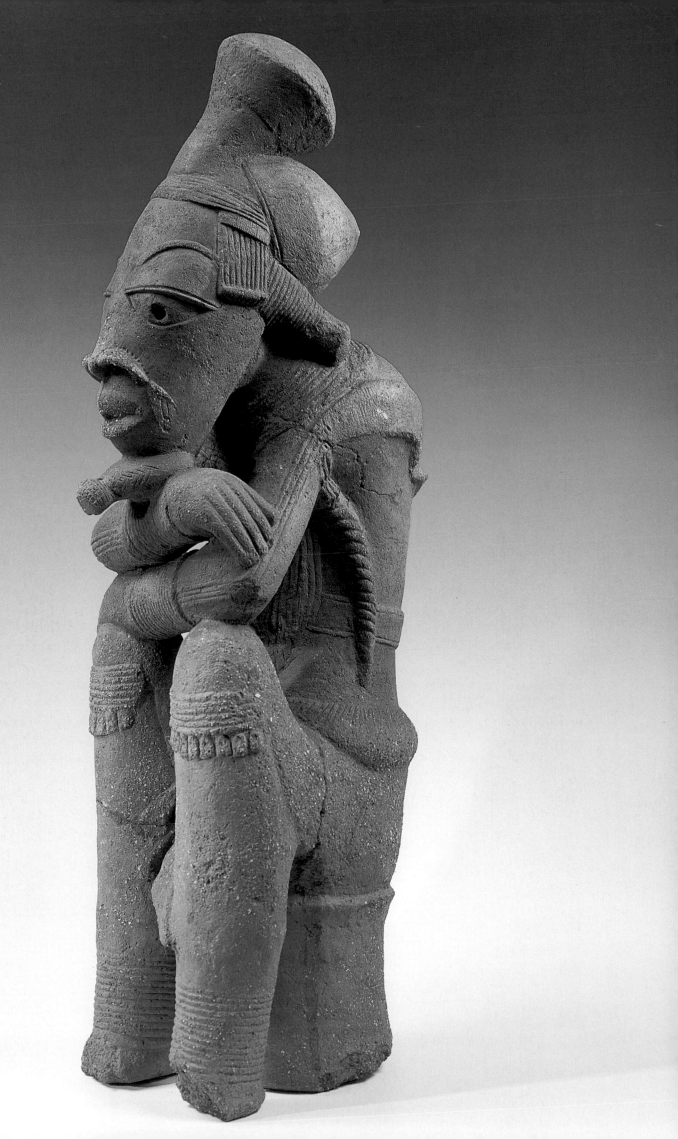

Male Figure

Sokoto Culture, Nigeria, ca. 400–100 BC
Terracotta; height 74 cm
Collection of Kathrin and Andreas Lindner

Sokoto, the name of a town and state in far northwestern Nigeria, is used to designate the second oldest archaeological horizon in the country. Located about 400 kilometers northwest of the dissemination area of the Nok Culture (see p. 64), the Sokoto Culture emerged almost concurrently and developed in parallel with it for centuries. While the first Nok pieces came to light in the 1920s, Sokoto figures were not known until the early 1990s. In both cases, terracottas are the sole silent artistic witnesses of these ancient Nigerian cultures. Almost all the Sokoto pieces that have entered the trade and Western collections are fragmented heads; the figure illustrated here is one of the few more completely preserved objects.

Sokoto sculptures are related to those of the Nok, and, like these, they are based on a relatively strict canon. Their features, as in the present piece, include lentil-shaped, or sometimes round, eyes (drilled through), heavy, protruding eyebrows, pronounced lips and a pointed beard. The convexities of the face—cheeks, bridge of the nose, forehead—are sparingly decorated with linear

markings, and the larger than life-size head wears a hemispherical, close-fitting cap. The style is on the whole strongly graphic, and the details tend to be executed in bas-relief. The arcs extending from the nose across the cheeks are artistically very effective. Though they can be read as decorative scarifications, they simultaneously suggest the lower eyelids. As in the Nok terracottas, the head is strongly accentuated with respect to the body, which is cylindrical and tapers slightly towards the head without actually forming a neck. Under the beard lies a close-fitting necklace of several strands of long beads, and a sort of clasp across the chest. The rudimentary arms are bent.

Whereas many Nok figures have a rather small, inverted bowl as a stand, the torso of this Sokoto figure seems itself to have the character of a hollow vessel. Some speculate that it originally served as the lid of a funerary urn, the figure possibly representing the deceased or an ancestor. Interestingly, the men represented in the Sokoto figures are clearly older than those of the Nok, for, as B. de Grunne has determined, 80 percent of the Sokoto figures have a beard. Many of the Nok figures appear much younger by comparison. Yet the most striking difference between the two groups lies in the coiffure, which in the Nok figures is elaborate and full, in contrast to the extreme simplicity of the Sokoto hairstyle. This reserve may originally have been compensated by colored paint, which could have accentuated the face, too. Whatever the case, the difference is significant and unusual, and might be explained by the differing functions of the figures. Whereas the Nok terracottas may have been placed as representational figures in shrines, those of the Sokoto presumably had a sepulchral function, which would be entirely in keeping with the seriousness and dignity of their expression. In the finest examples of Sokoto art, the facial expressions positively infuse the figures with a soul (see illus. left).

Bibliography: Phillips, in: Phillips, 1995, p. 531; Schaedler, 1997, pp. 195–215; Willett, 1997, p. 26; Bacquart, 1998, p. 83; de Grunne, 1998, pp. 28, 104f.; Bouillier, in: Kerchache, 2000, p. 122f.

Head of a figure, Sokoto, ca. 400–100 BC.
Private collection

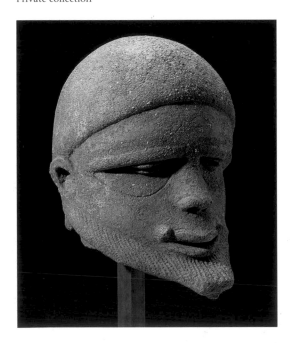

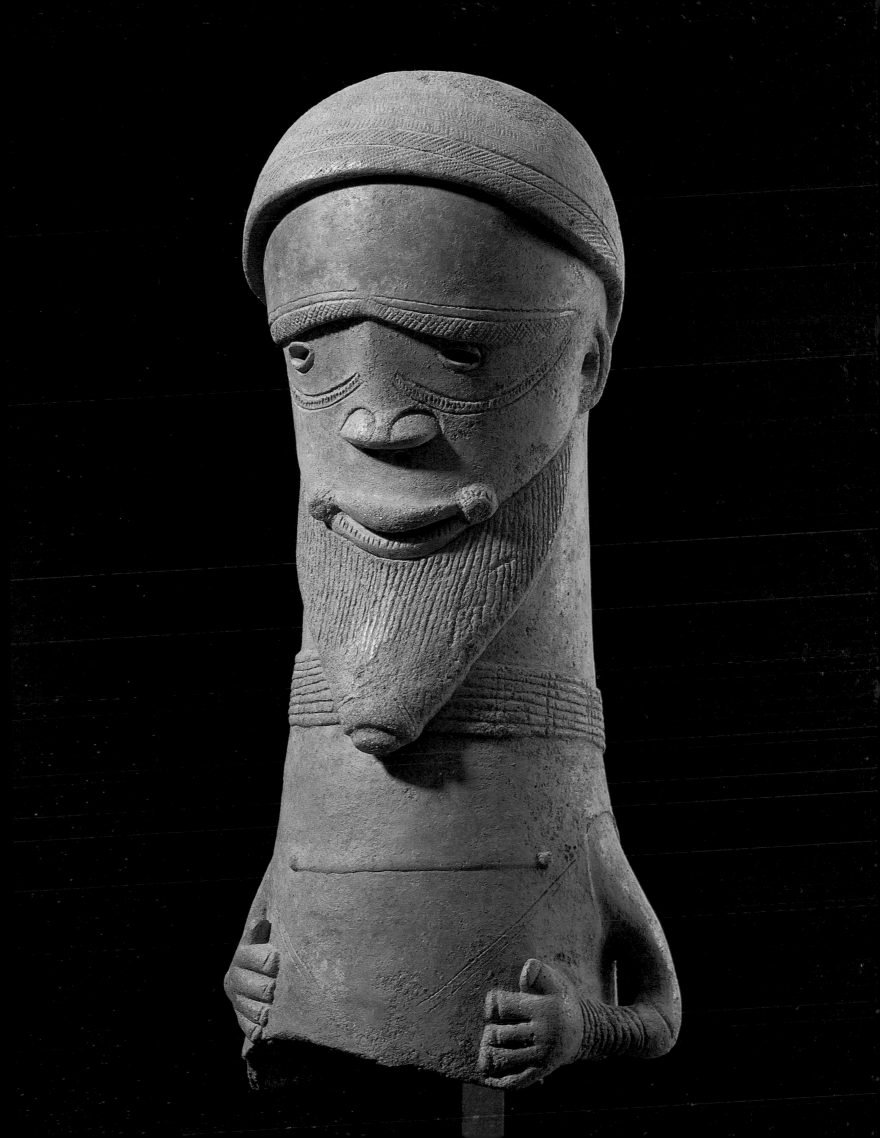

Head of an *Ooni*

Ife Kingdom, Nigeria, 12th–15th century
Cast bronze; height 31 cm
The National Commission for Museums and Monuments,
Ife, Nigeria

The working of metal is so taken for granted in modern civilizations that we tend to forget that in previous centuries, objects of bronze or iron were a rarity in certain regions and represented a special privilege. Metal extracted locally from ore or imported over long distances was often so costly that its use was reserved solely for the king and his court. The rarity and value of the material went hand in hand with a reverence of the persons who possessed a knowledge of alloys and metalworking techniques. Smelting and amalgamating processes were exalted to ritual status.

The West African kingdoms of Ife, Benin (see pp. 72–77), Igbo-Ukwu and the Ashanti (see p. 88f.) are characterized by their highly developed metalwork. The most impressive Ife works known to us are fabricated from metal. The bronze and brass sculptures created by Ife court metal crafters are technically and aesthetically among the finest of their kind. Their beautiful modeling and impeccable casting initially led Europeans mistakenly to assume that they had been imported from Europe.

Pieces like the present head of an *ooni*, excavated in 1938, are remarkable for another reason as well: they marked a culmination of African realism. Accustomed to African art that made no attempt to achieve verisimilitude and appeared unconcerned with portraiture in the Western sense (see pp. 13–14), observers were so struck by the naturalism of the Ife heads that they thought they must be individual portraits. The face of the present *ooni*, a sacred king of Ile-Ife, confronts the viewer with great calm, a candid gaze and a dignified, restrained expression. The proportions are so perfect that a canon could be derived from them. A sense of detail and overall unity, a proximity to nature and a restrained abstraction are so skillfully balanced that one can speak of the veritably "classical" beauty of this head.

However, its present appearance likely differs considerably from its original one. As the rows of holes indicate, the king once wore a crown of metal or other materials (to which the original wax model was adapted as it was being sculpted), and probably also a veil of beads over the mouth and lower face. In addition, there are indications that the head, or parts of it, originally had a polychrome finish. Strikingly, the face evinces no scarifications, in contrast to many of the bronzes and the majority of the terracotta heads so characteristic of Ife, which prominently display this type of physical adornment. Only the neck of the *ooni* bears a number of raised lines, which probably reflect an ideal of beauty and are an indicator of wealth.

Made by the lost wax process, the bronze likely was originally mounted on a wooden figure. Its use remains a mystery. According to Frank Willett, the figure may have served to wear the crown insignia of a deceased ruler on the occasion of his reinterment, in order to ensure the continuity of the office. On the other hand, it could conceivably have been used in the context of the annual rites of purification and renewal for the people and their ruler. The impression conveyed by the head remains untouched by such speculations. It is the embodiment of the ideal image of an Ife ruler during the best years of his life.

Bibliography: Willett, 1967, Eyo, 1977; Fyo and Willett, 1980, cat. no. 39; Drewal, 1989, pp. 45–75; Borgatti and Brilliant, 1990, p. 60; Willett, in: Koloss, 1999, pp. 32–40, cat. nos. 1–5

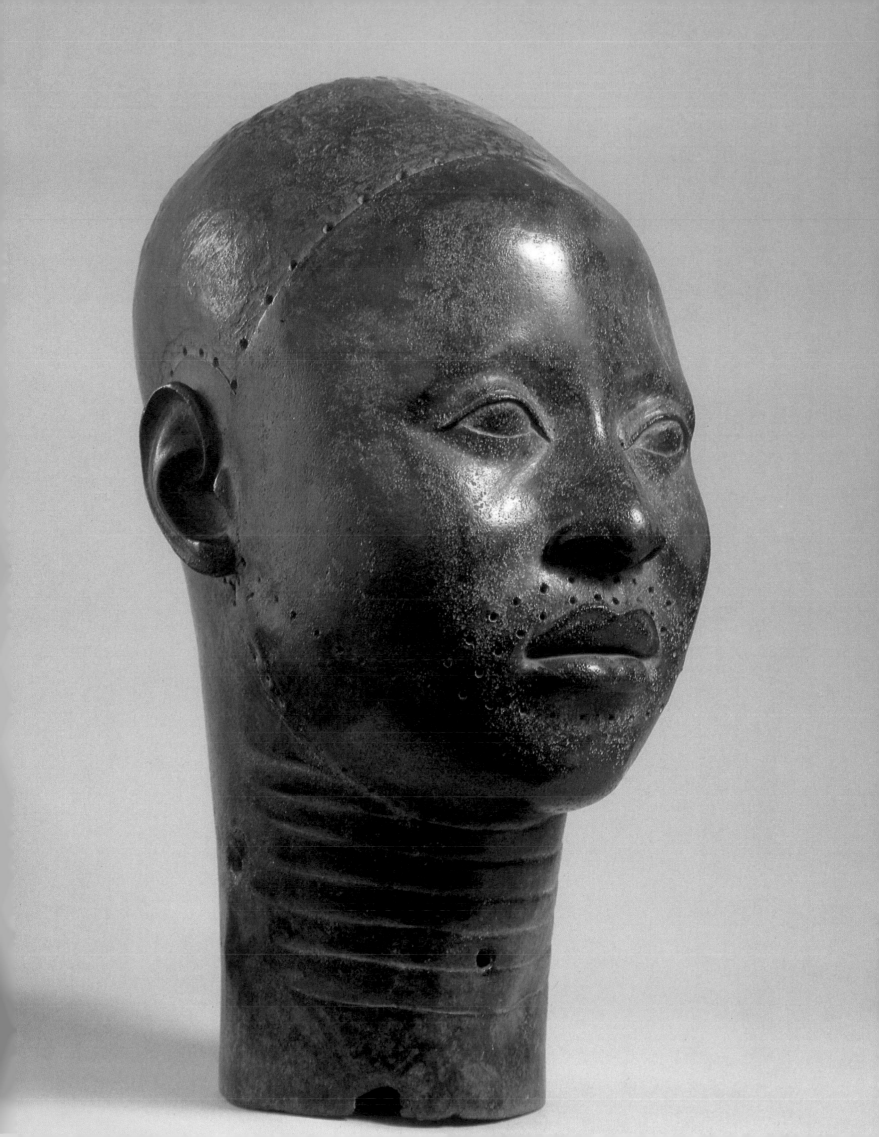

Seated Figure

From the Nupe village Tada, Nigeria, 13th–14th century
Copper; height 53.7 cm
The National Commission for Museums and Monuments,
Lagos

Despite its fragmentary state, this monumental figure is one of the most outstanding works of old Nigerian metal sculpture. Although most African art evinces strict symmetry, frontality and hieratic poses that are explained by the primarily ritualistic employment of the figures, striking exceptions to this rule are repeatedly found. The seated position of this male figure appears quite informal, even genre-like, with the right knee raised and the left leg resting drawn up on the ground. The broken arms were apparently once extended, perhaps holding a scepter and ram's horn or other insignia. The nobleman (for such he must have been) wears a hip cloth which is held at his left by various adornments and is covered with a beaded net. The head was once capped by a headdress, if not a full-fledged crown. The well-fed appearance of the man depicted and the full, round forms of his face correspond to the ideal image of a ruler, whose plumpness was a guarantee for the prosperity of his people. Representing a royal personage, the "Tada Figure" probably was not originally seated on the ground, but mounted on a pedestal or throne.

Some light is shed on the original use of the statue by a traditional custom that was observed as recently as the 1950s. The inhabitants of Tada, who had converted to Islam about 1830, brought the figure down to the Niger River every Friday and scrubbed it with sand, in order to ensure the fertility of their wives and the fish from which they lived. Perhaps this or a similar practice already existed at the time of the figure's creation, about 700 years ago, and continued, if not without modifications, down to the present day. Anointing figures with liquids, such as barley beer, or blood, or with redwood powder, etc., was a part of many rituals. Rubbing the metal figure with sand, however, proved detrimental, because this progressively wore down its features. Eventually the figure entered the collection of the National Museum in Lagos.

Although made almost 200 kilometers north of Ife, the figure is associated with the art of the Yorubas' holy city. Possibly it "represented" the ruler at a distance from his seat of government, playing a role in important official business. At any rate, its sculptor shed the last vestiges of schematism to create the culmination of Ife realism.

Bibliography: Willett, 1967, plate 8; Eyo and Willett, 1980, cat. no. 92; Willett, in Phillips, 1995, p. 406f.

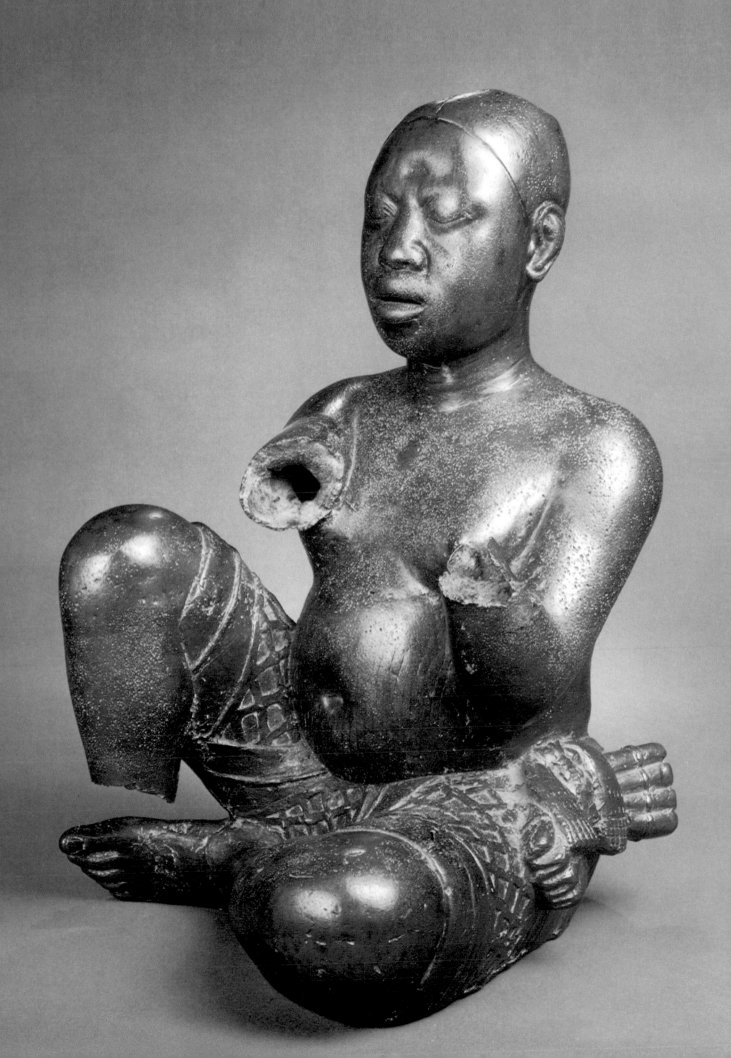

Court Dwarf

Kingdom of Benin, Nigeria, early 16th century
Bronze; height 59.5 cm
Museum für Völkerkunde, Vienna

The place held in painting by Diego Velázquez's portraits of dwarfs at the Spanish court in the 17th century is held in world sculpture by the bronze dwarfs of Benin. Painted or cast—the naturalism of the figures is equally gripping. Surprisingly, even the feudal contexts are comparable. In the mid-17th century, Olfert Dapper, a Dutch physician, evaluated earlier reports from Africa, interviewed merchants and diplomats who had traveled there and wrote a description that remains one of the most important documents on the art of this West African kingdom. "The King shews himself only once a year to his people," wrote Dapper, "going out of his court on horseback, beautifully attired with all sorts of royal ornaments, and accompanied by three or four hundred noblemen on horseback and on foot, and a great number of musicians. . . . Then he does not ride far from the court, but soon returns thither after a little tour. Then the king causes some tame leopards that he keeps for his pleasure to be led about in chains; he also shows many dwarfs and deaf people, whom he likes to keep at court." At this point Dapper refers to the serfdom practiced in Benin.

Dapper had an engraving made of the parade and its truly Baroque pomp, but Benin artists, too, had repeatedly depicted the court through the centuries. We encounter the king (oba) and his entourage on several hundred surviving bronze plaques that once adorned palaces (see p. 76f.), as well as in multifigure altar bronzes. Beyond this, there exist full figures in the round of court dwarfs or jesters, as well as leopards and other animals. The reason for this variety of themes, indeed for the sheer abundance of art at the period, was a flourishing trade that began in the 15th century, initially with Portuguese merchants who exchanged bronze and firearms for slaves, ivory and pepper. No other royal court in Africa reveled in such an abundance of bronze and ivory as Benin.

Evidently such large quantities of the material was imported that an iconographically secondary subject, such as a court dwarf (akaer onmwon), was considered worthy of depicting in the form of a monumental bronze statue. A subject as relatively seldom treated as this surely had the charm of the unconventional for the artist. A large proportion of official Benin art stood in the service of the cult around the kingdom's highest personages and was devoted for centuries to the same tasks. It thus fell into a certain schematic conventionality, which did not necessarily apply to the depiction of dwarfs.

Clad in a hip cloth and adorned with necklace and armbands, the man raises his hands as if about to speak. The facial expression is expectant, and the gaze alert and seemingly directed straight at an interlocutor. The artist's great powers of observation are evident from the subtle treatment of the short, plump body and deformed head. The most notable aspect, however, is that the precise physiognomic characterization is not obtained at the expense of the dignity of the person represented. Court dwarfs were occasionally attributed with supernatural abilities, and some of them made great contributions to the kingdom. It is therefore likely that these two figures (see illus. below) found a place on the ancestor altars of their kings. Some authors have detected in this refreshing naturalism the heritage of Ife art.

Bibliography: Dapper, 1670; W. Fagg, 1961–62; Ling Roth, 1968, p. 29; Ben-Amos, 1980–95; Duchâteau, 1990 and 1995; Curnow, in: Eisenhofer, 1997, pp. 82–96

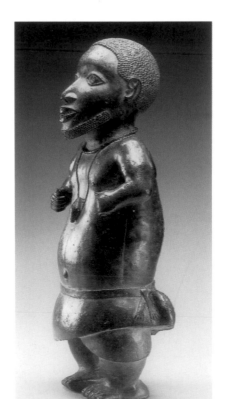

Bearded court dwarf, early 16th century, bronze, height 59 cm. Museum für Völkerkunde, Vienna

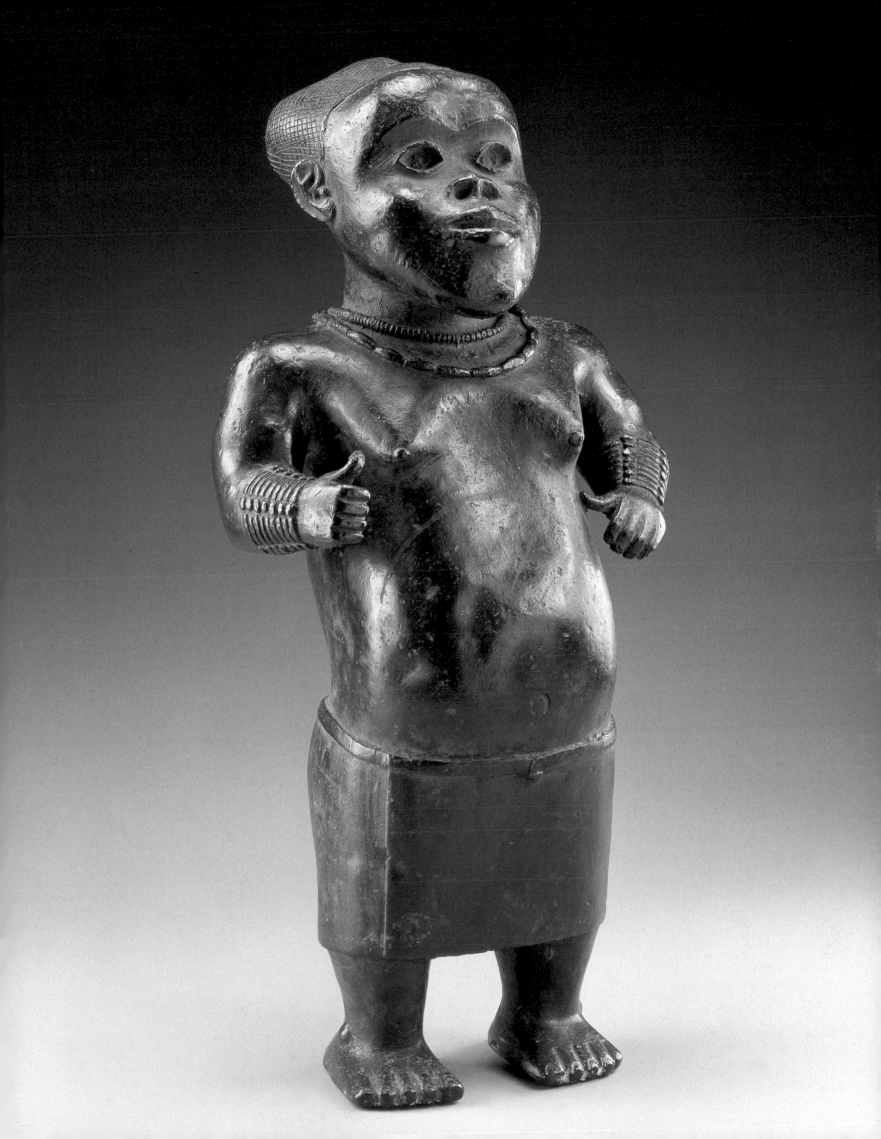

Ornamental Mask

Kingdom of Benin, Nigeria, early 16th century
Ivory, iron and copper; height 25 cm
The British Museum, London

Not only bronze casting but ivory carving flourished for centuries at the court of Benin. From the openings on the bronze heads on the ancestral altars in the palace rose fangs of ivory, carved all around with elaborate reliefs. Ivory transverse horns decorated with reliefs were blown when the oba, or king, made his entry, or at other auspicious occasions. Staffs and bells, figures and armbands were also carved from this precious material, as were wonderful sculptures in the round of leopards. Like bronze, ivory was a royal monopoly, and only members of the *igbesanmwan*, or royal guild of ivory and woodcarvers, were permitted to work it in the inner rooms of the palace precinct.

The elaborate adornments on the apparel of king and courtiers included ivory, but also bronze, masklike pendants such as the present one. These served as clasps to hold ceremonial gowns in place or were worn on the hip or breast as further luxurious accessories. This exquisite piece of parade jewelry was carved from a single elephant tusk, whose grain runs the length of the face. In order to reduce its weight, it was deeply hollowed out from the back, making the ivory well-nigh translucent and giving the head its masklike character. The present piece depicts a queen mother, Iyoba, who possessed considerable power and resided outside the palace. Presumably the mask was worn by a king at memorial ceremonies for his deceased mother (*ugie iye*) as well as at ceremonies that served to cleanse the kingdom of impure spirits (*emobo*). Several things speak in favor of it being a depiction of the legendary Idia, the mother of Oba Esigie (reigned 1504–50). She was so devoted to her son that she went so far as to raise an army on his behalf. She is also said to have put her magical powers at Esigie's disposal, her only son. In her honor Esigie made the office of queen mother into a prestigious institution. The present mask was therefore both an amulet with magical powers and a high-ranking emblem of the monarchy. It fell into the hands of British troops in 1897, who found it in the bedchamber of the reigning Oba during a penal expedition against Benin.

The face is depicted in strict symmetry, its gaze directed slightly downward with great dignity. The eyes were originally inlaid with copper, as were the two short bands on the forehead, which, together with the vertical strips adjacent to them, represent typical facial decorations of an Iyoba. The striking bas-relief coiffure is reminiscent of other depictions in which individual strands of hair are decorated with beads. The diadem consists of a row of stylized Portuguese heads (originally eleven in number), with long hair and beards and wearing hats. The face is framed at the bottom by a coral necklace and a broad plaited band decorated with drillings and metal inlays.

It may come as a surprise to see Portuguese depicted on a work of art as significant as a royal clasp. The Portuguese first went to the court of Benin in the year 1486. At the time, Oba Ozolua had been in power for just five years and had his work cut out for him in attempting to bring rebel cities and regions, as well as disloyal palace groups, back under his sway. The arrival of the foreigners came as a godsend to him and his successors.

It was exclusive trading rights with Portugal that enabled Benin to dominate its neighboring regions and establish its immense wealth and prosperity. In William Fagg's eyes, it was the luxury in which Portuguese settlers lived that spurred the king "to try to match the foreigners' pomp and standard of living in order to maintain the loyalty of his own subjects and vassals. The Obas craftily used the prestige of the Portuguese to heighten their own by frequently having foreigners depicted in bronze sculptures." Hence this ornamental mask reflects a complex political program that visually documents the self-image of the monarchy.

The Metropolitan Museum of Art, New York, has an iconographically and stylistically very similar piece, which differs only in having a "Portuguese frieze" around the lower part of the face whereas in the "diadem" Portuguese heads alternate with a mudfish ornament. Mudfish was one of the highest state symbols in Benin, being associated with Oba, who themselves appeared in the fishlike form of the god Olokun.

Bibliography: W. Fagg, 1963, p. 30f., plate 51; Ben-Amos, 1980–95, cat. no. 94; Ezra, 1984, p. 20f., cat. no. 14; Bassani and Fagg, 1988, pp. 154–59; Duchâteau, 1990 and 1995; Eisenhofer, 1993, p. 144f.; Kaplan, 1993[1] and 1993[2]

Relief Plaque Depicting a Bird Hunt

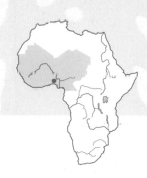

Kingdom of Benin, Nigeria, 16th century
Bronze; 45 x 34 cm
Ethnologisches Museum, Berlin

Olfert Dapper's report on the Kingdom of Benin (see p. 72) includes a description of the royal residence: "The king's palace is rectangular. It is probably as large as the city of Haarlem and surrounded by a strange wall. It is divided into many magnificent apartments and has lovely long, rectangular pleasure corridors that are about as large as the Stock Exchange in Amsterdam; yet each is larger than the next. The roof of the same stands on wooden columns, which are covered from bottom to top with brasses on which their warlike deeds and field battles are depicted."

Actually it is not so much battle scenes as armed men, chieftains and horsemen that are depicted on the virtually countless Benin bronze reliefs. Even more frequent are ceremonial scenes at court and, above all, depictions of courtiers of various ranks: dignitaries in full regalia holding the insignia of their office, splendidly clad court musicians with bells and royal messengers. All are represented frontally, standing at attention like statues, as if in a photo studio, and careful attention is paid to dress etiquette. Especially charming because less ceremonious and stiff are the reliefs depicting European merchants (concerning whose role see p. 74), or the plaques with crocodiles, snakes, fish and birds. Hunting scenes are also among these unconventional subjects, although they are the exception in Benin art. These are depictions of leopard hunts involving Portuguese hunters or, as in

the present case, of a bird hunt with bow and arrow. Not only is this a rare example of a genre scene in African art; this narrative relief is exceptionally unique on account of its lyricism.

Unfortunately the bird at which the royal hunter is aiming is broken off. All that remains are his long legs clutching a branch and his right wing. Another bird, safe for the moment, perches above. It may represent an ibis, judging by the long bill. The relief ground, as in many Benin plaques, is engraved with floral motifs. The tree, in which originally at least three birds perched, is artfully stylized, and the sparing foliage decoratively arranged across the plane. The hunter, wearing a cap and other adornments, is equipped with everything he needs.

This hunter is a masterpiece of figurative composition, all the more so as models for such depictions must have been rare in Benin. The natural torsion of the body recalls sculptures in the round, such as *Europeans with Firearms*, and should be viewed in light of imported models. While the hunter's legs are seen from the side and lie on the relief ground, his figure gradually becomes almost three-dimensional up to the shoulder area. The suspenseful moment just before the release of the arrow is wonderfully captured. The arms are generously elongated; the arrow surprisingly lies over the bow, yet the grasp of the left hand (which also holds an extra arrow) does not seem quite plausible. William Fagg has classified this relief in a group of about seven works whose artist he has named, after another relief in the Ethnologisches Museum, Berlin, the "Master of the Lion Hunt."

About 900 Benin reliefs have survived. Most of them came to the West together with nearly 2,000 objects in the wake of the British punitive expedition against Benin City in 1897. Distributed among several museums and private collections, they form the most coherent complex of African art, which developed over a period of several centuries.

Bibliography: von Luschan, 1919, plate 29, fig. 144; W. Fagg, 1963, plate 22; Eyo/Willett, 1983, cat. nos. 76–91; Bassani and Fagg, 1988, pp. 187–90; Koloss, 1999, plate 23

Three young men, Kingdom of Benin, Nigeria, 16th–17th century, bronze, Ethnologisches Museum, Berlin

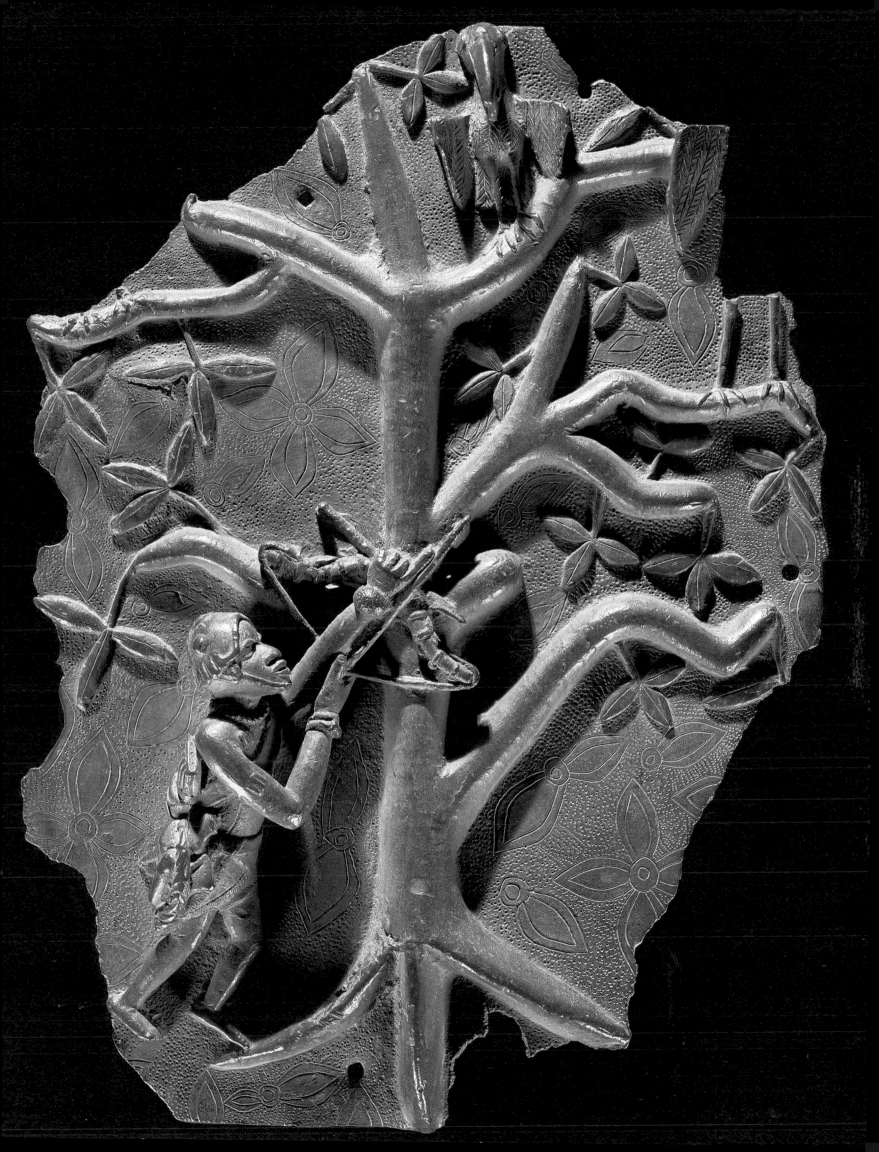

Saltcellar

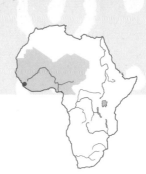

Sapi-Portuguese, Sierra Leone, ca. 1490–1530
Ivory; height 42 cm
Museo Preistorico Etnografico L. Pigorini, Rome

Salt was a valuable commodity for centuries, and ivory has been an exquisite material from time immemorial. A full ivory saltcellar was viewed as a symbol of wealth and was a feature of the sumptuously laid tables of rich European merchants and aristocrats. However, pieces as elaborate as this were withdrawn from everyday use.

The Portuguese were the first Europeans to map the west coast of Africa and open it to trade, starting about the mid-15th century. It took them decades to penetrate, piece by piece, from Cape Bojador to the mouth of the Senegal, thence to the "Gold Coast," to the Niger delta in the Bay of Guinea, and farther south in the direction of the Congo. Long before these regions were officially colonized, a lively trade had arisen from which both Africans and Europeans equally benefited. Ivory, gold and spices were among the most valuable goods that Portuguese traders brought back to Lisbon. Since the then-inhabitants of present-day Sierra Leone, the Sapi, had become excellent ivory carvers, like the Bini in the orbit of the royal court of Benin (see p. 74f.), the Portuguese not only acquired raw ivory but commissioned pieces locally—goblets, boxes, horns, spoons, knife handles, etc.—often based on European patterns. The resulting works exhibit a unique European-African syncretism in which diverse figurative and decorative influences were so skillfully merged that considerable acumen is required on the part of art historians to identify the original sources.

While the Bini-Portuguese ivories are clearly indebted to Benin bronze and ivory works (see pp. 72–77), those of the Sapi exhibit a proximity to their own concurrently fabricated *nomoli* figures of soapstone. In contrast to the Bini style, which reflects adherence to a stringent courtly formalism, the works from Sierra Leone have a much more relaxed visual idiom that extends even to the humorous and grotesque. The saltcellar selected for this volume is one of the most outstanding accomplishments in this style.

Above the base rises a sort of arbor with four seated figures. The saltcellar proper consists of a sparingly decorated spherical container whose lid forms a stage for an execution scene. A looming executioner in European hat and trousers has already beheaded six people and is about to dispatch a seventh, who kneels submissively before him (his head, and the executioner's hand and axe, are later additions). Although the scene recalls images of martyrdom depicted in European art, such events conceivably could have taken place in Sierra Leone. Yet its horror is mitigated by the decorative effect of the heads, whose facial expression scarcely differs from the executioner's (the heads served as knobs with which to open the lid). The two female and two male figures seated below on a sort of balustrade and clad only in wraparound skirt or breeches with codpieces, seem unconnected with the cruel scene above. They support themselves on decoratively woven ropes down which four small crocodiles can be seen crawling. The female figures, nude from the waist upwards and richly scarified, and the facial features throughout are pithily characterized. Precisely incised ornamental bands lend unity to the piece. Bassani, who compiled a corpus of Afro-Portuguese ivories, has attributed it to the "Master of the Symbolic Execution," a name that derives from this work, who created two further famous saltcellars.

Bibliography: Grottanelli, 1975 and 1976; Bassani and Fagg, 1988, cat. no. 31; Bassani, in: Phillips, 1995, p. 467; Bassani, 1994 and 2000, cat. no. 736 (with bibliography), "Additional notes . . .," pp. 285–304

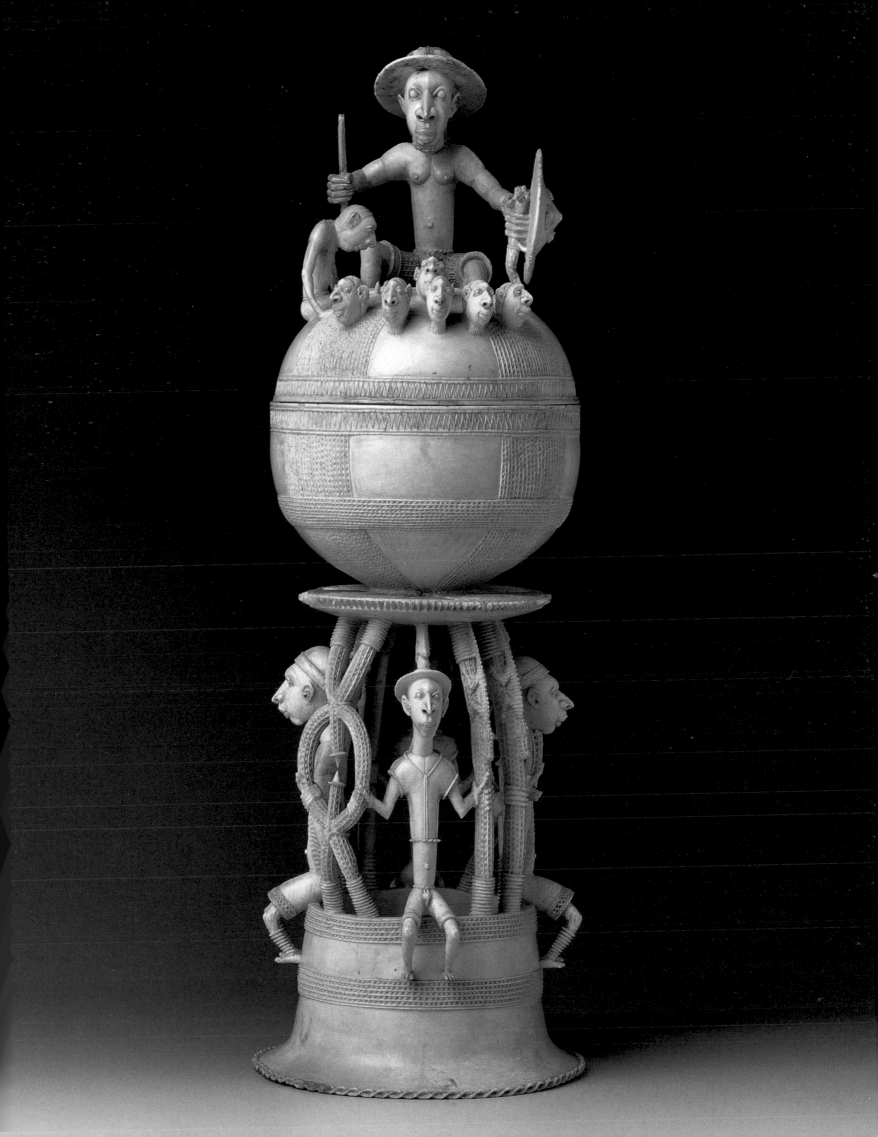

Shrine Figure

Yoruba, Nigeria, late 19th century
Wood; height 60 cm
Collection of Ian Auld

The Yoruba believe in a pantheon of gods and spirits (*ori-shas*) whose strong character, active intervention in human affairs and ambivalent and tragic nature have long reminded Europeans of the deities of Classical antiquity. Yet, despite their colorful and graphic life stories and personality traits, images of these figures were seldom made by the Yoruba in the form of statues.

A cult was dedicated to each *orisha*, administrated by priests and priestesses known as *eleguns*—"those who are ridden," which indicates that beyond ritual ceremonies and a general veneration, their identification with the spirit went so far that it could take complete possession of them. Qualification for the office of priest was associated with this ability to surrender oneself entirely.

The most powerful *orisha* was Sango, the hurler of lightning bolts and maker of rain, who was unpredictable and moody but loved the truth, punishing liars and thieves. His veneration long had the status of a state cult in the Kingdom of Oyo. The wooden figures that stood on altars in his shrines generally represented priestesses, female worshipers or his favorite wife, Oya. She herself was a goddess, and a personification of the Niger River and of the storms from which Sango's thunder and lightning crashed down. She, too, had her own cult, and it is possible that the present figure once stood in a shrine dedicated to her. As Babatunde Lawal explains, "Because of the collaboration between the pair, Oya's sacred symbol (a pair of buffalo horns) can be found on many [Sango] shrines, while Sango's thunderbolts or carved double-axes adorn Oya's shrines."

As a rule, Yoruba worshipers adhere to the cult to which their parents belonged. But personal preference or the advice of an oracle can have an influence as well. Believers turn to their *orisha* whenever an important decision has to be made. The altar figures, kneeling and offering a sacrifice, wonderfully embody the reverence accorded to the *orishas*. Yet they were not idols worshiped for their own sake. Mother figures with a child likely symbolized the life-giving force of Sango, who not only brought rain to ensure the fecundity of the fields but the fertility of women as well.

The affection and dependence of a child on his mother is rendered with great sensitivity in the present sculpture. Hanging from his mother's back, the youngster reaches under her arms in an effort to brace himself. The mother's expression is one of profound reverence. Naked except for a hip chain, arm and foot rings and a necklace with amulet, she holds out a sacrificial bowl. The head on the long neck conveys a sense of supreme dignity. Further adornments are visible in the high-piled, elaborate coiffure. The theme of the figure is perhaps not so much the mother's affection for her child as the mother's religious reverence, intended to ensure her infant's health and welfare. Such figures also served as votive offerings to a shrine by women whose plea—such as for the conception of a child or the recovery of a sick child—had reached the ears of her *orisha*.

As the above implies, the identity of a female figure of this kind was not firmly established but could change depending on the ritual context. This sculptural masterpiece exhibits striking affinities with the works of the renowned carver Abogunde of Ede.

Bibliography: Beier, 1959, plate 26; Pemberton, 1982; ibid., in: Drewal et al., 1989; pp. 146–187; Abiodun et al., 1991; Lawal, in: Phillips, 1995, pp. 422–24; Eisenhofer, 1997, pp. 204–17; Drewal, in: Falgayrettes-Leveau, 2000, pp. 49–65

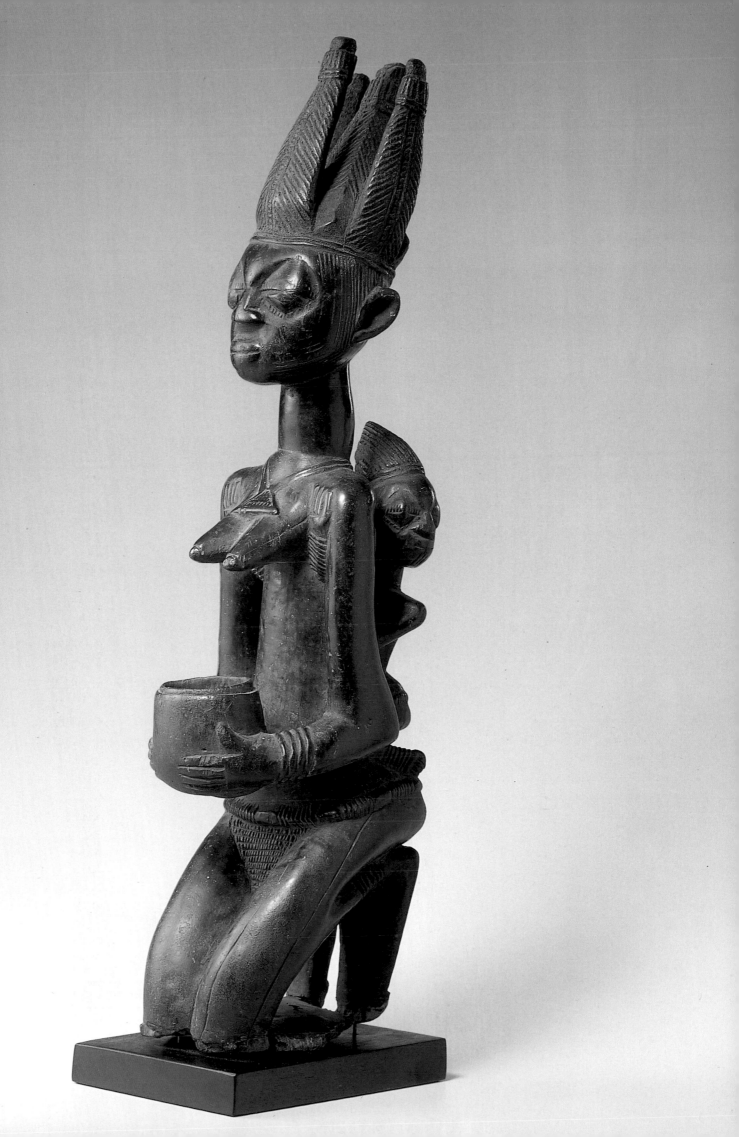

Janus-Faced Headdress Mask

Boki, Nigeria, 19th–20th century
Wood, leather, horns, plaitwork and sheet metal; height 54 cm
Private collection

Headdress masks from the Cross River region in southeastern Nigeria and the adjacent Cameroon region possess perhaps the most striking, indeed disturbing, faces in all African sculpture. All the more so because of their human-like appearance. Their naturalism goes so far as to include coverings of thinly scraped antelope hide, monkey skin or sheepskin (or, in earlier times, human skin) stretched over the wooden core. Human features were imitated down to the last detail, and their verisimilitude was increased by inlaying the eyes with painted metal plates and representing the teeth by means of pieces of bone, bamboo or metal. Vegetable pigments were used to accentuate such details as lips and eyebrows. Hair was frequently represented by actual human hair. Yet it is the waterbuck horns that lend this mask its striking appearance. The masks' size was exactly that of a human head, and in fact they perfectly resembled the trophy heads of slain enemies from which they developed. Originally the base consisted not of wood but of a skull. Mansfeld, who explored the Cross River region in the early 20th century, heard reports of headhunting and saw the resulting trophies in the "palaver house" or in concealed bush villages behind the houses.

According to Keith Nicklin, such masks were usually worn in pairs, one representing an "ugly," aggressive male character and the other evoking feminine charm. Among the Boki, three secret societies used skin-covered masks of this kind: a warriors' society (*ekang*), a hunters' society (*bekarum*) and a women's society (*egbebe*). The latter was responsible for the training of adolescent girls prior to marriage, and it is they who were principally associated with the lovely female masks. The masks were donned during initiation rites, as well as at funerals and agricultural ceremonies. According to Robert Farris Thompson, their leather covering was intended to attract the spirits of the deceased. The dance of the masqueraders, whose costumes completely concealed them, supposedly served to bring together the realms of the living and the dead. This hypothesis, derived by comparison with Afro-Cuban traditions, is however difficult to reconcile with the origins of this mask type in headhunters' trophies.

The forehead, cheeks and chin of the cap mask bear delicate facial adornments, as well as pairs of flat disks on the temples. These echo the circular and semicircular ornaments on the forehead (of one side of the head), while the cheeks exhibit highly differing patterns. As Maria Kecskési explains, these do not represent tattoos but symbols known as *nsibidi*. "Through facial painting renewed daily, women indicated which experiences (such as love, reconciliation, birth and death) occupied them at the moment." This custom is especially prevalent among the Igbo in southern Nigeria.

The double mask faces may be interpreted as representing the dual field of perception of the spirit embodied in the mask, who sees everything. But he also has the capacity of looking into both this world and into the world beyond. According to an Ejagham informant (1969), Janus masks perhaps also represent Tata Agbo and his wife. Tata Agbo once lost his brothers and sisters in war, so his wife, fearing he would meet the same fate, followed him into every subsequent battle and loaded his rifle for him—looking in the other direction to guard his rear. However, unlike similar specimens, the present piece shows little distinction between a female and a male face, which are normally characterized by a contrast of light versus dark. Apart from the face painting, the features are almost identical. The beauty of this dual mask and its fine state of preservation seem to have resulted not only from the skill of the Boki in tanning leather but also from its fabrication for intended export to Europe.

Bibliography: Mansfeld, 1908, p. 149f.; Jeffreys, 1939; Nicklin, 1974 and 1979; Thompson, in: Vogel, 1981, p. 175f.; Schaedler, 1982; Vogel, 1986, pp. 104–6; Nicklin, in: Phillips, 1995, p. 376; Kecskési, 1987, p. 182f., and 1999, p. 29

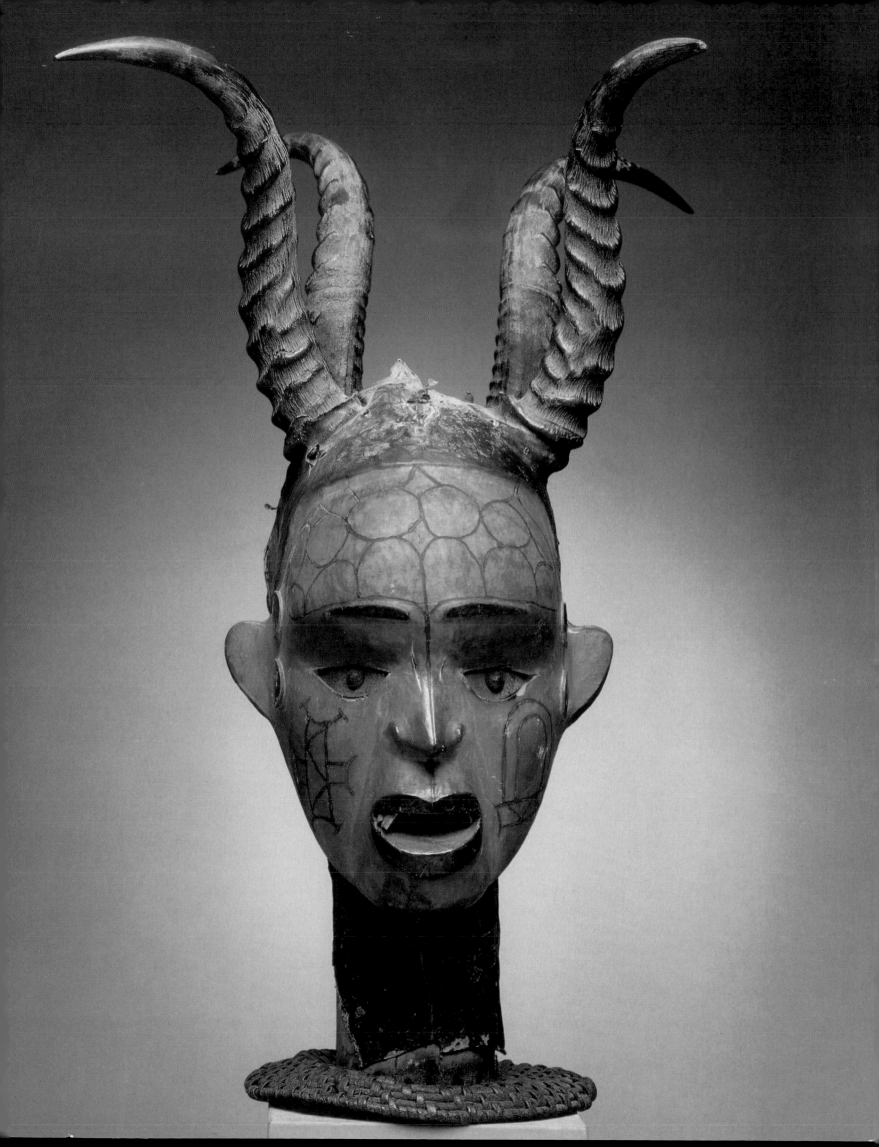

Throne Figure

Kingdom of Kom, Cameroon, 19th century
Wood and sheet copper; height 190 cm
Ethnologisches Museum, Berlin

The great meaning and symbolic power attributed to stools and chairs in many parts of Africa to this day are scarcely conceivable to non-Africans. As a rule, seats are considered private property that not just anyone may use. In fact the act of sitting itself, especially on elaborate chairs, is often not a question of personal preference and comfort but an indication of social rank. Sitting implies the possession of authority. Certain types of stool signal the high social prestige of their user, or are indeed inextricably linked to a particular office. Some might belong just as much to the insignia of a ruler as crown, scepter or certain attire. In analogy to the Western "dress code," one can speak of an African "seating code."

Beyond this, royal thrones form a special category, for it is not a private person who takes his place on them but a personality who represents a community or an entire people. It is not his personal opinions that his audience expects to hear when he publicly announces decisions through a speaker from his throne, but the resolutions reached by all those who stand behind him, ideally including his ancestors. A king represents the latest link in a chain of high dignitaries in whose name he speaks. The so-called caryatid stools—stools whose seat is held up by a figure—represent a symbolic expression of the fact that the man seated on them is literally *supported* by an ancestor, male or female.

A still higher level of development, in which the stool takes on a sacramental nature, is reached when it comes to represent the power of the king's office itself and he is not even permitted to use it (cf. stool of the Ashanti, p. 88). To this category belongs this royal throne of Kom, from the northern Cameroon Grasslands. The seat and the lifesize standing male figure have been carved from a single block of wood. The figure holds a drinking horn in his right hand and wears a royal cap—both attributes of notables. Typical of the Grasslands style are the smooth, full facial features, the wide open eyes with continuous upper and lower lids and the slightly open mouth, as well as the realistic proportions of the face.

The figure's high rank is indicated, among other things, by the covering of the hands and face with sheet copper, the latter being a feature otherwise found only in kings' masks. It was also the king's privilege to have a stool decorated with the depiction of an animal. The present throne has a counterpart with a female figure (also in the Ethnologisches Museum, Berlin). As H.J. Koloss explains, "Three such royal figures have remained the most significant ritual objects among the Kom to this day, being considered the 'things of Kom.' … They were not meant to recall specific royal personages but, rather, to represent ideal figures of a king, his first wife and the king's mother, who symbolized the continuity of the royal dynasty and its power." According to the same author, these thrones were presented during the xylophone dance that took place after a newly enthroned ruler had emerged from a year of seclusion.

The artist who made them was apparently King Yu (reigned 1865–1912), who was known as a great carver, or his workshop, and they were originally entirely sheathed in glass beads (see illus. left). This luxury article imported from Europe was likewise strictly restricted solely to the use of the court. Copper sheet, animal motifs and beads—the list of costly details exhibited in this work is surpassed only by the fact that it includes a human figure, something that was permissible only in the context of courtly art. Its monumentality would justify viewing the piece less as a throne (with figure) than as a statue (with stool), an interpretation that is supported by its original purpose.

Bibliography: Bocola, 1995; Koloss, 1999, cat. no. 69; Notué, in: Falgayrettes-Leveau, 2000, p. 228f.

King's throne from Bamum, Cameroon, covered with glass beads and cowry shells, Museum für Völkerkunde, Vienna

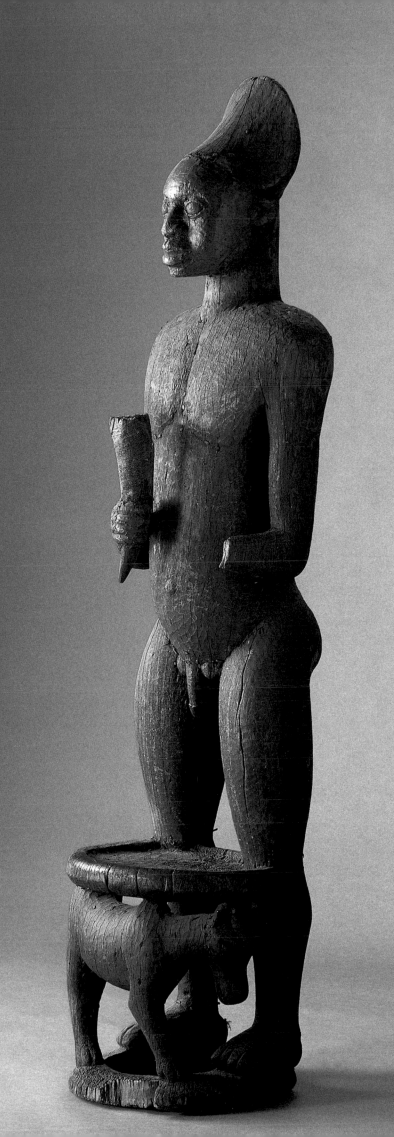

Female Memorial Figure

Bangwa, Cameroon, 19th–20th century
Wood; height 82 cm
Musée Dapper, Paris

Back in the 1960s, William Fagg described the Bangwa as the most gifted figurative sculptors of the Grassland peoples, pointing out that they were well-nigh alone in Africa in their discovery of the torsional potentials of the human body, which rarely adjusts itself to strict frontality.

The present figure shows a masterly combination of the statuesqueness required of a representational figure and a natural dynamism evoking movement. Knees slightly bent as if emerging from a crouch, the "dancer" pauses and turns her head to the right. She grasps a rattle and her mouth is open as if about to sing. The slight turn of the torso to the right is sufficient to obviate strict frontality and bring more than a single vantage point into play. In fact the sculptor's accomplishment is to have created several highly effective points of view. The side view in particular reveals a rhythmical sequence of forms that compellingly evokes musical associations. There is scarcely an inch of the figure that does not stand under high sculptural tension. The face is suffused with charm and vitality; the feet, calves, thighs and full breasts are rendered as such swelling volumes that they seem to take on a life of their own. This impression of independent segments is augmented by the multiple rings around ankles and wrist, hips and neck (in real life made of bronze or iron, some with beadwork). These ornaments, rather than appearing superadded, are integrated in the overall sculptural configuration. A collar extending around chest, shoulders and back, and a tall cap, complete the attire of this noble lady. The figure represents either the wife of the king or a high-ranking chieftain or a *mafwa*, the queen mother, a high office that can also be held by one of the king's sisters. A *mafwa* has a higher status than any other notable in the kingdom and enjoys numerous privileges.

This "dancer" may have a counterpart in the form of a chieftain figure represented in a similar dancelike pose. As certain details suggest, the two masterpieces may even be from the same sculptor's hand. As a pair, the figures would form an incomparable ensemble of African art. The Kingdom of Bangwa was characterized by a highly differentiated social hierarchy, whose apex was occupied by the monarch of each of its nine chiefdoms. Figures of the kind illustrated here, often carved during the person's lifetime, kept the memory of deceased members of the ruling clan alive; they were kept under guard in special places and were presented during memorial celebrations in a sacred grove.

Bibliography: W. Fagg, 1964; Brain and Pollock, 1971, p. 124; Harter, 1986, p. 314; Northern and Franklin, 1986, pp. 20, 24f.; von Lintig, 1994 and 2001; Notué, in: Falgayrettes-Leveau, 2000, p. 226f.

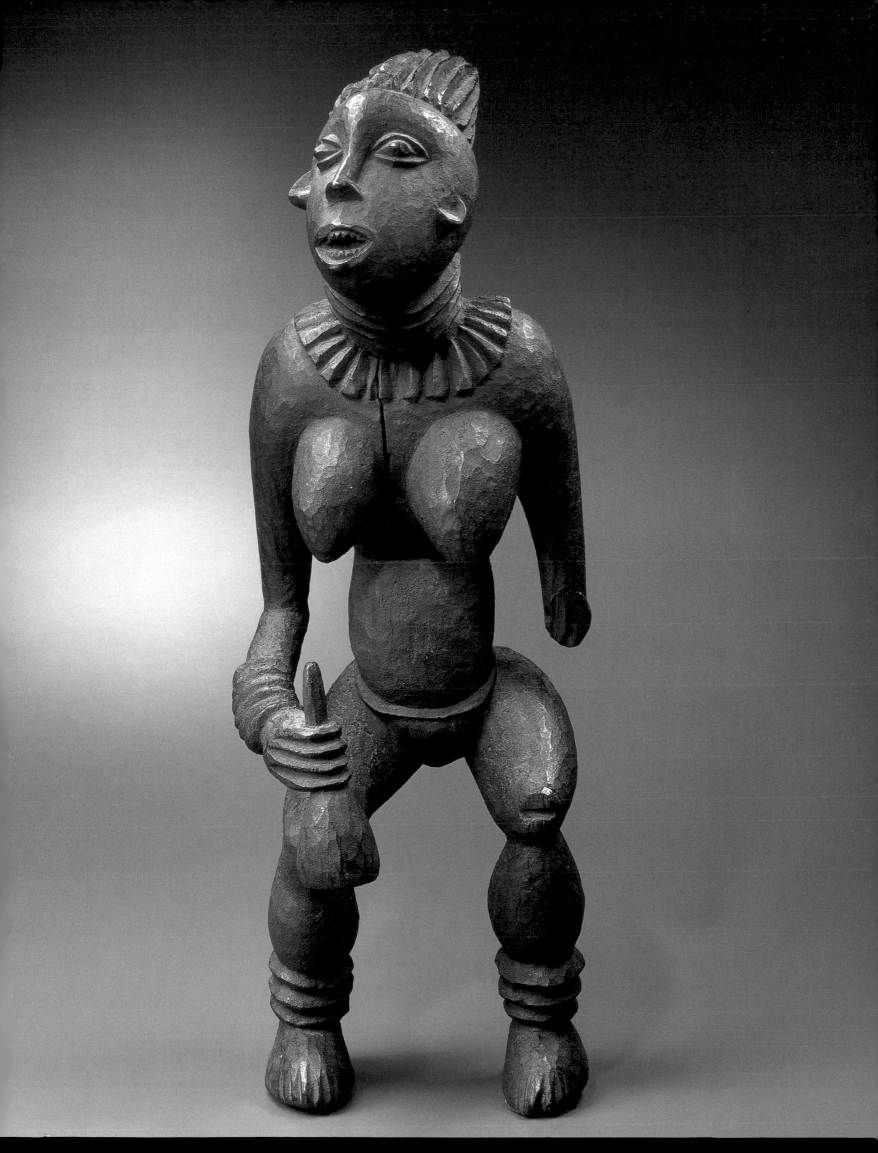

Skink (or Monitor) and Crocodile

Ashanti, Ghana, ca. 1900
Gold (9–10 k/14 k); length 21.8/33.5 cm
Anglo Gold Collection, South Africa
(formerly in the Musée Barbier-Mueller, Geneva)

If the Kingdom of Benin is synonymous with a highly developed art of bronze and brass casting (see pp. 72–77), the Ashanti Empire stands for perfection in another metal—gold. Historically the precious metal played such a prominent role there that it gave its name to an entire country in the colonial period: the Gold Coast, present-day Ghana. And the African El Dorado still lies in this region. Great national corporations now use enormous earthmovers to mine gold ore, yet in rural regions of Ghana and Burkina Faso, village women still wash gold dust from river mud with calabash bowls.

The most supreme status symbol of the Ashanti was the Golden Stool, which is said to have fallen from the sky, metaphorically sealing the founding of the Ashanti Empire by Osei Tutu at the end of the 17th century. No mortal, not even the king, was permitted ever to take a seat on this resplendent chair. Down to the present day, stools and chairs, many decorated with gold leaf, have continued to enjoy a veritably sacred status. The insignia of the chiefs of the Akan peoples, to whom the Ashanti belong, and their official adornments consist of such an abundance of gold that their official appearances have the character of gold festivals. The same holds for the queen mothers, who have their own insignia of rule, for the spokesmen with their gilded staffs, for royal messengers and sword-bearers and for lower-ranking chieftains.

Among the finest examples of Akan goldsmiths' work is the ornamentation on headdresses and sandals, heavy arm and leg rings and magnificent breastplates (*akrafokonmu*). Even chains and finger rings challenged the creative imagination of Akan goldsmiths, who frequently gave them figurative form. The wearing of gold was by no means limited to the royal retinue. The jewelry of Wolof and Peul women in Senegal and Mali is among the most magnificent in the world.

A special form of applied ornament was the decoration of swords. Swords served primarily ritual or status purposes, and their blades were blunt. Below the hilts, which were adorned with gold leaf, an ornate decor was applied, which in earlier periods had the character of trophies. According to Timothy F. Garrard, the red shells of heart cockles, animal skulls or various seashells were preferred ornaments. By the 18th century much of this decor, generally in the shape of animal heads, had begun to be cast in gold. Later the sword ornaments came to illustrate the proverbs so popular among the Akan.

As the two pieces selected for this volume show, these ornaments could attain a considerable size and weight (the massive, cast crocodile weighs over 600 g). While the identification of the latter is simple, the interpretations of the animal above, quoted in Garrard's fieldwork, ranged from a skink, a small reptile with a snakelike head, to a monitor, a very large carnivorous reptile. Crocodiles were a popular sword adornment, and perhaps their ability to live both in water and on land symbolized the dual nature or talents of a chief. The sculpture is covered with a fine network of chasing that lends its surface great vitality. Both figures represent official insignia and therefore depict the animals with a virtually heraldic concision, which also has a highly decorative effect.

Bibliography: Garrard, 1989

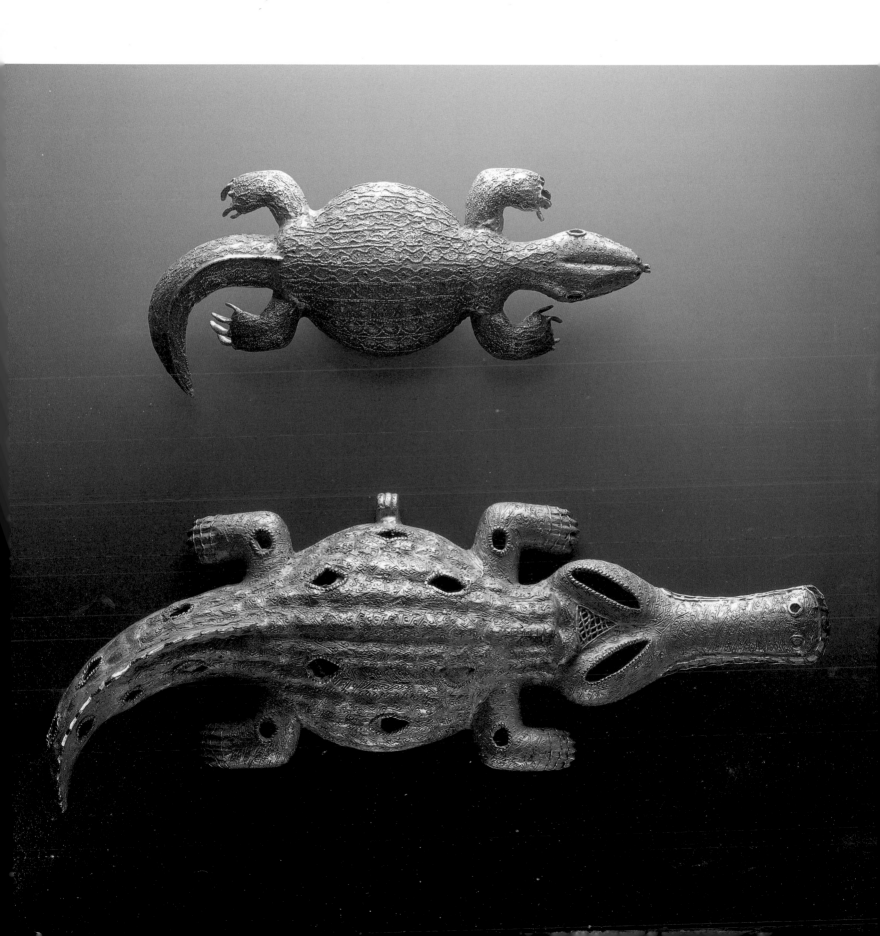

Man's Robe

Ewe-Adangbe, Kpetoe, Ghana, early 20th century
Cotton; 370 x 212 cm
Peter Adler Collection

Ashanti and Ewe fabrics from Ghana made from silk or cotton are among the finest in the world. Woven on treadle looms in narrow strips, which are afterwards sewn together edge to edge, the most elaborate examples show a lattice structure of highly variegated fields. Their bright coloration and imaginative ornamentation make them the epitome of opulence and richness.

Whereas Ashanti fabrics are entirely abstract in ornamentation, those of their neighbours to the east, the Ewe, are notable for incorporating figurative motifs. This piece consists of 19 strips, in which distinctive geometric/figurative motifs alternate with striped squares. The fields are sewn together such that the strips offset each other, and each row in turn features both highly elaborate and plain panels. The variety of geometric motifs is astonishing, ranging from V-formations and zigzags to patterns that are reminiscent of oscillograms. Recurrent panels with motifs that depict birds, quadrupeds and frogs enliven the geometric patterning. But the most striking feature in this piece is the arrangement of most panels around a symmetrical axis. In the case of the striped squares, this produces structures and patterns that evoke the works of Op Art. Unembellished black fields provide powerful visual contrasts, lending the cloth additional liveliness.

This robe comes from the village of Kpetoe, in the heart of the Ewe region, the home of the Ewe-Adangbe. It is identified as *susuavor adanudo* and is thus an exponent of the highly prized textiles with more complex patterns that are made exclusively to order. In the centralized Ashanti Kingdom, weaving was placed wholly at the service of the royal hierarchy. Patterns adhered to a fixed canon and some were reserved for the privileged few. Thus only the *asantehene*, the king of the Ashanti, and the members of his court were permitted to wear fabrics woven from pure silk with *asasia* ornamentation. The center of Ashanti weaving is Bonwire, east of the capital of Kumasi, where the *bonwirehene*, a sort of religious authority, monitors quality standards and compliance with the rules.

Things are different among the Ewe. Their social order is less rigid, and weaving villages are distributed throughout their territory. Weaves are produced not only to order but also for the free market. Accordingly, Ewe weavers have always reacted quickly to changes in demand. Although they are known to copy Ashanti patterns, they can also look back proudly on their own traditions. They rarely work in silk, for which the Ashanti have had their own specialists since the early 19th century. Among the Ashanti, yellow silk textiles for notables enjoy a status equal to prestigious jewelry or insignia made from gold (see p. 89). The warm golden tone of this fabric gives an impression of such sumptuous richness. The Ewe, in contrast, have perfected the art of cotton weaving. Their works are highly creative, not the product of a prescribed visual idiom. As among the Ashanti, Ewe weaving is done by men, along with their assistants and apprentices. Boys begin practicing on miniature looms at a very early age.

Bibliography: Schaedler, 1987; Picton and Mack, 1989, p. 117f.; Adler and Barnard, 1992, pp. 99–110, cat. no. 92; Picton, in: Phillips, 1995, p. 432f.

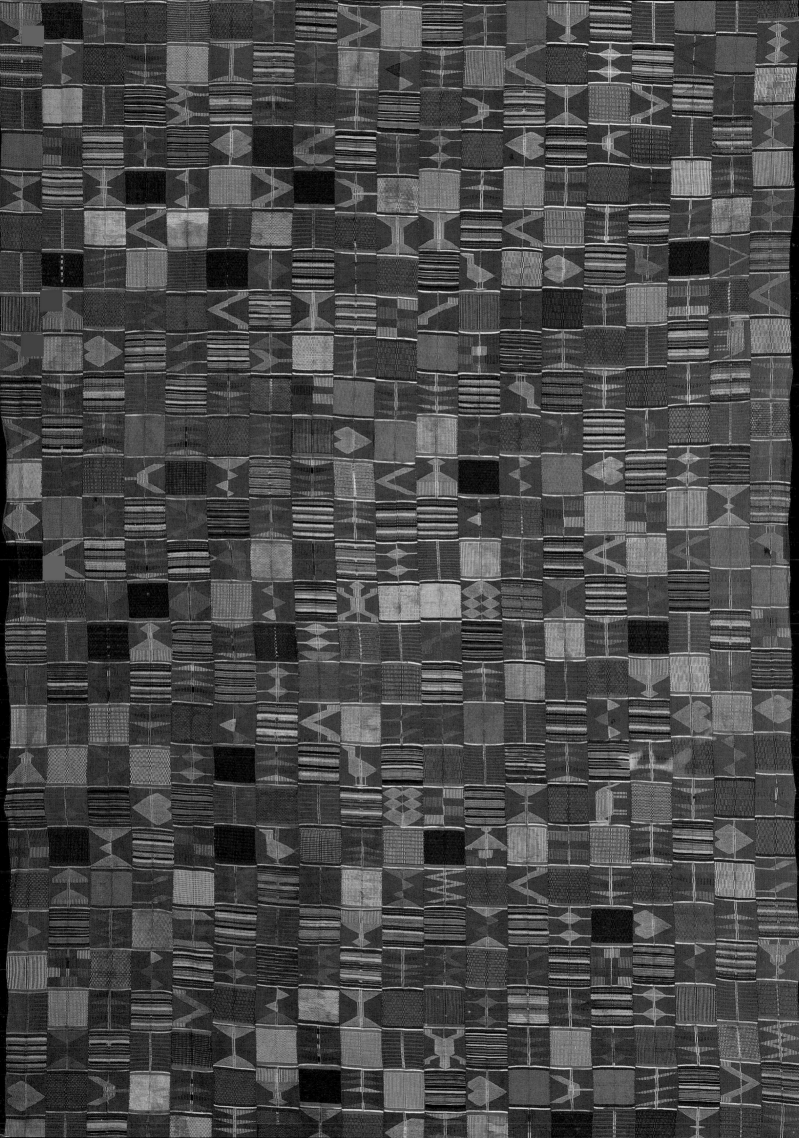

Asafo Banner

Fante, Ghana, first half of 20th century
Cotton; 108 x 155 cm
Private collection

The Asafo are corporations among the Fante, the coastal peo-ple of Ghana. They go back to warrior groups that formed military units during the period of European influence and later, during British colonial rule. The Fante region was divided into 24 independent states, each of which had a paramount chief, a complex hierarchy of chieftains and up to a dozen or more Asafo associations.

These associations no longer have a military purpose but per-form social and cultural tasks, apart from being responsible for overseeing the election and coronation of chiefs. They might be described as associations for the preservation of traditions. Every city has several of them, and they maintain altars and some-times elaborate, statue-adorned shrine houses (*posuban*) in the streets. Occasionally parades are held in which traditional attire is worn and the associations' most significant emblems, the Asafo banners, are waved. Rivalry among the various groups in a city keeps their spirit alive. In earlier centuries, clashes that led to wounded and dead were recorded. Yet when their powerful adversary to the north, the Ashanti Kingdom, presented a threat, the associations rapidly united into a formidable army. In addi-tion to an officer (*supi*) and a company chief (*asafohen*), each Asafo group has various rankings, including female officers, drummers, horn blowers, clergymen and banner bearers.

Since Western collectors have long recognized the aesthetic value of these banners, old specimens are now rare, even among the Fante themselves. Before the Gold Coast gained indepen-dence, in 1956, a Union Jack invariably appeared in an upper corner of the flag, generally sewn in appliqué technique . Yet even when double eagles and lions based on European heraldry were employed, they were tied into some narration, the eagle, for instance, picking at a snake or human being, or transforming into a monstrous legendary bird. The strength of the company might be emphasized by an automobile, airplane or lighthouse,

apart from the more traditional whale or elephant. Great vigi-lance, of which they were quite proud, was symbolized by a rooster. Yet still more popular were lively, many-figured scenes that usually had a single purpose—to boast the superiority of one's association. Adversaries were generally depicted as weak-lings and not seldom made to look ridiculous. The entire range of proverbs still popular among the Akan peoples today was marshaled in such designs.

On the present banner, the officer, or *supi*, of an Asafo group confronts three vultures with a double-pommeled sword. The Fante consider these birds dirty and disgusting. "Since vultures live from carrion and do not fight over their food," explains Kay Heymer, "they make apt symbols of cowardice and craftiness. When a company confronts their rivals with a flag of this kind, they say, 'We came to fight, but not with you, you rotten vul-tures!' A more impudent provocation is hardly imaginable." Other sayings include, "Our enemies are as easy to catch as fish with a trawling net," or "If a bird sits too long on a tree, it will catch a stone." But pieces of folk wisdom are also illustrated on the banners, such as "Power is like an egg: If you clutch it too hard, it will break; if you hold it too loosely, it will slip away."

In the Asafo banners the enjoyment of storytelling reflected in African myths and tales reaches a visual culmination. The old, ceremonial art, which had to be serious, representative and, above all, effectual, had no place for such narrative depictions. Even the eloquent speaker's staffs of the Akan with their repre-sentations of proverbs had to limit themselves to terse messages conveyed by one or two figures. With their flags, the Fante ful-filled the desire for imaginative narratives unfolded on the two-dimensional plane. The fact that they were not able to look back on a centuries-old tradition, nor were beholden to one, is one reason for the freshness and charm of these depictions.

Bibliography: Adler and Barnard, 1992; Heymer, in: Güse, 1995

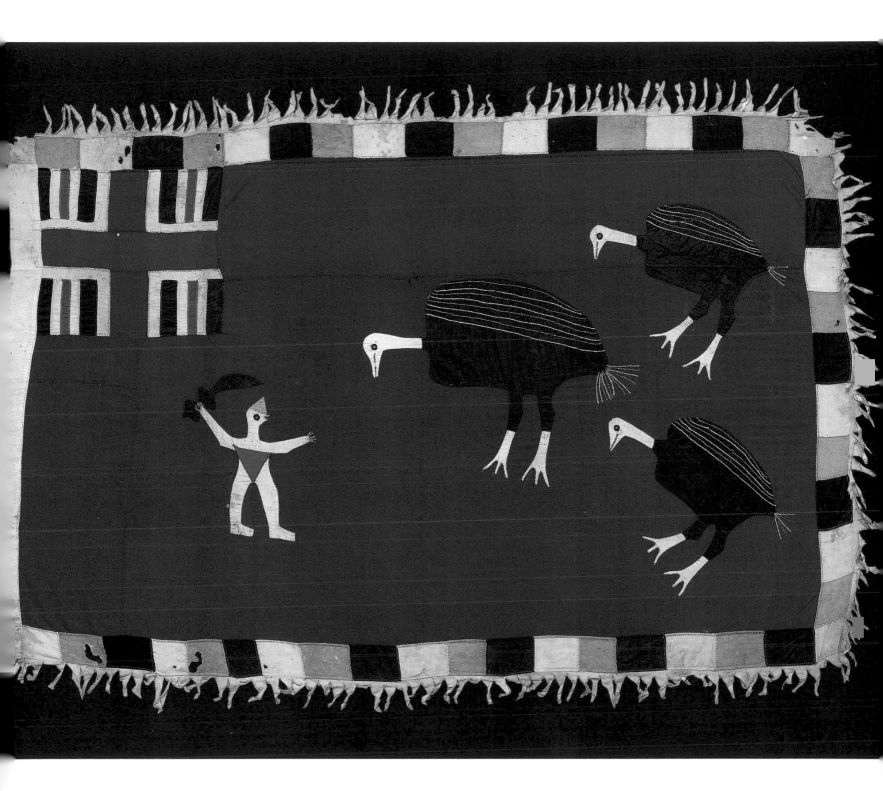

Deangle Mask

Dan, Liberia/Ivory Coast, 19th/20th century
Wood; height 24 cm
Musée Dapper, Paris

The image of African art in the 20th century was decisively shaped both by the preferences of French taste and sculpture in the Francophone colonies. In the case of masks, it was those made by the Dan in Liberia and the Ivory Coast that came to epitomize the Western notion of the African mask. Neatly and tidily separated from the fibers and pieces of material that were part of the original mask costume and then polished, many Dan masks on display in collections resembled elegant Art Deco objects. To Western eyes, they symbolized "primitive aesthetics" in a pleasing way. The secret of their success was that they were essentially anthropomorphic and carefully abstracted, and as such they became best sellers in the ethnographic trade and at auctions. There were soon more Dan masks than Dan. They became early icons of African art, giving rise to many a misunderstanding.

On account of its high artistic quality, the example illustrated here stands out from the majority of Dan masks, which are frequently overly smooth either because they are merely schematic or have been made with an eye to the art market. The closed eyes are not mere lines arranged decoratively, but convincingly convey an inner experience of the hereafter. The full lips are only slightly parted. The striking scarifications are a peculiarity of the mask: two bands of hatching running diagonally from the upper part of the nose across the cheeks, a vertical central scar across the high forehead as well as—and this is a rarity—U-shaped scarring above the eyebrows. The decorative vertical scarring on the forehead corresponds to the scarifications of Dan women in former times. The elegantly proportioned features and the gentle appearance combine to express an ideal of feminine beauty.

"The figures represented by Dan masks are manifestations, i.e. certain spirits living in the forest made visible. These jungle spirits long to be incarnated into the world of humans, in their villages. They wish to help, entertain or teach people. ... The mask spirits ask someone—in the case of the Dan always a man—to possess them temporarily to allow them to lead a visible and active part in village life." (Fischer and Himmelheber). In contrast to the runner's mask (*gunye ge*) and the fire mask (*zakpei ge*), which have striking round openings for the eyes, the *deangle* mask has an aesthetic beauty and radiates gentleness. It is found with a head covering that either stands upright or has the appearance of a helmet, has a shawl over its shoulders and wears a fiber skirt and carries around with it cows' tails as whisks. While other Dan masks—of which there are many—have law-enforcing and judicial functions, the *deangle* mask (literally: laughing, joking mask) has a social and educational role. It accompanies the boys who, following their circumcision, spend two months being educated in the bush camp. *Deangle* is responsible for providing food and a sense of well-being and acts as a link to the village. Joking with the women preparing food in the village, it requests food from them for the boys living away in the isolation of the sacred grove. *Deangle* neither sings nor dances, but makes his pronouncements in a cooing language that belongs to the realm of the jungle. Someone always accompanies the mask so as to make its sounds intelligible to bystanders.

Bibliography: Donner, 1940; Fischer and Himmelheber, 1976; Verger-Fèvre, 1985; Hahner-Herzog, in: Eisenhofer, Hahner-Herzog, Stelzig, Stepan, 2000, pp. 84, 168

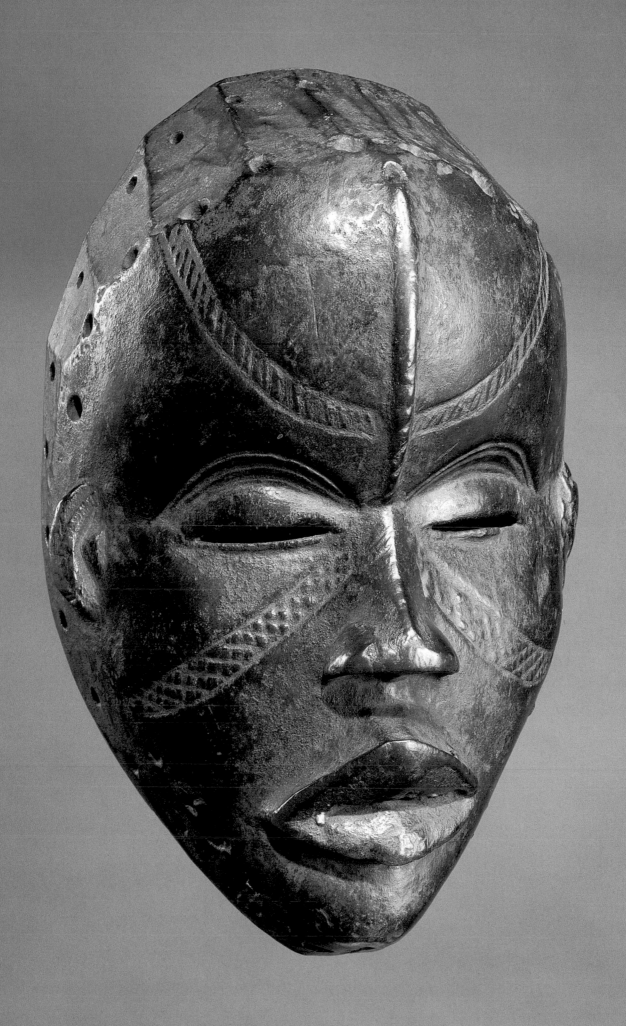

Garment of a Dignitary

Manding, Liberia, end of 19th century
Cotton and wool; 178 x 97 cm
Rautenstrauch-Joest-Museum für Völkerkunde, Cologne

Until recent years, the traditional garb known as *boubous* was a striking sight on the streets of West African villages, where Islam had triumphed almost a millennium ago. Worn with great aplomb especially by men—but also, in the more Western areas, by women—they set bright color accents against a background of Sudanese clay houses or modern urban bustle. Apart from mosques, *boubous* were the most visible sign of the presence of a religion from distant parts, which had, if not always, tolerantly made its peace with the local animistic beliefs. These garments were one symbol of this typically African synthesis. Their basic form was entirely African, as a comparison with *boubous* from Mediterranean North Africa indicates. A *boubou* is a wide-cut garment pulled over the head with broad, long sleeves. The large surface area of the material used, which in the present example consists of 15 vertically sewn strips, positively invited decoration.

Nowhere south of the Sahara has Islamic-inspired ornamentation so freely unfolded itself as in the art of textile adornment. A counterpart to the richly ornamented carpets of the North African countries, it is a two-dimensional art par excellence. In the present example, the effect of the lucid, geometric motifs on the two-tone indigo ground is compelling. The lines and color scheme of the motifs are designed to engender striking contrasts throughout. Strictly rectangular bands (in chain stitching) are set against monochrome red arcs (of European wool flannel) and enclose a fantastically interlocking pattern of squares. The linear elements are flanked by volutes and diagonal crosses.

Little more than a dozen old *boubous* of this type still exist. No low-ranking member of a West African royal court or tribal group could afford a garment like this, which a professional embroiderer spent weeks in applying ornament to both front and back. According to B. Gardi, they were probably worn by Islamized chiefs who ruled over a largely non-Islamized populace. Standing out clearly from the earth tones or indigo of average people's clothing, such *boubous* represented a highly visible profession of faith on the part of their wearers. They documented their membership in a culture of ornaments, calligraphic symbols and writing.

The official function of its wearer likely explains the frequency of motifs apparently derived from Islamic amulets on this garment. The field on the front (over a breast pocket) consisting of five circular and four square shapes apparently served the function of a magic square. A similar pattern is found on diagrams drawn on paper and sewn into leather amulets. On the right side of the breast and over the left shoulder there is a spiral motif like that seen on Tellem garments from as early as the 12th century (see p. 104). Its meaning, like that of the red arc shape, is sadly unknown. The latter, as B. Khan Majlis points out, has the appearance of a relic that was no longer understood. Embroidery techniques of the type used here (chain, festoon, feather and loop stitching) have been practiced for centuries, and many of the motifs are disseminated far beyond the region from which the garment originated.

Bibliography: Khan Majlis, in: Völger, 1999; cat. no. 2; Gardi, 2000

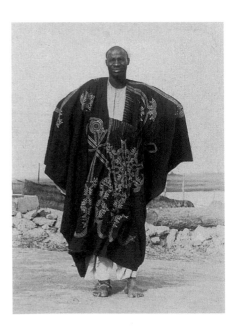

Man from Djenne, Mali, with a *boubou* made by the Soninke near Nioro, 1893–94. Photograph: Albert Rousseau. Herzog Collection, Basel.

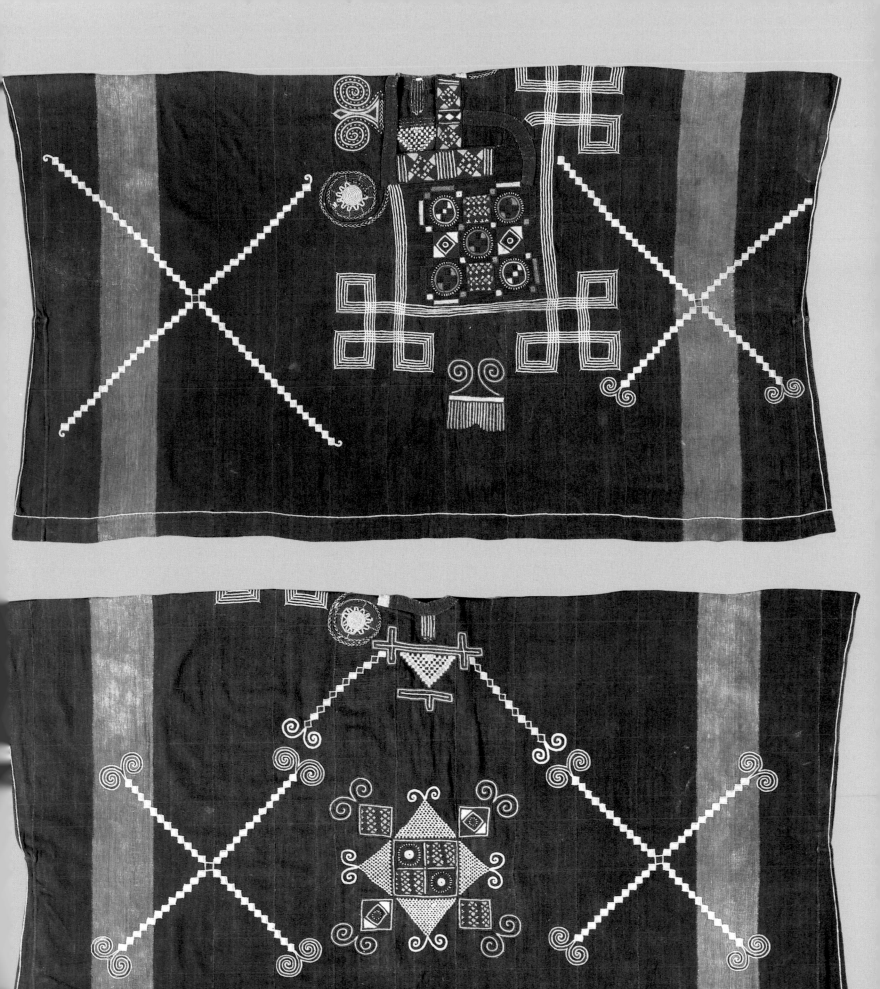

Female Figure

Master of Lataha, Senufo, Ivory Coast, early 20th century
Wood; height 95 cm
Museum Rietberg, Zurich

In addition to a variety of masks, the Senufo, who live from agriculture, fabricate ritual female statues, including mother-and-child figures, as well as statuettes depicting bush spirits and supernatural beings. Especially impressive are their *deble* figures (*poropiibele do:ogele, pombibele, pombia*). These are carved with a drum-shaped base from a single block of wood in such a way that the feet merge with the base. The *poro* society keeps them in a sacred grove and allows them to be used during funerals. The southern Senufo carry them on mourning processions in which elderly men wave them back and forth to drum rhythms and stamp them on the ground. The powers of both male and female statues are "activated" by means of such practices. Owing to this use, as well as to insect infestation, the figures' arms and feet are often worn down or missing.

As may be concluded from a comparison with two more complete figures of this type (The Metropolitan Museum of Art, New York; Musée Barbier-Mueller, Geneva), this one probably originally had arm rings and an ornament around the hips, which is still just visible. Scarifications are seen on the forehead, temples and navel. Remainders of a necklace with pendant are also detectable. The three-part hairstyle with the crowning bulge typical of the Senufo is that of an aristocratic woman.

Yet all these emblems of status pale by comparison to the enormous physical presence of the figure. The head, with closed eyes and long nose, exudes dignity, even majesty. The body is likewise a masterpiece of geometric abstraction. Torso, arms and legs approximate cylindrical forms and are proportionally quite elongated. The slender torso underscores the impression of strict verticality. Although the figure seems rooted in the base, it conveys a sense of upward thrust. Heavy breasts protrude from an arc shape formed by shoulders and upper arms. The genitalia appear to have been uncovered. On the whole, the figure's meaning can be assumed to be connected with fertility and the welfare of the community.

Like Senufo masks, such figures belong to the ritual appurtenances of the *poro* society rather than to an individual, and thus are known as "children of the *poro*." This secret society permeates the lives of the Senufo and contributes materially to maintaining the egalitarian social structure, which is not governed by kings or chiefs but organized in family groups. Many of the *poro* ceremonies and much of their paraphernalia were long taboo to non-initiates. Their tasks included the arrangement of funeral rites. In the course of such rites, the most powerful *poro* mask served to ensure the final departure of a deceased person's soul (*nyui*) from his relatives and the village so that it could enter the realm of the dead. The function of the present figure as a "rhythm pounder" was associated with this context.

It was photographically documented, together with other Senufo objects, in the early 1950s in a repository in the town of Lataha, near Korhogo. Until that date, Western travelers had been forbidden to see sacred objects of the *poro*, much less to enter the holy groves. This relaxation of rules may be attributed to the rise at that period of a new cult, which rendered the symbols of the old faith superfluous. It was not long after this that such figures found their way into Western collections.

Bibliography: Förster, 1988 and 1992; Koloss, 1990; Glaze, in: Schmalenbach, 1988, p. 82f.; Glaze, in: Barbier, 1993, II, p. 22; Garrard, in: Phillips, 1995, p. 459; Gottschalk (unpublished)

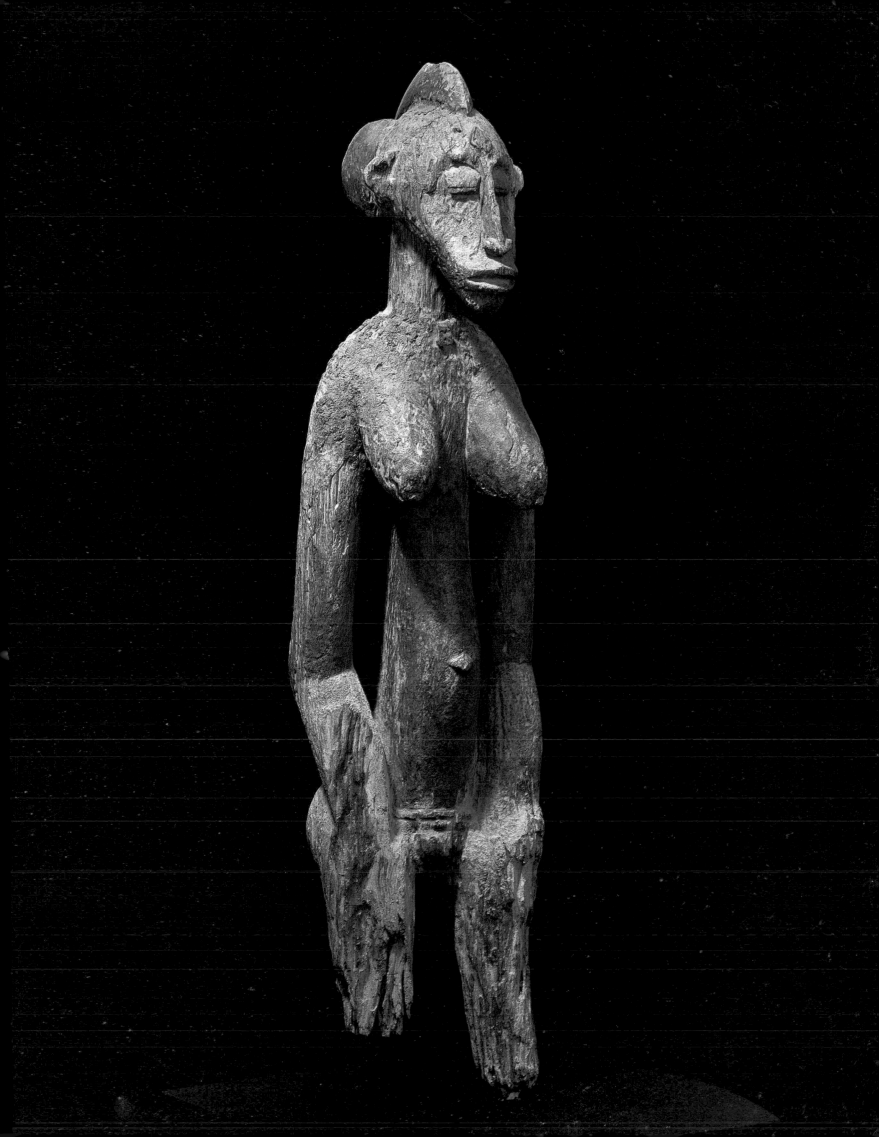

Female Figure with Child and Male Figure

Lobi Region, Burkina Faso, 19th–20th century
Wood and bronze ring; height 59 cm/66 cm
Collection of Marrilies Tschäppät, Uitikon, Switzerland

These figures represent one of the most remarkable sculptural concepts in West African art. The different sections of the body form distinct volumes. For instance, the figures' heavy, massive legs are reduced to drumlike shapes (in contrast to the Bangwa figure, p. 87). The torso, shoulders and arms are likewise treated as a unit, from which the thick short neck and round head directly emerge. Striking accents are used to set these volumes off from one another: the lines at the height of ankles and groin, and the horizontal under the chest muscles. Ankles, navel, breasts and nipples have the look of applications and are proportionately quite small, as if to underscore the compactness of the body volumes. The same is seen in the face, where nose, eyes and mouth appear carved in relief. The ears are shaped like horseshoes, opening to the front. An idiosyncrasy of these and a small number of similar figures is the continuation of the raised eyebrows around the eyes. The sculpturally reduced treatment and the tense pose of these figures lend them an athletic look.

The two statues evidently were not originally a pair, but their style is so similar that it is legitimate to present them together. A handful of further works can be attributed to the sculptor who created them. Their clarity and monumentality distinguish them from the general pattern of Lobi sculpture, even though they draw on the same basic vocabulary of form. These are definitely the works of a master. Based on the fieldwork of P. Meyer, he may have been a Puguli from the city of Gaoua. The Puguli, the smallest subgroup of the Gurunsi, enjoyed a reputation among the Lobi as highly skilled brass casters and sculptors, and their woodcarvings were much in demand. The outstanding place of these two figures within Lobi sculpture may indeed be explained by the special ethnic origin of their creator.

Meyer notes that, "For the Lobi, statues are neither works of art nor simple wooden, metal or shaped clay objects but living beings who can see and communicate with one another, who can move and—this is one of their tasks—can ward off witches and black magicians." *Bateba*, as these figure-beings are known, are ordered by the *thila* spirits sent by god to stand beside human beings and protect them from illness, hunger and death, in addition to being on hand to help with any problems that arise in everyday situations. When a Lobi goes to a fortune-teller for advice, he may be told that a *thil* wishes to be embodied in one or the other figurative shape. He will then order such a figure from a carver. The form it takes depends on what task the *bateba* is intended to perform.

The unusually large figures illustrated here belong to the category of "normal *batebas*," who "just stand there" and whose generally grim expression is meant to recognize and ward off adversities. The "eye rings" so characteristic of these figures may have served to heighten the intensity of their protective gaze, in order to recognize danger and to confront it. In the struggle against witchcraft, equal abilities were attributed to male and female *bateba*, as indeed the gender of the figures seems to play no particular role.

If one were to ask a Lobi why the female figure holds a child at her side (or why both wear a neck ring), one would probably be told that a *thil* commanded it to be so. Evidently the statue does not represent a *maternité*, a mother-and-child figure serving the purpose of veneration, nor does it depict an ancestor. The woman neither turns to the child in a motherly manner, nor does she dandle him or offer him her breast. The small, doll-like figure has the appearance of an adjunct, attached from the back at the woman's side. This large female *bateba* seems entirely absorbed in her duty to ward off evil forces. The child is perhaps an indication of the importance accorded to a woman's child-bearing role and to protecting offspring.

Bibliography: Meyer, 1981; Bognolo, in: Falgayrettes-Leveau, 2000, pp. 157–77

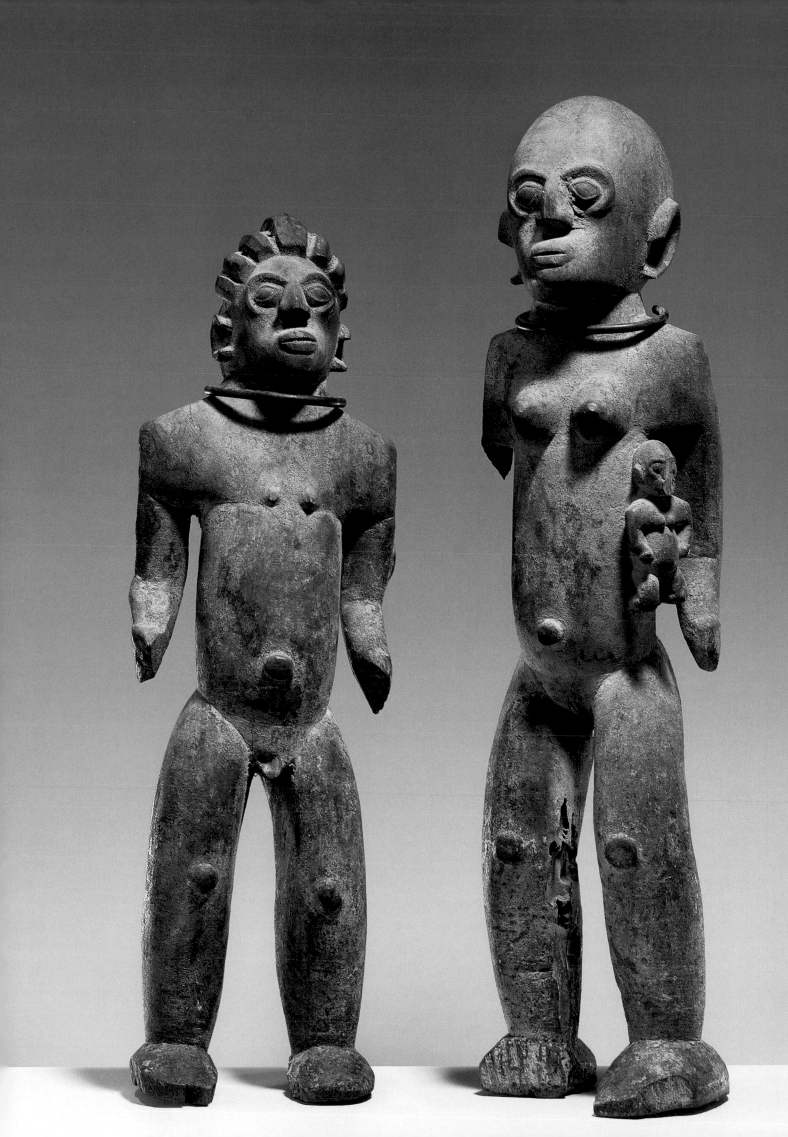

Seated Male Figure

Region of Segou, Mali, 14th–16th century
Terracotta; height 44.3 cm
Musée Barbier-Mueller, Geneva

The valley of the Niger, the third largest river in Africa, has a similar meaning for the Mali cultural region as the Nile once did for Egypt. The interior Niger delta on the southern rim of the Sahara experiences seasonal flooding that ensures cyclical irrigation and natural fertilization of the fields, in which the herding peoples' cattle, sheep and goats graze. Thanks to the river's navigability, trade and commerce have long burgeoned, and its abundance of fish provides a further important source of food.

Over the centuries major cultures have arisen on both banks of the Niger, although today they can be studied only by archaeological methods. Their names derive from the locations where diggers—for the most part plunderers—have made finds: Bankoni, Segou, Tenenkou, Djenne-Jeno, Gimbala and others. Each of these regions produced a distinctive style of art. An abundance of terracottas, and some bronzes, bear witness to the existence of a highly developed sculptural art. Many of these works can be read as an expression of an autochthonous, animistic religion, and thus document the coexistence in West Africa since the turn of the millennium of advancing Islam and earlier forms of belief.

The majority of the terracottas found originate from Djenne-Jeno. Many are depicted with snakes creeping up them, an indication that the place was likely the center of a snake cult. Figures covered with boils would suggest that one reason people gathered in Djenne-Jeno was to heal their afflictions. Consequently, the figures might well have had a votive character. Many of them are depicted in a crouching pose, with arms and hands in various positions: the hands might be resting on the knees, folded or placed over the heart; the arms are frequently crossed over the breast (see illus. on this page). Most of the persons depicted hold their heads high in an attitude of reverence. Terracottas portraying mothers with a child in their lap, riders or people so emaciated that they are merely skin and bones, have also been found.

The wonderfully preserved figure illustrated here does not come from Djenne-Jeno but from the region of Segou farther west. The seated figure's lower legs are extended to the side and his hands are resting in a relaxed manner on his left leg. This quiet, expectant pose is quite different from the commanding pose of the "Tada Figure" (see p. 71), which can be dated somewhat earlier. The male figure is clad in a hip cloth and wears a heavy bracelet on each wrist. Wound around his neck like a necklace is a snake. As to the facial type, the figure does not so much recall the stylized, masklike and ornamental Djenne-Jeno heads with their wedge-shaped, protruding eyeballs as it does the zoomorphic figures of Tenenkou (especially around the mouth). The smooth modeling would seem to confirm this. The figure differs fundamentally from those of Segou, whose costuming lends them a rather grotesque appearance. It therefore holds a special place in the medieval figurative sculpture of Mali, an observation that also applies to the artistic quality of the piece.

Bibliography: de Grunne, 1980; *Vallées du Niger*, p. 2f.; Garrard, in Schmalenbach, 1988, p. 58f.; Garrard, in: Phillips, 1995, pp. 488–95; Schaedler, 1997, pp. 32–69

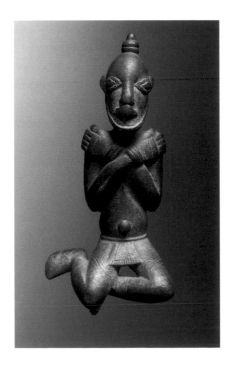

Pendant, Djenne, Mali, bronze,
Musée Barbier-Mueller, Geneva

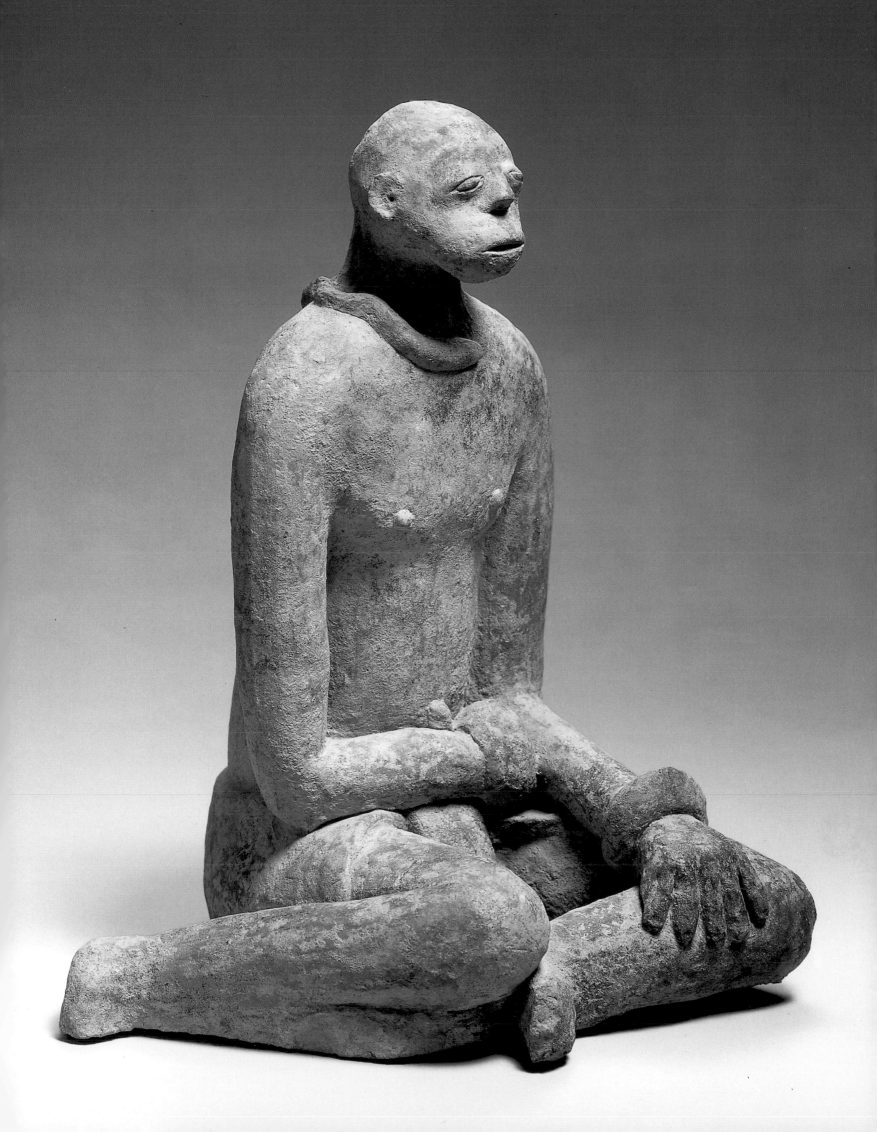

Figure with Raised Arms

Dogon, region of Tintam, Mali, ca. 16th century
Wood, heavily patinated; height 98 cm
Museum Rietberg, Zurich

The Dogon, an agriculturalist people of southwestern Mali, owe the fine preservation of works from their centuries-old sculptural tradition to a topographical feature. They live immediately alongside the Bandiagara escarpment, a kilometers-long overhanging cliff in which their sacred sites and necropolises are protected from the elements. In the first millennium the Toloy settled there, followed by the Tellem, who eventually merged with the Dogon who migrated there in several waves, beginning over 700 years ago. Many old Dogon figures might actually be the work of the Tellem, especially as motifs of the cult and art of this old established culture were evidently passed on to the newcomers.

One such motif was a figure with raised arms, which might be seen as a gesture of supplication and pleading, perhaps for rain for the crops, or for help in warding off enemies, conceiving children or healing the sick. Recent authors tend increasingly to interpret these figures with raised arms as representing ancestors responsible for the welfare of the community.

We are confronted here by a high-ranking personage who has both breasts and a beard—a hermaphrodite figure. In the eyes of many peoples of this region, god encompassed both sexes, and such depictions were quite common, especially among the Dogon. We also find numerous representations of couples seated next to one another with their arms around each other's shoulders, a symbol of balance between the genders. The only other country in Africa where corresponding double figures occur is Egypt. Other signs of the high position of the person represented are the rings around the wrists and upper arms, and the necklace of flat beads or amulets. The headdress is that of a male chieftain. The figure's left hand is extended, while the right is closed in a fist.

Stylistically, it evinces subtle transitions and a preference for rounded volumes. This organic approach differs from the more angular style of groups in southeastern Dogon country. "Dogon" is a blanket term applied to linguistically and topographically diverse ethnic groups. The different periods of migrations into the area and different degrees of Islamization also ensured the diversity of their art. According to Wolfgang Lauber and Hélène Leloup, the organic style in sculpture corresponds to the primarily circular ground plan of the village houses on the western plateau, while the more abstract, geometrical figure style reflects the rectangular house plans of the southeast.

The Dogon made regular offering to figures such as this one, pouring barley mush over them or rubbing them with other substances, which explains the heavy patination seen here.

Bibliography: Schmalenbach, 1988, cat. no. 7; Leloup, 1994, cat. no. 104; *Dogon*, 1994, p. 90; Homberger, 1995; Lauber, 1998; Schneider, in: Völger, 1999, cat. no. 3

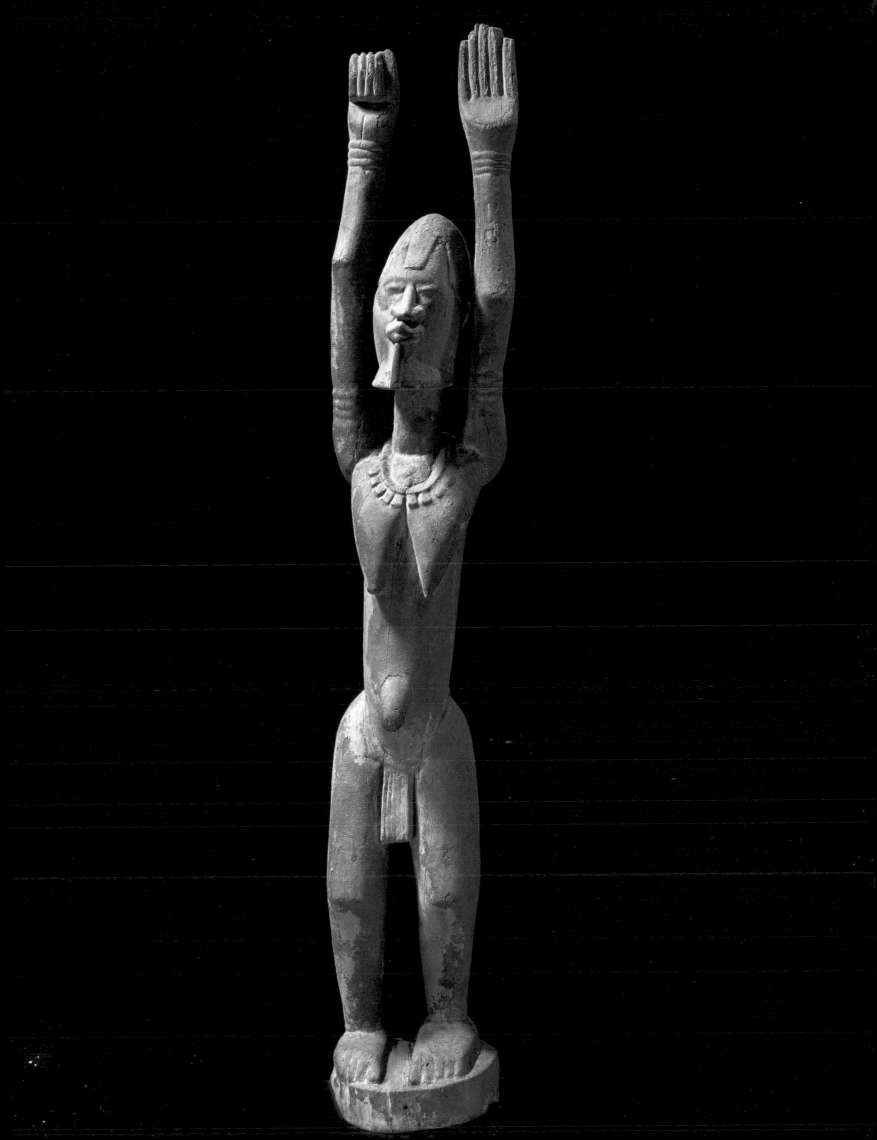

Figure of a Warrior

Dogon, Mali, 19th–20th century
Iron; height 81 cm
Koenig Foundation, Landshut

Slender as a length of yarn, this masterpiece of abstraction belies every notion of the crude earthiness of African art. The figure is so matter-of-factly elongated and its limbs so confidently reduced to a minimum that it would appear that the human figure never had any other shape. More like a drawing in space than a sculptural volume, the figure stands tall, exuding pride. Despite his fragile appearance, there can be no doubt that this warrior armed with spear and shield is capable of performing his mission. The shape of the torso, no thicker than a heavy wire (8–12 mm), continues without transition up into the neck and down into the lower limbs. The wiry, abbreviated legs and feet were designed to be stuck into the ground. The gentle curve of the figure evinces a noble gesture and lends it dramatic tension.

While bronze is cast and usually requires the fabrication of a wax model, iron is forged in a red-hot state, in a direct physical involvement with the material—a fundamentally different process. Both metals are known to have been worked in sub-Saharan Africa as early as the first millennium BC (see p. 64).

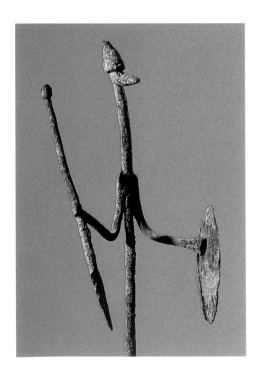

The present warrior's torso was made by repeatedly hammering and stretching a cylindrical mass. The arms were forged on, the shield riveted on and the spear was likewise added separately. The beard shape—an attribute of dignitaries—was welded into a small cleft. Thus this work of art consists of six parts.

Now, a woodcarver's ideas are naturally limited by the shape of the block, which dictates, for instance, that the extremities of a figure must lie quite close to the torso. An ironsmith, by comparison, has a greater range of positions and movements at his disposal (although admittedly certain restrictions are posed by the higher cost of iron). African smiths have obviously enjoyed exploring the design possibilities inherent in their material, taking anatomical form to the point of distortion, and plastic complexity to the verge of the fantastic and bizarre. The figure-staffs of the Yoruba and Bamana, up to two meters in height, are further striking examples of this exploration.

Although depictions of infantrymen are almost unknown in the wood and bronze sculpture of the Dogon, depictions of cavalrymen are quite common. Our standing warrior may therefore represent a subject typical of the material chosen. Men bearing a shield and spear—these were none other than the Dogon themselves, who entrenched themselves in their cliff bastions to ward off the attacks of enemy cavalry. Their defense was so successful throughout their history that they repeatedly eluded both slave traders and forced Islamization. The aesthetic compellingness of the present figure rests on the manner in which the smith brought the requirements of material and technique into perfect accord with his artistic idea.

Bibliography: Leloup, 1994, p. 545f.; *Dogon*, 1994, pp. 189–92; Hoffmann, in: Phillips, 1995, p. 512; Eisenhofer, Hahner-Herzog, Stelzig, Stepan, 2000, pp. 34, 161 (with bibliography)

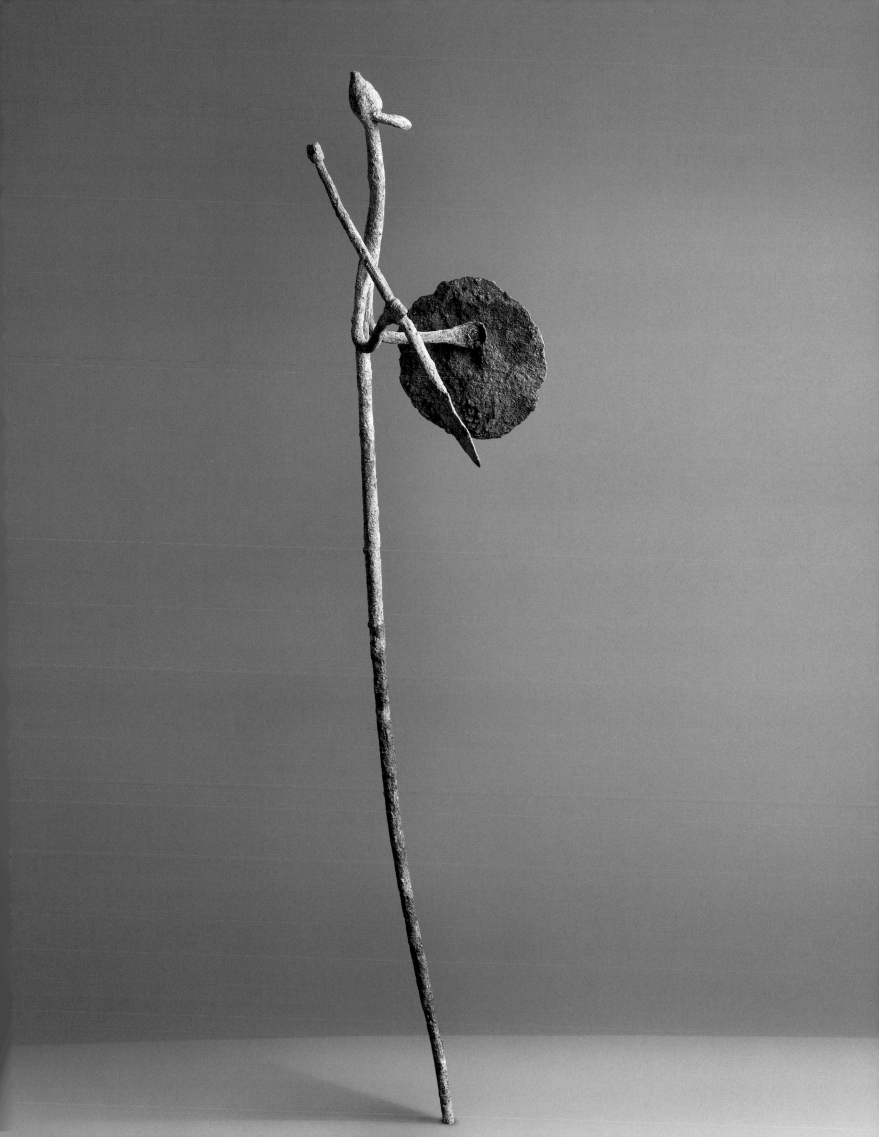

Kanaga Mask

Dogon, Mali, 19th–20th century
Wood, leather and fur cords and bast net; height 115 cm
Musée Barbier-Mueller, Geneva

The performance is among the most thrilling in all Africa: forming straight lines, the *kanaga* masqueraders dance with powerful, ecstatic movements to the rhythm of the drums. In strict synchrony the great cap masks dip and plunge almost to the ground. In view of the dynamism of the dance, it is no wonder that old *kanaga* masks are hardly to be found intact, since broken parts were continually replaced. While the section of the mask tied over the face consists of a carving in the round, the superstructure is made of flat planks, laced together in a rectangular arrangement. Painted in highly contrasting white, black and occasionally blue, this "assemblage" is visually very effective from a distance.

It is not hard to recognize an abbreviated human figure in it. Yet, according to another interpretation, it represents a bird, *komolo tebu*, a bustard, whose belly and wings are white. It is said that it was shot by a mythical hunter who depicted it in the form of such masks. The spectacular structure of the mask however could also be seen to symbolize a water-boatman, a god's hand, a punished fox lying on its back pleading to be forgiven for its wrong doings, etc. French ethnologists have not tired of gleaning ever more imaginative explanations from the *Dogon*.

The head piece of this *kanaga* assumes a boxlike shape that is likewise dominated by right angles. The nose is reduced to a long board, and the "nostrils" extend the full width of the face.

Beneath them is a cone that represents chin and mouth. The eyes are trapezoidal apertures. Two horns emerge from the helmet-like forehead, probably representing those of the oryx antelope, the mythical primeval ancestor of the Dogon. The two figures in the middle of the top plank of the superstructure are also linked with the complex mythology of the Dogon. They represent one of four pairs of twins of both sexes, children of the mythical creator of humanity, Nommo, who brought them into the world on an ark together with an antelope and other creatures. Simple *kanaga* masks tend to have either animal motifs or geometrical decorative elements on this part of the structure, if at all.

Anthropomorphic and zoomorphic features hold the balance in this *kanaga* mask. Of the more than 70 Dogon mask types that are donned at a variety of festivities, the head piece resembles the *walu* mask, some *samana* and antelope masks. Depending on the precise region, considerable variations can be found. This mask most probably originates from Sanga. *Kanaga* masks appear at the *dama* memorial celebrations for the dead, held by the *awa* association every five years, as well as during the *baga-bundo* rites, which immediately precede the burial of a man.

Bibliography: Griaule, 1938; De Mott, 1979; Homberger, 1995, cat. no. 85f.; Hahner-Herzog, Kecskési and Vajda, 1997, plate 7; Doquet, 1999; Ndiaye, in Bilot et al., 2001, pp. 110–117

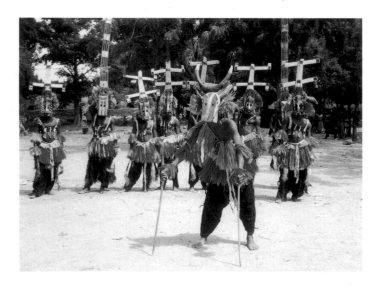

Masked dancers in the country of the Dogon, 1998. Photograph: Monique Barbier-Mueller

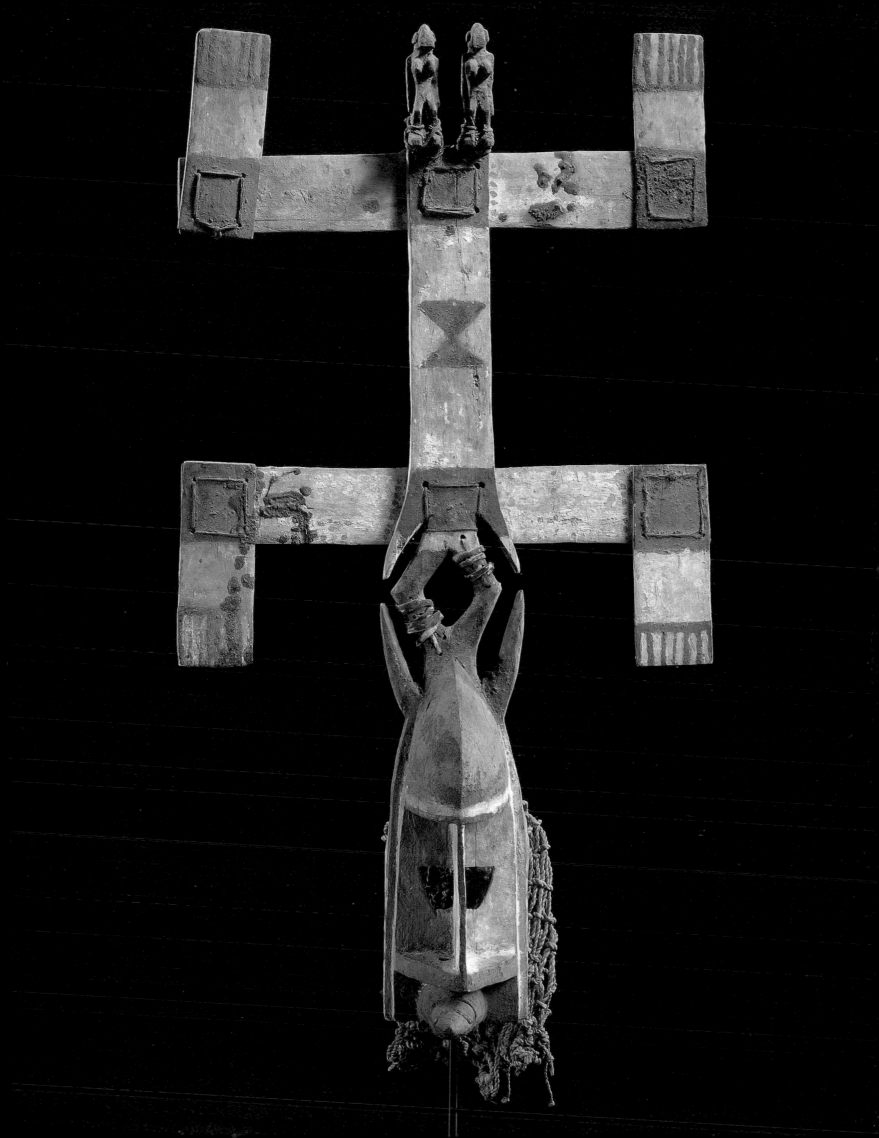

Mother and Child

Bamana, Mali, 19th–20th century
Wood; height 123.5 cm
The Metropolitan Museum of Art, New York, The Michael C. Rockefeller
Memorial Collection, Bequest of Nelson A. Rockefeller

For many Bamana, this mother figure is the embodiment of Faro, the goddess of water and mother of all mankind. As an androgynous entity, Faro also has male features. She manifests herself in rain and rainbows, or thunder and lightning. In other Bamana regions the figure is a representation of Musokoroni, likewise of divine origin and the first magician. In other places the mother figure is also seen as an ancestor, endowed with powerful magic.

The figure shown here, which comes from the southern Mali region around Bougouni and Dioila, radiates great maternal and ritual authority. Full of profound solemnity, the woman has her eyes closed, her hands firmly grasping the child by the back and clasping it to her belly. Only details of her jewelry, which underlines her status, break the overall absolute symmetry (she carries a dagger strapped to her left arm as a symbol of her ability to defend herself).

Although this is a seated figure, the body proportions are characteristically almost "Gothic" in their elongation, with long upper arms, heavy pendant-like breasts, a long neck with trailing strands of hair and an erect head with a steep *bamada* cap. On this we find representations of amulets and horns filled with magical substances—symbols of her supernatural powers. The figure's simple forms and smooth modeling, which is brought out all the more clearly by the few linear edges, contribute to the impression of a highly hieratic aura. Such figures used therefore to be interpreted as queens. Though this is not wholly appropriate, it conveys the majesty of its appearance.

Among the Bamana, mother figures have less to do with their six known initiation sodalities than with the *do* (also: *yo*), which is possibly the oldest society of this people. According to Y.T. Cissé, the *do* ("secret") was an important institution not only among the Bamana but also among the Marka, Bozo and Somono people in the Segou, Ke-Massina, San and Djenne regions. In certain areas, three figures stand at the heart of the *do* cult: a male figure (*do fa*), a female or mother figure (*do ba*) and a girl figure (*do nyeleni*). The figure of the "father of the *do*" features

the enthroned creator god, usually with a sword or spear in his right hand and a horn of consecrated oil in his left hand. The "chosen girl of the *do*" is endowed with all the signs to indicate her marriageable age. Finally, the "mother of the *do*" is shown likewise seated on a throne. She is depicted as pregnant, holding her hands beneath her breasts and to this extent presenting them to the viewer. She often appears with a child, who is always a boy, either on her back, her lap or—as here—clasped to her belly.

Female figures played a particularly important role during the fertility rites of a sodality closely related to the *do* called a *gwan*, in which women were members and occupied important positions. The female figures helped women become pregnant and bring children into the world. The figures themselves were generally not ritually sacrificed. Independently of this, in many places the trio of figures was also publicly displayed by the Bamana in the course of major festivals. For this purpose, the sculptures were ritually cleaned and rubbed with oil. In a more explicitly cultic context, among the Marka, for example, the father and mother figures are permitted to be seen only by initiates. They are set up only at night in the sacred grove and illuminated with wick lights. "Sacred songs are sung in their honor, including '*Yeelen, yeelen*' (Light! Light!), a celebration of love, . . . the spirit, knowledge and virtue, which are equally the qualities that distinguish Faro and her twin brother Bemba. Unanimously considered God's deputy on earth, it is her duty to lead mankind along the path at the end of which Matigi awaits, lord and master of all things" (Y. T. Cissé).

Within a society comprehensively dominated by men, such as the Bamana—polygamous, patriarchal, patrilineal and patrilocal—the religious needs of women found articulation within the framework of the *gwan*. The sculpture of the mother and child is an expression of the dignity of this female spirituality.

Bibliography: Zahan, 1974; Ezra, in Vogel, 1981, p. 26f.; Ezra, 1983, 1986, p. 22f.; Imperato, 1983, pp. 46–49, plates 5–7, 27; Cissé, 2000, pp. 150–53

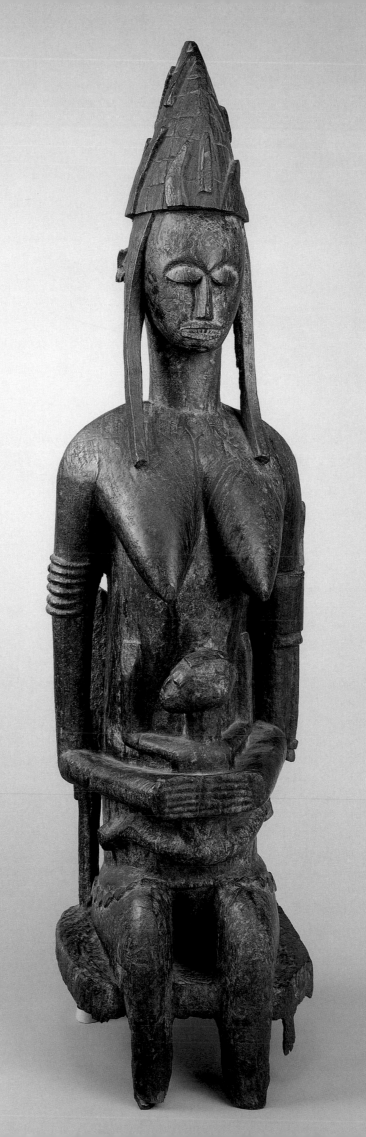

Tyi wara Masks

Bamana, Mali, 19th–20th century
Wood; height 87 cm/66 cm
Collection of Alain Schoffel, Rouziers de Touraine

The wearing of such masks by the Bamana is closely associated with the agricultural cycle. This farming people live in the dry savanna bordering on the southern Sahara, a zone subject to the crass fluctuations of the dry and wet seasons. The timely beginning of the rainy season and sufficient precipitation during the growing period are essential to ensure that there will be enough food for the entire year. In other words, the Bamanas' lives and survival are intimately dependent upon the vicissitudes of climate. After months of searing heat, the rains usually set in in May, and the farmers begin to till their fields.

Men who work their fields persistently and untiringly and bring in a good harvest in the fall are highly respected among the Bamana. They are known as *tyi wara* (literally "a wild animal of farming"). Their mythical primeval predecessor was the eponymous culture hero, half human, half animal, who taught the Bamana how to till the fields. Gifted with magical powers, he even allegedly made corn and barley grow from weeds. Tyi Wara's memory is kept alive in the Bamana *boli* altars, elements of which were reputedly present at fertility rites held on the fields. According to P. J. Imperato, the custom of dancing masks at these rites is only a few generations old. Originally they appeared out of the public eye, in secret ceremonies arranged by members of the *tyi wara* society. Later this taboo was relaxed, and non-initiates, women and children were also permitted to see the masks. The dancing continued to serve the purpose of an invocation of Tyi Wara, in an attempt to gain his blessings for the crops.

It was only in a later phase of this gradual secularization process that *tyi wara* mask dances came to be understood as festivities, where drums were played and the girls sang songs to encourage the young farmers' efforts. Hoeing contests were one occasion for their appearance; another was community work in fields belonging to the village by a young people's association known as *ton*. In fact in many places the *ton* has since taken over the role of the *tyi wara* society in carrying on the tradition, if it has not vanished entirely.

The *tyi wara* masqueraders, whose face and body were entirely hidden by costumes made of plant fibers, always appeared in pairs, wearing a male and a female headdress mask. Both mask types consist of brilliantly stylized animal forms. While the male figure is based on the powerful roan antelope (*hippotragus equinus*) with its massive, backward-curving horns, the female mask goes back to the slender oryx antelope (*oryx gazella beisa*) with its long, pointed horns. The animals' bodies are reduced to a stool-like configuration above which rise a tensely curving neck and a wedge-shaped head. Characteristically, the headdresses take the form of flat silhouettes and have the graphic effect of reliefs. When danced, they convey to viewers a fascinating oscillation between full side view and narrow front view.

Although the ancestor Tyi Wara was the son of a snake, the antelope (like the pangolin and aardvark in related mask types) took on prime significance. Fast and powerful and difficult to hunt, it was an ideal animal for farmers to identify with. Antelope masks, appearing in pairs like a small "family," became an agricultural symbol intimately connected with marriage and procreation.

The different appearance of the two antelope species was skillfully employed by *tyi wara* carvers to evoke the contrast between the genders. The attributes of the male mask generally include a broad neck with a mane of ornamental bands in tracery work, a commanding head with long ears and sometimes, but not always, a phallus. The female mask features a gracefully shaped neck, head and ears and a relatively small, young foal perched on the mare's back. Within the typology outlined by D. Zahan, the male figure shown here, with its neck of three openwork bands (some masks have up to six) and its finely balanced rhythm, occupies a middle place. The female figure has gentle contours and a verticality that is well-nigh archaic in effect. An iconographical idiosyncrasy is that the head of the foal looks at the mother while moving in the other direction, as if the sculptor had toyed with the motif of youthful disobedience.

Bibliography: Imperato, 1970; Zahan, 1976 and 1980; Zahan, in Vogel, 1981; Brink, in Vogel, 1981; Roberts, 1995, p. 81f.; McNaughton and Attenborough, in Phillips, 1995, p. 501f. (with bibliography); Cissé, 2000, p. 141f.

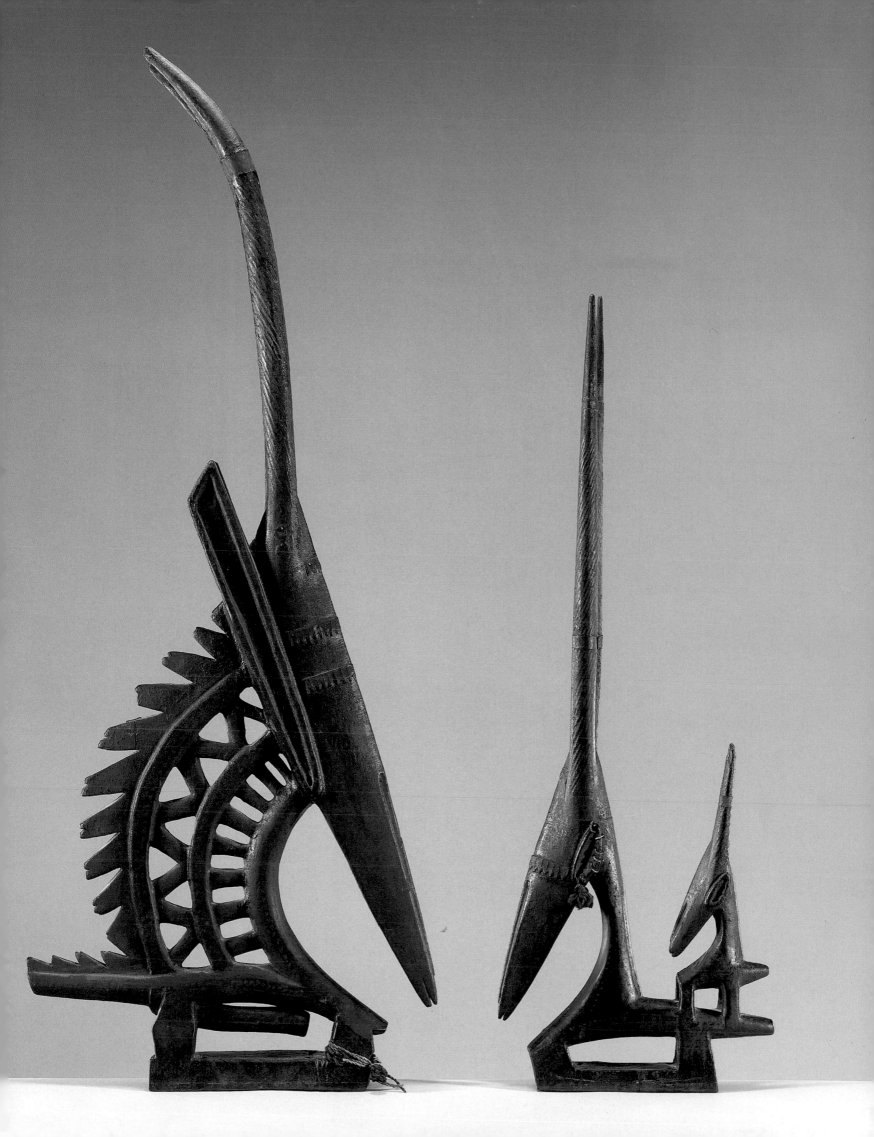

Male Figure with Shield and Headdress

Eastern rim of Aïr Mountains (south of Adrar Bous), Niger,
end of the first millennium BC
Petroglyph, chiselled; height approx. 80 cm

If it were not for such images carved in rock, who would suspect that large game once roamed the Sahara, that enormous herds of cattle grazed there, that water flowed in the rivers and wetlands were not uncommon? The human inhabitants of the area, already a motley mixture of peoples, lived from hunting and fishing. The art they left behind on the rocks reveals to us the miracles, but also the agonies, of life in an increasingly desiccated land. One witness to the inexorable desertification of the Sahara was the horse. By the time horses were introduced, in the middle of the second millennium BC, the great lakes had already gone dry, and many tribes had left the core region of the Sahara. Their exodus, which continued for many centuries, took them mostly to the rainy south. Behind them in the steppe they left the heavy stones and pestles they had used to grind grain, as well as the imagery carved in the rocks by their ancestors.

The present engraving of a figure bearing a shield is relatively recent, dating from toward the end of this "Horse Period" (1500 BC—the birth of Christ). By the time it was made, rock art in the Sahara could already look back on an almost 9,000-year history. In the valley of the Niger to the south, cultures concurrently flourished that produced highly developed terracotta sculptures (see p. 64f.). While in the preceding "Cattle Period," scenes from everyday life, courting and hunting were depicted in great detail and representations of various animals—especially cattle—and of ritual practices were common, this enjoyment of storytelling drastically waned with the onset of the "Horse Period." The social circumstances had also radically changed. Mediterranean groups had migrated from the coast of Libya to the central Sahara, penetrating the Aïr Mountains, where they gradually asserted their dominance. Horse-drawn war chariots were their status symbols. Against this background of rapid change in social structures in the direction of a more rigorous organization based on a strict hierarchy, the character of the indigenous peoples' rock art soon changed as well.

From this point on human figures began to be rendered in a highly schematic manner, with a body in the shape of a double triangle and the head often reduced to a mere stick. Instead of dynamic scenes, static, iconic depictions predominated. Figures with bent arms were engraved on rocks and cliffs time and again. The motif of a human figure with horse became veritably stereotypical. The image shown here stands out from this series of "status depictions" not only for its artistic quality but also its unusual size.

The frontally depicted figure is not only defined by a contour line; its entire surface has been worked with a stone chisel. The torso is decorated with an elaborate pattern of negative shapes in which the original stone surface shows through. As its vertical arrangement would suggest, the pattern probably does not represent body painting but the elaborate decor of an article of clothing, an emblem of prominent social rank. This impression is underscored by the plumes on the headdress and the long pendant earrings. Despite the fact that the figure's hips are quite prominent and the upper body slender, it represents a man. In connection with rock art of this type, K. H. Striedter has spoken of "ideographs" and traced a development from realistic representation toward a more abstract conception, a picture-writing analogous to that of Egyptian hieroglyphs.

It was not long until the increasingly hot and dry Saharan climate proved detrimental to horses, which were supplanted by dromedaries. Another brief chapter in the history of rock art began. It was to be its last.

Bibliography: Striedter, 1984

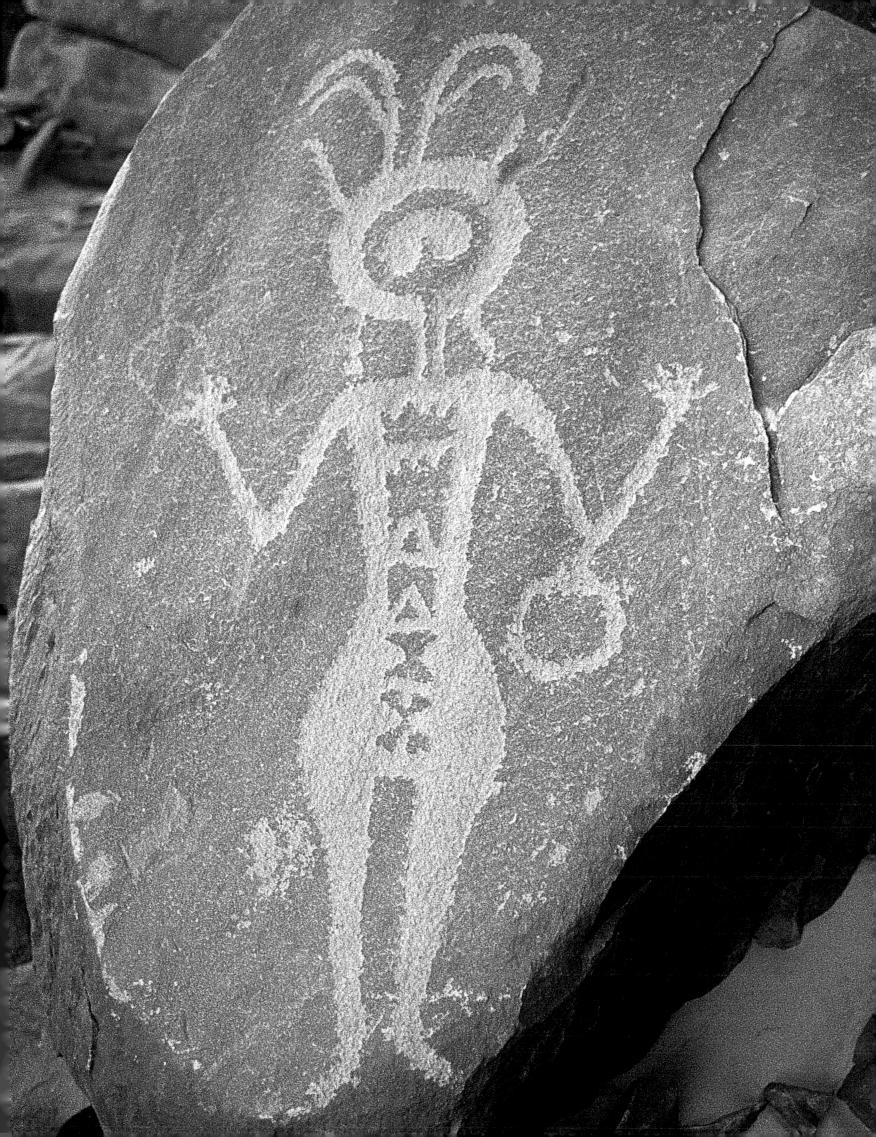

North Africa

In the millennia in which rock art flourished the Sahara was not a barrier but a fertile region providing a place and means of existence for many peoples. Economic and cultural influences passed unchecked from south to north and vice versa. Once the lakes began to vanish, in the fifth millennium BC, migration toward the Mediterranean or the southern rain forests was inevitable, and is to some extent still taking place. The Mediterranean countries of Africa—Morocco, Algeria, Tunisia, Libya and Egypt—thus acquired their overall cultural character from ancient Mediterranean cultures and those of the Near East. Influences continually passed southward across the Sahara from the north. Thus the horse was introduced from North Africa from the 15th century BC, while in the sixth century the dromedary followed suit, slowly spreading across the Sahara. From the eighth century AD, parts of West Africa were converted to Islam from the north, with many ethnic groups fleeing, even in subsequent centuries, to avoid forced conversion. At the end of the 16th century, the Sultan of Morocco conquered flourishing Timbuktu, putting an end to the Songhai Empire. The fair-skinned Berber Tuaregs kept black slaves right down to these southern outposts (Bella).

Successful resistance to Islam occurred not just among numerous groups in West Africa but in the north as well. There it was the non-Arab Berbers, constituting an autochthonous population, who withdrew to the mountains and remote desert regions. Of the Maghreb countries, Morocco has the highest proportion of Berber populations. While an international Arab culture developed in the fertile plains and towns, the old traditions persisted in the Rif and remote regions of the Atlas Mountains, even when the conversion to Islam later took place. Berber art is notable for its resistance to facile ornamentation and urbane elegance. It was an art practiced in and for the family; pieces were sold only rarely. Berber women of the mountain villages made their own carpets and, like their sisters in Kabylia in northern Algeria, made pottery intended for household use. Berber jewelry is a special case in that, for religious reasons, metalworking was preferred to be left to other peoples, such as the Jewish goldsmiths who migrated there from Andalusia from the late 15th century, bringing a variety of developed techniques with them (cloisonné, niello, etc.) and taking silverwork in Morocco to new heights. The example of jewelry shows what is true for other genres as well, and not only in Morocco: cultural and ethnic symbiosis enriches artistic sensibilities, sharpens aesthetic perceptions and, by means of creative dynamism, achieves more than individual cultures are capable of in isolation.

Zarbia Knotted Carpet

Mrabtine, region of Rehamna, Morocco, ca. 1930
Goat hair (warp), wool (weft, pile), aniline dye;
490 x 180 cm
Private collection, Zurich

Weaving and knotting are a common technique of textile-making in the Oriental cultural region, used to lend simple cloth additional density, opulence and rich decoration. In North African countries knotted carpets are found both among indigenous Berber groups and in the urban centers more strongly influenced by Islamic and Ottoman art. South of the Sahara, the raffia plushes of the Kongo and Kuba have a certain affinity with these carpets (see p. 27). They are not knotted but are of pile cloth.

Morocco's non-urban carpets come from farming or nomadic communities whose economy rests on self-sufficiency. Consequently, they are traditionally made of wool, not however by specialized artisans but by the women themselves, and solely for their own use. Unlike the strongly Arabianized cities of Morocco, where complex geometric patterns are preferred, ornamentation in the village regions between Rif and Anti-Atlas is indebted to a much older tradition. The Neolithic and ancient formal heritage, the sense of design possessed by groups that have lived in the area since time immemorial and tribes that migrated there over the centuries, have combined to produce a vital world of forms and symbols which have survived on one of the oldest textile culture-levels of mankind.

Carpets from the plains around Marrakesh, Morocco's key carpet center, exhibit an especially great variety of designs. In the region of Rehamna live both the indigenous El Rherraba and the El Araba, who have migrated there since the 16th century and whose culture bears strongly nomadic traits. This group includes the Mrabtine, a Rehamna ethnic group, from whom the carpet illustrated originates. The original Berber population has been absorbed in these migrant groups.

Rehamna carpets are generally about four meters in length, coarsely textured and principally red, a color that until the 19th century was derived from the root of the madder vine. The Mrabtine, by comparison, used a red closer in tone to the bluish-red of cochineal (an insect-derived dye from the Canary Islands employed from 1870 to 1900 in both rural and urban areas of Morocco). In addition to monochrome carpets in gradations

of red (*qtifa*) there are carpets known as *zarbias* with white, and earlier white and blue, decor, which in the present case has a surprisingly abstract, freeform effect. All orientation to the horizontal-vertical grid appears to have been abandoned. Avoiding straight lines, the weaver created a pattern dominated by plant forms that recall sheaves of grass, shrubs and reeds. Along the sides run two zigzag bands, the right of which seems to fade away toward the top—perhaps symbolizing a watercourse. Characteristic of Rehamna carpets is the sawtooth edging of black goat's wool used to strengthen the long sides, and the kelim bands along the narrow sides. An especially delightful feature of this piece is the way in which the light lines approach the sawtooth edge as if to run under the frame. Rarely does the graphic pattern of a carpet so closely approximate the character of a freehand drawing.

The motifs of Rehamna carpets pose riddles, even to field investigators and experts in symbolism, as K. Minges reports: "Interviewing the weaver, who usually keeps her own carpet, yields no certain information for several reasons. She will only reluctantly admit her 'superstition' to an outsider, because the Imam has already reproached her with it often enough. She will not wish to speak in front of men, since many of the symbols stem from a collective female code. Perhaps she even no longer knows the significance of the signs she learned from her mother, or doesn't believe in them and will invent explanations. But even if she firmly believes in the symbols, she knows that their magic will vanish if one talks about them."

Interviews conducted by researchers, the Korolniks, indicate that the design on the present carpet may represent irrigation canals like the *seguiaoko* in Saharan oases. Members of the family in whose possession it formerly was described themselves as descendants of the people who were responsible for irrigation in the oases and functioned as "rainmakers." They traced their lineage back to Saharan Bedouins.

Bibliography: Fiske, Pickering and Yohe, 1980, pp. 155–71; Pickering and Yohe, 1994, pp. 38–41; Ramirez and Rolot, 1994; Spring and Hudson, 1995; Jereb, 1995, pp. 40–71; Vivier and Erzini, in Phillips, 1995, p. 572f.; Minges et al., 1996; Korolnik, 1998; Rainer, 1999

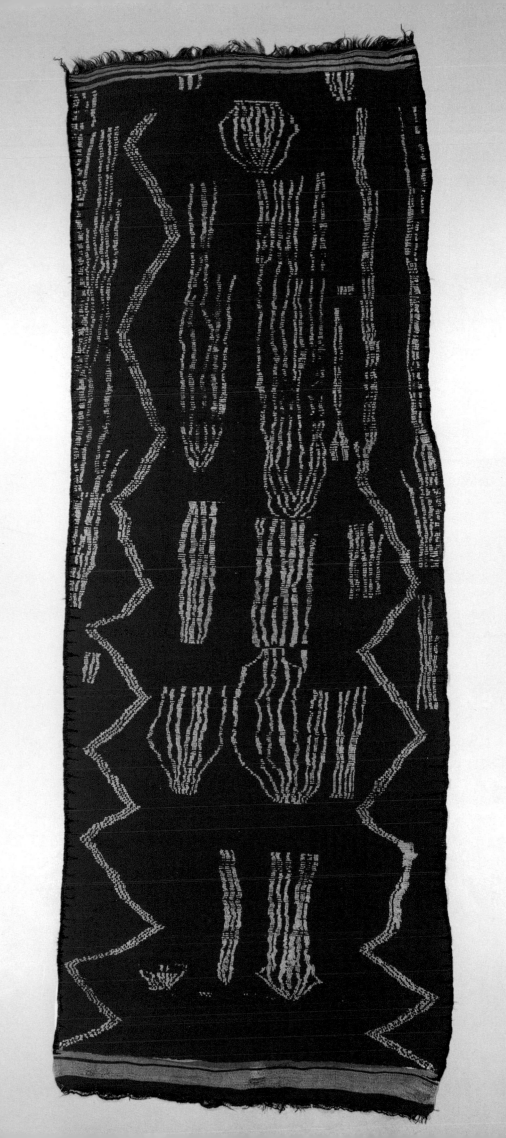

Fibulae with Connecting Chain

Western Anti-Atlas Mountains, Tiznit, Morocco, 20th century
Silver, cloisonné, glass, coins; overall length 147 cm
Musée Barbier-Mueller, Geneva

Fibulae are among the oldest ornaments for garments known. At the front of the body, they keep both sides of a cloak or a shawl closed and have always been made into ornaments. Fibulae (tachlalt) are part of every Moroccan woman's trousseau. As there are always two pieces to hold a cloak or loose garment at the shoulder or lower down, the equally elaborately worked connecting chain lends the overall ornamentation the appearance of a necklace.

On account of its unusually large size, the equally high value of its materials and the richness of its decoration, the example shown here is very much a luxury item that was not used as everyday jewelry, but was worn on special occasions only. Ownership of such an item indicated high social standing.

In keeping with the regional style, the fibulae are triangular in shape and were skillfully engraved and chased, with additional gradated triangular shapes projecting from the edges. The geometry of the design is austere and cool, but is lightened by the inclusion of floral stylizations. Hemispheres mounted on the fibulae and the clasps are decorated in cloisonné enamel—a technique that was part of the Andalusian Jewish goldsmith tradition that became established in Morocco in the 15th century. The combination of yellow and green is characteristic of the workshops in and around Tiznit.

The disc-like tips of the clasps and the tips of the rectangles are accentuated by colored glass. Silver coins attached to the hemispheres and the chain shimmered and chinked with the wearer's every movement. The connecting piece is made of two bands of woven silver thread with square settings as well as a large, hollow bead (*tagemout*) with an engraved, geometrical design in *cloisonné* enamel. To secure it, the bead is attached to another chain. Beyond their decorative purpose, the silver coins with their star and hexagram motifs—Morocco's national emblem into the 1930s—indicate that elaborate jewelry of this type also fulfilled the function of charms that provided protection, particularly against the "evil eye."

Bibliography: Hasson, 1988; Rouache, 1989; Steinmann, 1996; Erzini, in Phillips, 1995, p. 570f. (with bibliography); Rabaté, 1996, pp. 12, 34f.; Rainer, 1999, p. 69f.; Borel, 1999, p. 37

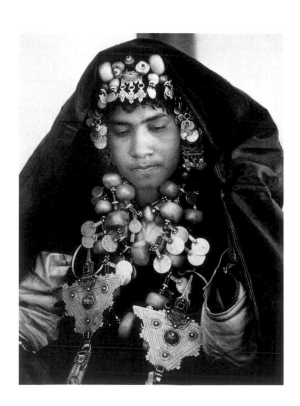

Ammeln-Berber woman wearing black *tamelhaft* and jewelry for a festive occasion, Tafraout, 1920s/'30s.
Photograph: Jean Besancenot

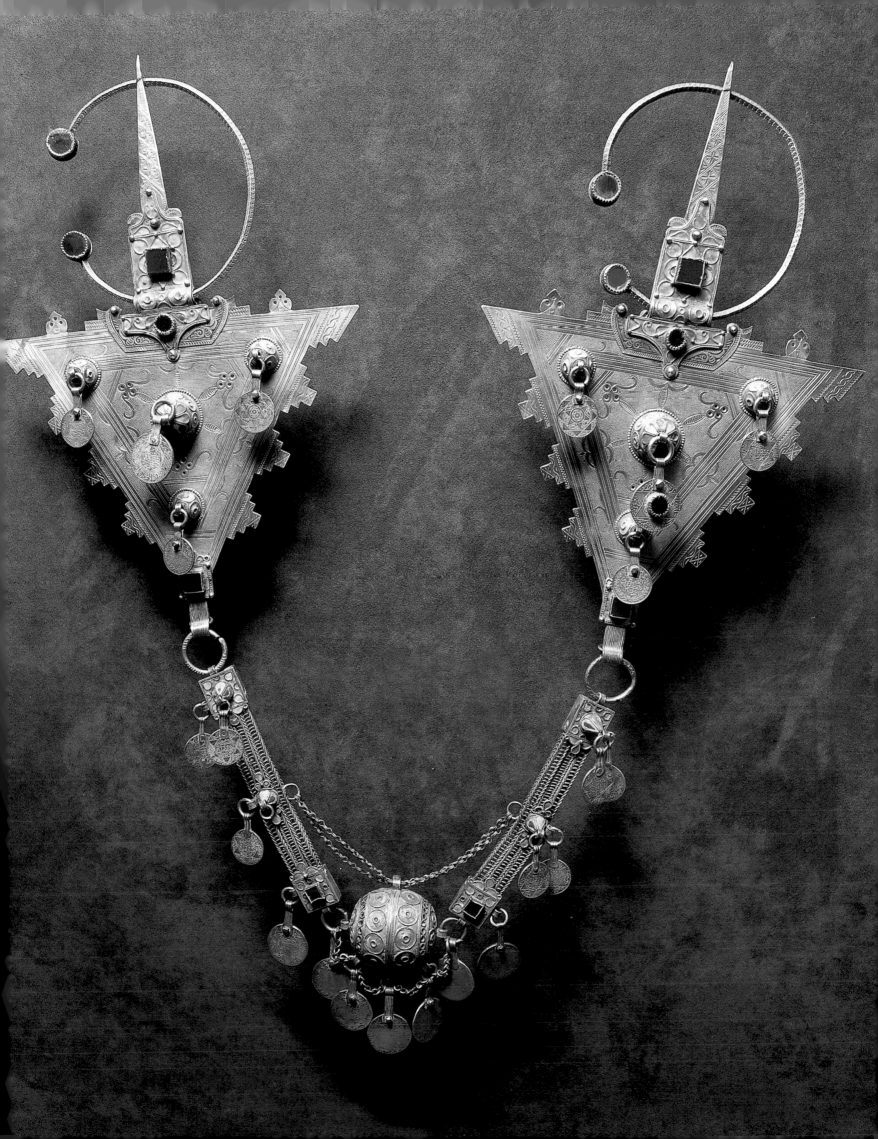

Isar Door and Wedding Curtain

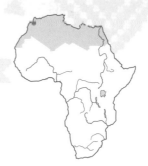

Rabat, Morocco, end of 19th century
Silk embroidery on machine-embroidered cotton; 300 x 230 cm
Private collection, Zurich

Like that of most African countries, Morocco's population is ethnically diverse. It is the result of centuries of migration on the part of diverse ethnic groups and tribes, each of which brought its own craft traditions with them. Many of these styles and techniques have survived in a relatively unchanged form down to the present day, while some have been amalgamated with others in the great cultural melting pot of the big cities.

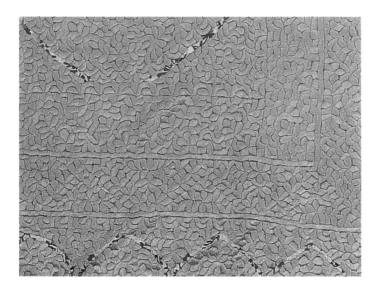

Parts of the indigenous Berber population sought safety from the Arab invaders in remote mountain regions, where many of their artisanal traditions have remained intact to this day. The trading towns and political and cultural centers, on the other hand, were Arabianized. Under pressure of the Catholic Restoration in victorious Spain in the 15th century, Arabian and Jewish artists found a haven in Morocco, and they brought a highly refined architecture, gold and silversmith's art as well as textile traditions to Rabat, Salé, Meknès and Fès. Finally, Bedouin tribes from the Sahara—from Senegal to Algeria—repeatedly settled in Morocco, mixed with the autochthonous populace, thus

contributing to the development of the country's culture. Also significant were Ottoman influences, not to mention those of Europe from the 19th century onward.

Apart from the Berber havens in the Atlas Mountains, cultural hybridization was common in Moroccan art. New stylistic impulses came in wave after wave. At the intersection of these diverse streams stood especially the textile art of the large cities, whose tailors and embroiderers produced works of great urbane refinement and aesthetic effect. The curtain shown here belongs to this category. Artistic textiles of this kind were luxury articles, which not every family could afford. Thus befriended families used to lend these valuable possessions for special occasions, or even rent them out. In general they were known as "wedding curtains," but no less apt is the term "door curtain" or "portière" (Arabian: *isar*). Costing as much time and effort to fabricate as a Gobelin, pieces like this were used to separate the women's area in a house from the men's.

The hand embroidery was done on a cotton or linen cloth likely made in France for Morocco, which consists of three widths embroidered with a fine multicolored floral pattern. Over this, women under the supervision of female master embroiderers (*ma'allem*) applied a decor in yellow-orange silk composed of flat and braid stitching ('soie broché'). Finally the three widths were sewn together with two red silk ribbons. (Comparable specimens consist of only two widths and have merely one silk strip; two other types have a ground pre-embroidered with white floral patterns or over-embroidery in dark reddish-violet or in several colors.)

The monochrome over-embroidery forms a deliberate contrast to the fine multicolored pattern of the cloth, and similarly employs closely spaced floral motifs. Internally framed, its design is strictly symmetrical. Though floral in detail, the embroidery as a whole forms configurations that recall mosque cupolas, minarets or mihrabs, and thus belongs entirely to the Islamic formal canon. The viewer has the feeling of looking through a window or a closed tracery work portal into a paradisaical garden.

Bibliography: Vivier, 1991; Lemaistre and Vivier, 1996; *Touches . . .*, 1996; *Maroc . . .*, 1993, p. 183, cat. no. 3; *Zarte Bande . . .*, 2000

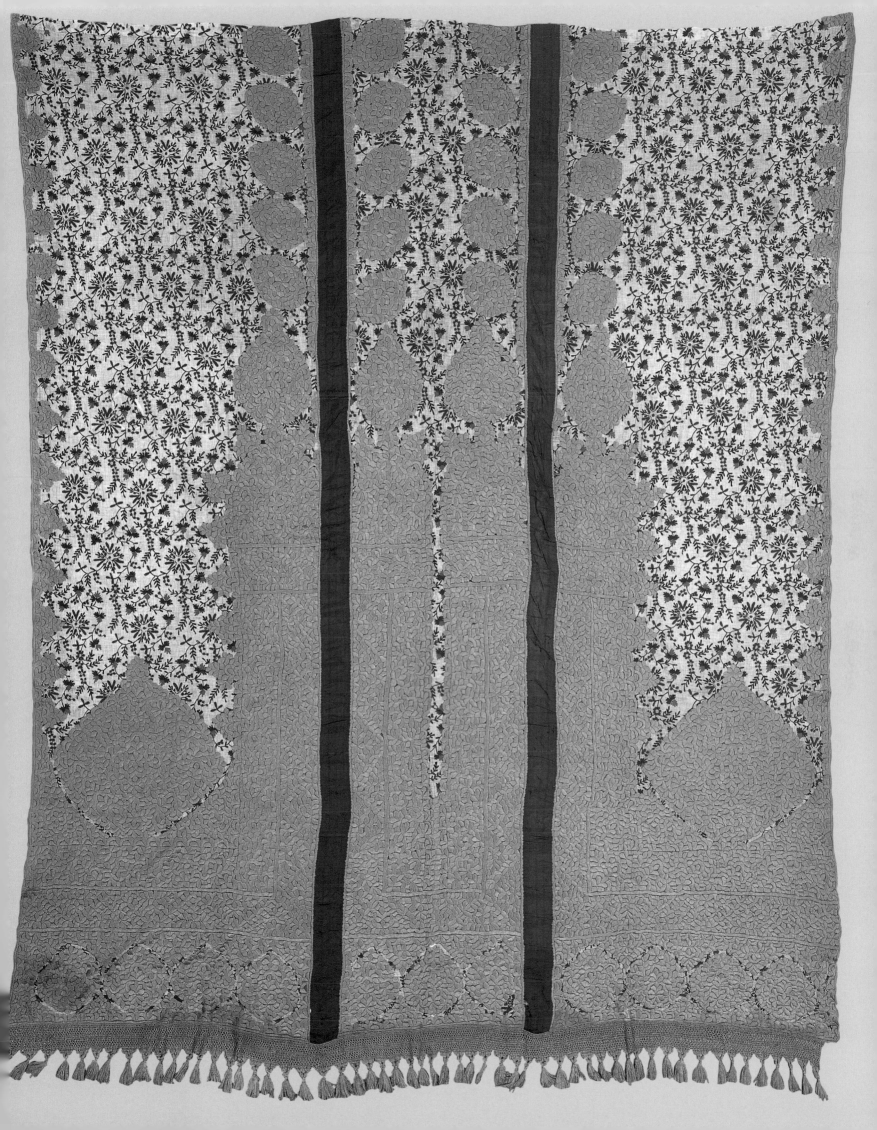

Amphora

Berber, Aït Mesbah, Great Kabylia, Algeria,
middle of the 20th century
Ceramic, varnished; height 89 cm
The British Museum, London

Antique amphorae from the Mediterranean region were used to transport and store wine, olive oil or other commodities, a tradition in which this noble vessel stands. Slender and graceful, it rises from a conical base and ends in a long, narrow neck. The long, arching handles are attached at four points each for reinforcement, and made the vessel relatively easy to carry despite its great weight when full.

Vessels of this type were traditionally made by Berber women in the Great Kabylia, in the hinterland between Algiers and Tunis, for their own use although, in more recent tims, they are made for the tourist trade. They were not thrown on a potter's wheel but built up of coils of clay. As a rule, the lower part of the vessel was left to dry to a leathery consistency before beginning the upper part. After it was finished and completely dry, the surface was carefully smoothed with a pebble and, after the application of an *engobe* (slip), given another polishing. Only then was the decor applied. After firing in an open kiln the vessel was varnished while still hot to lend it a fine gloss. The final finish thus consists not of a glaze but of a sort of lacquer, made of the sap of the juniper tree with an admixture of mandrake and weld root. While the varnish used in neighboring Tunisia is colorless, the Kabyle favor a warm, yellowish tone. Varnished vessels are not used for storing water since the cooling effect of evaporating water on the surface would otherwise have been diminished.

The decor is not incised but applied with a brush, using slip tinted with a reddish, brownish or black tone. Unlike that of ceramics south of the Sarhara, the decor has a more graphic than haptic effect. It is so finely articulated that it recalls textile patterning. A special feature is a passage in relief representing the hand of Fatima, the daughter of the Prophet, and flanking disks with checkerboard patterns, which can be interpreted as eyes. The pairing of these symbols is thought to enhance their ability to ward off greed and harm, and thus protect the vessel's contents from both front and back. (According to A.A. Amamra the disks represent honeycombs and stand for diligence, abundance and marital fidelity.)

The vessel's amulets are embedded in framed fields filled with linear and geometric patterns. Zigzag bands and crosshatched triangles repeatedly occur. The lower zone of the amphora is left free of decoration apart from vertical, wavy lines. If its form recalls that of antique pottery, the linear geometry of the decor evinces striking similarities to Bronze and Iron Age pottery, especially of Cypriotic or Sicilian origin. The body painting, textile and carpet designs of the Kabyle all exhibit a general preference for certain patterns. The Berbers belonged to the pre-Islamic, indigenous population of North Africa, whose culture, despite its location on a migration route, has proven an astonishing persistence.

Bibliography: Balfet, 1966; Gruner, 1973, 1986; Bynon, 1982; Amamra, in Mack, 2000, p. 56f.

Berber woman
fetching water,
Tafsa bou Machr,
Great Kabylia, 1970.
Photograph:
Dorothee Gruner

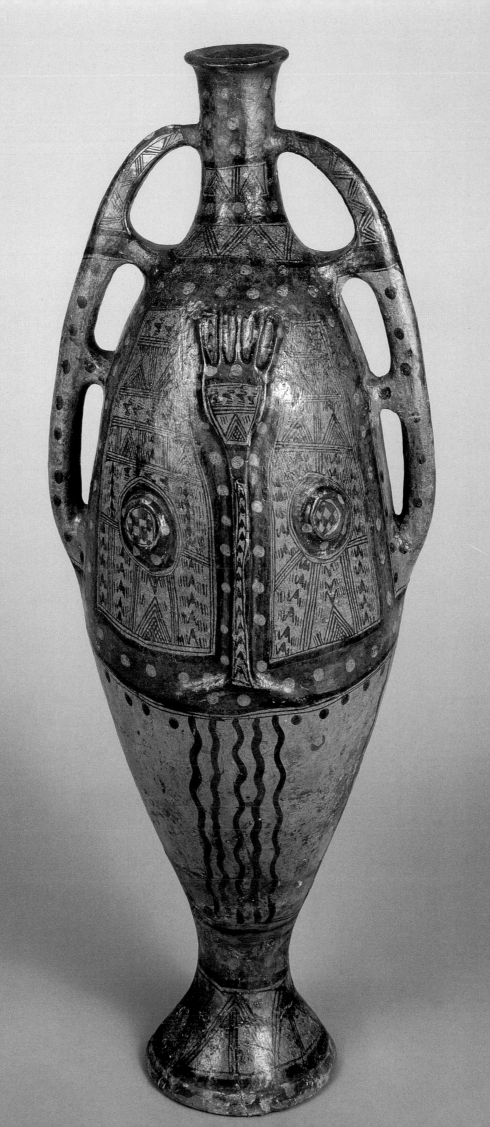

Bibliography

Abiodun, Rowland, Henry John Drewal, and John Pemberton III. *Yoruba: Art and Aesthetics*. Exh. cat. Museum Rietberg, Zurich, 1991.

Adams, M. J. "18th Century Kuba King Figures." *African Arts* 21, no. 3 (1988): 32–38.

Adler, Peter, and Nicholas Barnard. *African Majesty: The Textile Art of the Ashanti and Ewe*. London, 1992.

—. *Asafo! African Flags of the Fante*. London, 1992.

Art pictural des Pygmées. Exh. cat. With contributions by R. Bailey, P. Claes, F. Fasel and W. Schmalenbach. Musée Barbier-Mueller, Geneva, 1990.

Azaïs, R. P., and R. Chambard. *Cinq Années de Recherches Archéologiques en Ethiopie*. Text vol. and Atlas. Paris, 1931.

Bacquart, Jean-Baptiste. *The Tribal Arts of Africa*. London, 1998.

Balfet, H. "Ethnographical Observations in North Africa and Archaeological Interpretation: The Pottery of the Maghreb." In F. R. Matson (ed.), *Ceramics and Man*. London, 1966.

Barbier, Jean Paul (ed.). *Art of Côte d'Ivoire from the Collections of the Barbier-Mueller Museum*. 2 vols. Geneva, 1993.

Bassani, Ezio. "A Note on Kongo High-Status Caps in Old European Collections." *Res* 5 (1983): 74–84.

—. *African Art and Artefacts in European Collections, 1400–1800*. London, 2000.

Bassani, Ezio, and William B. Fagg. *Africa and the Renaissance: Art in Ivory*. Exh. cat. The Center for African Art, New York. Munich, 1988.

—. "Additional Notes on the Afro Portuguese Ivories." *African Arts* 27, no. 3 (1994): 34–45.

Bastin, Marie-Louise. "Tshibinda Ilunga, A propos d'une statuette de chasseur ramenée par Otto Schütt en 1880." *Baessler Archiv*, n. s., XIII, 1965, 501–37.

—. "Statuettes Tshokwe du héros civilisateur Tshibinda Ilunga." *Arts d'Afrique Noire* 19 (1978; suppl.).

—. *La sculpture Tshokwe*. Meudon, 1982.

—. "Mwanangana une effigie d'un seigneur Tshokwe." *Arts d'Afrique Noir* 72 (1989): 12–16.

—. *Escultura Tshokwe Sculpture*. Porto, 1999.

Beier, Ulli. *A Year of Sacred Festivals in One Yoruba Town*. Lagos, 1959.

Ben-Amos, Paula G. *The Art of Benin*. London, 1980 (1995).

Benitez and Barbier. *Shields: Africa, Southeast Asia and Oceania, From the Collections of the Barbier-Mueller Museum*. Munich, London and New York, 2000.

Bilot, Alain, Geneviève Calame-Griaule and Francine Ndiaye. *Masques du pays Dogon*. Paris, 2001.

Bocola, Sandro. *African Seats*. Munich and New York, 1995.

Borel, France. *The Splendour of Ethnic Jewellery*. London and New York, 1994.

Borgatti, Jean M., and Richard Brilliant. *Likeness and Beyond: Portraits from Africa and the World*. Exh. cat. The Center for African Art, New York, 1990.

Brain, Robert, and Adam Pollock. *Bangwa Funerary Sculpture*. London, 1971.

Bynon, J. "Berber Women's Pottery: Is the Decoration Motivated?" In *Earthenware in Asia and Africa*. Percival David Foundation Colloquies on Art and Archaeology in Asia. Vol. 12. London, 1982.

Carey, Margret. *Beads and Beadwork of East and South Africa*. Aylesbury, 1986.

Cornet, Joseph. *Art Royal Kuba*. Milan, 1982.

Dam-Mikkelsen, Bente, and Torben Lundbæk. *Ethnographic Objects in the Royal Danish Kunstkammer, 1650–1800*. Copenhagen, 1980.

Dapper, Olfert. *Description of Africa*. London, 1670.

Dewey, W. J. "Declarations of Status and Conduits to the Spirits: A Case Study of Shona Headrests." In *Sleeping Beauties: The Jerome L. Joss Collection of African Headrests at UCLA*. Exh. cat. Fowler Museum of Cultural History, Los Angeles, 1993.

Dewey, William S., and Els de Palmenaer (eds.). *Legacies of Stone: Zimbabwe Past and Present*. Exh. cat. Royal Museum for Central Africa, Tervuren 1997

Dogon. Exh. cat. With contributions by Germaine Dieterlen, Jean-Louis Paudrat et al. Musée Dapper, Paris, 1994.

Donner, Etta. "Kunst und Handwerk in NO-Liberia." In *Baessler Archiv* n. s. 23 (1940): 45–110.

Doquet, Anne. *Les Masques dogon: Ethnologie savante e ethnologie autochtone*. Paris, 1999.

Drewal, John, John Pemberton III and Rowland Abiodun. *Yoruba: Nine Centuries of African Art and Thought*. New York, 1989.

Duchâteau, Armand. *Benin: Trésor Royal*. Exh. cat. Musée Dapper, Paris, 1990.

—. *Benin – Royal Art of Africa*. Munich and New York, 1994.

Eisenhofer, Stefan. *Höfische Elfenbeinschnitzerei im Reich Benin*. Munich, 1993.

—. *Kulte, Künstler: Könige in Afrika, Tradition und Moderne in Südnigeria*. Exh. cat. Oberösterreichisches Landesmuseum, Linz, 1997.

Eisenhofer, Stefan, Iris Hahner-Herzog and Christine Stelzig. *Mein Afrika: Die Sammlung Koenig*. With an introduction by Peter Stepan. Munich, London and New York, 2000.

Eyo, Ekpo, and Frank Willett. *Treasures of Ancient Nigeria*. New York, 1980.

Ezra, Kate. *Figure Sculptures of the Bamana of Mali*, Ph. D. Diss. Northwestern University, 1983.

—. *A Human Ideal in African Art: Bamana Figurative Sculpture*. Washington, DC, 1986.

—. *African Ivories*. Exh. cat. The Metropolitan Museum of Art, New York, 1984.

Fagg, William. *Nigeria – 2000 Jahre Plastik*, Exh. cat. Städtische Galerie im Lenbachhaus, München, Munich 1961/62.

—. *Nigerian Images*. London, 1963.

—. *Tribes and Forms in African Art*. London, 1966; German edition 1964.

—. *Nok Terracottas*. Lagos and London, 1977.

Falgayrettes-Leveau, Christiane (ed.). *Arts d'Afrique*. Exh. cat. Musée Dapper, Paris, 2000.

Fischer, Eberhard, and Hans Himmelheber. *The Arts of the Dan in West Africa*. Zurich, 1984; German edition 1976.

Fiske, Patricia L., W. Russell Pickering and Ralph S. Yohe (eds.). *From the Far West: Carpets of Morocco*. Exh. cat. The Textile Museum, Washington, DC, 1980.

Förster, Till. *Die Kunst der Senufo*. Zurich, 1988.

—. "Senufo Masking and the Art of Poro." *African Arts* (1993, 1): 30–41.

Gardi, Bernhard. *Boubou: C'est chic, Gewänder aus Mali und anderen Ländern Westafrikas*. Exh. cat. Museum der Kulturen, Basel, 2000.

Garlake, Peter. *The Hunter's Vision*. London, 1995.

Garrard, Timothy F. *Gold of Africa: Jewellery and Ornaments from Ghana, Côte d'Ivoire, Mali and Senegal in the Collection of the Barbier-Mueller Museum*. Munich, 1989.

Gibson, G. D., and C. R. McGurk. "High Status Caps of the Kongo and Mbunda Peoples." *Textile Museum Journal* 6, no. 4: 71–96.

Gottschalk, Burkhard. *Senufo, Massa und die Wächter des Poro*. Düsseldorf, forthcoming.

Griaule, Marcel. *Masques dogons*. Paris, 1938 (1994).

Grottanelli, Vinigi L. "Discovery of a Masterpiece: A 16th Century Ivory Bowl from Sierra Leone." *African Arts* 8, no. 4 (1975): 14–23.

—. "Su un'antica scultura in avorio della Sierra Leone." *Quaderni Poro*, Venice (July 1976): 23–34.

Gruner, Dorothee. *Die Berber-Keramik am Beispiel der Orte Afir, Merkalla, Taher, Tiberguent und Roknia*. Wiesbaden, 1973.

—. *Berber Keramik*. With a foreword by Eike Haberland. Exh. cat. Jahrhunderthalle Hoechst and Rautenstrauch-Joest-Museum für Völkerkunde, Cologne, 1986.

Grunne, Bernard de. *Terres cuites anciennes de l'ouest africain/Ancient Terracottas From West Africa*. Louvain-la-Neuve, 1980.

—. *Naissance de l'art en Afrique noire: La Statuaire Nok au Nigeria*. Paris, 1998.

— (ed.). *Masterhands/Mains de maîtres. À la découverte des sculptures d'Afrique*. Exh. cat. Espace Culturel BBL, Brussels, 2001.

Güse, Ernst-Gerhard (ed.). *ASAFO: Fahnen aus Ghana*. With contributions by Kay Heymer et al. Munich and New York, 1995.

Hahner-Herzog, Iris, Maria Kecskési and László Vajda. *African Masks*. Munich and New York, 1998.

Hallpike, C. R. *The Konso of Ethiopia: A Study of the Values of a Cushitic People*. Oxford, 1972.

Harter, Pierre. *Arts anciens du Cameroun*. Arnouville, 1986.

Hasson, Rachel. *Schmuck der islamischen Welt*. Exh. cat. Museum für Kunsthandwerk, Frankfurt/Main, 1988.

Herreman, Frank. *In the Presence of Spirits: African Art from the National Museum of Ethnology, Lisbon*. Exh. cat. Museum for African Art, New York. Gent, 2000.

Hersak, Dunja. *Songye Masks and Figure Sculpture*. London, 1986.

Homberger, Lorenz. *Die Kunst der Dogon*. Exh. cat. Museum Rietberg, Zurich, 1995.

Homberger, Lorenz, and Piet Meyer. "Concerning African Objects." In Sandro Bocola, *African Seats*. Munich and New York, 1995.

Imperato, Pascal James, "The Dance of the Tyi Wara." *African Arts* 4, no. 1 (1970): 8–13, 71–80.

—. *Buffoons, Queens and Wooden Horsemen: The Dyo and Goun Societies of the Bambara of Mali*. New York, 1983.

Inskeep, R. R., and T. M. O'C. Maggs. "Unique Art Objects in the Iron Age of the Transvaal, South Africa." *The South African Archaeological Bulletin* 30, nos. 1/2, 117/118 (June 1975): 114–38.

Jahn, Jens (ed.). *Tanzania: Meisterwerke afrikanischer Skulptur*. Exh. cat. Haus der Kulturen der Welt, Berlin, and Städtische Galerie im Lenbachhaus, München. Munich, 1994.

Jargstorf, Sibylle. "Afrikanisches Design mit europäischen Glasperlen." In Stefan Eisenhofer (ed.), *Spuren des Regenbogens: Kunst und Leben im*

südlichen Afrika/Tracing the Rainbow: Art and Life in Southern Africa. Stuttgart, 2001.

Jeffreys, M. D. W. "Some Notes on the Ekoi." *Journal of the Royal Anthropological Institute* 69 (1939): 95–108.

Jensen, A. E. "Das Gada-System der Konso und die Altersklassen-Systeme der Niloten." *Ethnos* 19, nos. 1–4 (1954): 1–23.

Jereb, James F. *Arts and Crafts of Morocco*. London, 1995.

Jordán, Manuel (ed.). *CHOKWE! Art and Initiation Among Chokwe and Related Peoples*. Munich, London and New York, 1998.

Kan, Michael, and Roy Sieber (eds.). *African Masterworks in the Detroit Institute of Arts*. Washington, DC, and London, 1995.

Kandt, Richard. "Gewerbe in Ruanda." *Zeitschrift für Ethnologie* 36 (1904): 329–72.

Kaplan, Flora E. S. "Iyoba, the Queen Mother of Benin." *Art History* 16, no. 3 (1993): 386–407.

—. "Images of the Queen Mother in Benin Court Art." *African Arts* 26, no. 3 (1993): 55–63, 86.

Kecskési, Maria. *Kunst aus dem Alten Afrika*. Innsbruck, 1982.

—. *African Masterpieces and Selected Works from Munich: The Staatliches Museum für Völkerkunde*. Exh. Cat. The Center for African Art, New York, 1987.

—. *Kunst aus Afrika: Museum für Völkerkunde München*. Munich, London and New York, 1999.

Kerchache, Jacques (ed.). *Sculptures: Afrique, Asie, Océanie, Amériques*. Exh. cat. Musée du Louvre, Paris, 2000, 169–71.

Koloss, Hans-Joachim. *Die Kunst der Senufo*. With an essay by Till Förster. Exh. cat. Berlin, 1990.

—. *Afrika: Kunst und Kultur, Meisterwerke afrikanischer Kunst*. Museum für Völkerkunde Berlin. Munich, London and New York, 1999.

—. *World-View and Society in Oku (Cameroon)*. Berlin, 2000.

Korolnik, Marcel. "Fire & Water: Rehamna Carpets, Recent Field Research in the Plains of Marrakesh." *Hali: The International Magazine of Antique Carpet and Textile Art* 99 (1998): 64–69.

Kreuzer, Anne. "Die Flechtarbeiten aus dem Zwischenseengebiet." *Baessler Archiv* n. s. 39 (1991): 345–439.

Krieger, Kurt. *Ostafrikanische Plastik*. Museum für Völkerkunde, Berlin, 1990.

Kubik, Gerhard. "African and African American Lamellophones." In Jacqueline Cogdell DjeDje (ed.), *Turn Up the Volume: A Celebration of African Music*. Exh. cat. UCLA Fowler Museum of Cultural History, Los Angeles, 1999.

Laburthe-Tolra, Philippe, and Christiane Falgayrettes-Leveau. *Fang*. Exh. cat. Musée Dapper, Paris, 1991.

Lauber, Wolfgang (ed.). *Architektur der Dogon: Traditioneller Lehmbau und Kunst in Mali*. Munich and New York, 1998.

Laurenty, J.-S. *Les Sanza du Congo*. Tervuren, 1962.

Leloup, Hélène. *Statuaire dogon*. Strasbourg, 1994.

Lemaistre, Joëlle, Marie-France Vivier et al. *De Soie et d'or, broderies du Maghreb*. Exh. cat. Institut du Monde Arabe, Paris, 1996.

Levinsohn, Rhoda. *Art and Craft of Southern Africa*. Craighall, 1984.

Lewis-Williams, J. David. *The Rock Art of Southern Africa*. Cambridge, 1983.

—. "The San Artistic Achievement." *African Arts* 18, no. 3 (1985): 54–59.

—. "The World of Man and the World of Spirit: An Interpretation of the Linton Rock Paintings." *Margaret Shaw Lecture* 2 (1988): 1–16.

Lintig, Bettina von. "Die bildende Kunst der Bangwa: Werkstatt-Traditionen und Künstlerhandschriften." Ph. D. Diss. Munich, 1994.

—. "Ateu Atsa, les sculpteurs, les prêtres-rois et la mémoire iconographique des Bangwa au Cameroun." In de Grunne, 2001, 94–117.

Luschan, Felix von. *Die Altertümer von Benin*. Berlin, 1919.

MacGaffey, Wyatt. *Art and Healing of the BaKongo, Commented by Themselves*. Stockholm, 1991.

MacGaffey, Wyatt, and M. D. Harris. *Astonishment and Power*. Exh. cat. National Museum of African Art, Washington, DC, 1993.

Mack, John. "Bakuba Embroidery Patterns: A Commentary on their Social and Political Implications" In Idiens D., and K.G. Ponting (eds.) *Textiles of Africa*. Bath, 1980: 163–175.

—. "Art, Culture, and Tribute among the Azande." In Schildkrout and Keim, 1990, 217–31.

—. (ed.). *Africa: Arts and Cultures*. London, 2000.

Maggs, Tim, and Patricia Davison. "The Lydenburg Heads and the Earliest African Sculpture South of the Equator." *African Arts* 14, no. 2 (1981): 28–33.

Mansfeld, Alfred. *Urwald-Dokumente: Vier Jahre unter den Crossflussnegern Kameruns*. Berlin, 1908.

Maroc: Magie des Lieux. Exh. cat. Institut du Monde Arabe, Paris, 1999.

Meurant, Georges. *Shoowa Design: African Textiles from the Kingdom of Kuba*. London and New York, 1986, (1995).

Meurant, Georges, and Robert Farris Thompson. *Mbuti Design: Paintings by Pygmy Women of the Ituri Forest*. London, 1995.

Meyer, Piet. *Kunst und Religion der Lobi*. Exh. cat. Museum Rietberg, Zurich, 1981.

Minges, Klaus, Marcel Korolnik et al. *Berber: Teppiche und Keramik aus Marokko*. Exh. cat. Museum Bellerive, Zurich, 1996.

Mott, Barbara De. *Dogon Masks: A Structural Study of Form and Meaning*. Ann Arbor, 1979.

Mudimbe, Valentin Y. *The Invention of Africa: Gnosis, Philosophy, and the Order of Knowledge*. Bloomington, Indianapolis and London, 1988.

Neyt, François. *Luba*. Exh. cat. Musée Dapper, Paris, 1993.

Nicklin, Keith. "Nigerian Skin-covered Masks." *African Arts* 7, no. 3 (1974): 8–15, 67–68.

—. "Skin-covered masks of Cameroon." *African Arts* 12, no. 1 (1979): 54ff.

Northern, Tamara, and Valérie Franklin. *Expressions of Cameroon Art: The Franklin Collection*. Exh. cat. Beverly Hills, 1986.

Nowack, E. *Land und Volk der Konso*, Bonn, 1954.

Olbrechts, Frans M. *Les Arts plastiques du Congo Belge*. Brussels, 1959.

Pemberton, John, III. "Figure with Bowl," "Shango Shrine Sculpture." In William Fagg and John Pemberton III, *Yoruba: Sculpture of West Africa*. New York, 1982, pls. 34, 53.

—. "The Oyo Empire." In John Drewal, John Pemberton III and Rowland Abiodun. *Yoruba: Nine Centuries of African Art and Thought*. New York, 1989, 146–87.

Perrois, Louis. *Ancestral Art of Gabon: From the Collections of the Barbier-Mueller Museum*. Geneva, 1985.

Phillips, Tom (ed.). *Africa: The Art of a Continent*. Munich and New York, 1995.

Pickering, Brooke, W. Russell Pickering, and Ralph S. Yohe. *Moroccan Carpets*. London, 1994.

Picton, John, and John Mack. *African Textiles*. London, 1989 (1999).

Pirat, Claude-Henri. "Le Maître de Buli: Maître isolé ou 'atelier'? Essai de catalogue raisonné." *Tribal Arts* 3, no. 10 (1996): 54–77.

Plaschke, Dieter, and Manfred A. Zirngibl. *Afrikanische Schilde/African Shields*, Munich, 1992.

Powell, Ivor. *Ndebele: A People and Their Art*. Cape Town, 1995.

Rabaté, Jacques, and Marie-Rose Rabaté. *Bijoux du Maroc*. Paris, 1996.

Rainer, Kurt. *Tasnacht: Teppichkunst und traditionelles Handwerk der Berber Südmarokkos*. Graz, 1999.

Ramirez, F., and C. Rolot. *Tapis et Tissages du Maroc*. Courbevoie, 1994.

Roberts, Allen F. *Animals in African Art*. Exh. cat. The Museum for African Art, New York. Munich, 1995.

Roberts, Mary Nooter. "The Naming Game: Ideologies of Luba Artistic Identity." *African Arts* 21, no. 4 (1988): 56–73.

Roberts, Mary Nooter, and Allen F. Roberts. *Memory: Luba Art and the Making of History*. Exh. cat. The Museum for African Art, New York. Munich, 1996.

Rosenwald, J. "Kuba King Figures." *African Arts* 7, no. 3 (1974): 26–31.

Roth, Ling H. *Great Benin: Its Customs, Art and Horrors*. London, 1968 (1903).

Rouache, David. *Bijoux Berbères au Maroc dans la tradition judéo-arabe*. Paris, 1989.

Schaedler, Karl-Ferdinand. *Ekoi*. Munich, 1984.

—. *Weaving in Africa South of the Sahara*. Munich, 1987.

—. *Erde und Erz: 2500 Jahre afrikanische Kunst aus Terrakotta und Metall*. With contributions by Armand Duchâteau, Till Förster et al. Munich, 1997.

Schildkrout, Enid, and Curtis A. Keim. *African Reflections: Art from Northeastern Zaire*. Exh. cat. American Museum of Natural History, New York, 1990.

Schmalenbach, Werner (ed.). *African Art. From the Barbier-Mueller Collection, Geneva*. Munich, 1988.

Schmidt, C. E. "African Mbirea as Musical Icons." In M.-T. Brincard (ed.). *Sounding Forms: African Musical Instruments*. New York, 1989, 73–79.

Schneider, Elizabeth Ann. "Ndebele Mural Art." *African Arts* 18, no. 3 (1985): 60–67.

Selassié, Guèbrè. *Chronique du règne de Ménélik II, roi des rois d'Ethiopie*. Paris 1930.

Spring, Christopher. *African Arms and Armour*. London, 1993.

Spring, Christopher, and Julie Hudson. *North African Textiles*. London, 1995.

Steinmann, Axel. *Blickfänge: Schmuck aus Nordafrika*. Exh. cat. Museum für Völkerkunde, Vienna, 1996.

Striedter, Karl Heinz. *Felsbilder der Sahara*. Munich, 1984.

Stritzl, Angelika. *Die gestickten Raffiaplüsche: Eine ergologisch-technologische Untersuchung unter historischen Stoffart unter Berücksichtigung des sozialen Kontextes*. Ph.D. Diss. Vienna, 1971.

—. "Raffiaplüsche aus dem Königreich Kongo." *Wiener Ethnohistorische Blätter* 3 (1971): 37–55.

Szalay, Miklós (ed.). *African Art from the Han Coray Collection, 1916–1928*. Munich and New York, 1998.

Tessmann, Günter. *Die Pangwe*. 2 vols. Berlin, 1913.

Thompson, Robert Farris. "The Grand Detroit N'kondi." *Bulletin of the Detroit Institute of Arts* 56, no. 4 (1978): 207–21.

—. *The Four Moments of the Sun: Kongo Art in Two Worlds.* Exh. cat. National Gallery of Art, Washington, DC, 1981.

—. "Tree, Stone, Blood, and Fire: Dawn of the Black Atlantic Altar." In Robert Farris Thompson, *Face of the Gods: Art and Altars of Africa and the African Americas.* Exh. cat. The Museum for African Art, New York. Munich, 1993.

Thompson, Robert Farris, and S. Bahuchet, *Pygmées? Peintures sur écorce battue des Mbuti (Haut-Zaïre),* Exh. Cat. Musée Dapper, Paris, 1991.

Touches of the Eye. Exh. cat. Meridian Center, New York, 1996.

Trowell, Margaret, and Klaus Philipp Wachsmann. *Tribal Crafts of Uganda.* London, New York and Toronto, 1953.

Vallées du Niger. Exh. cat. Musée national des Arts d'Afrique et d'Océanie et al. Paris, 1993–94.

Vansina, Jan. "Ndop: Royal Statues among the Kuba." In D. Fraser and H. M. Cole (ed.), *African Art and Leadership.* Madison, Wisconsin, and London, 1972, 41–55.

—. *The Children of Woot: A History of the Kuba Peoples.* Madison, 1978.

Verger-Fèvre, Marie-Noël. "Etude des masques faciaux de l'ouest de la Côte d'Ivoire conservés dans les collections publiques françaises". In *Arts d'Afrique Noire* 53 (1985): 17–29, 54, 19–33.

Verswijver, Gustaaf, et al. *Afrikanische Kunst: Verborgene Schätze aus dem Museum Tervuren.* Exh. cat. Kunstsammlung Nordrhein-Westfalen, Düsseldorf. Munich, London and New York, 1998.

—. *Masterpieces from Central Africa.* Exh. cat. Kunstsammlung Nordrhein-Westfalen, Düsseldorf. Munich, London and New York, 1996.

Vivier, Marie-France. *Broderies Marocaines.* Exh. cat. Musée des Art d'Afrique et d'Océanie. Paris, 1991.

Vogel, Susan M. "The Buli Master and Other Hands." *Art in America* (May 1980).

—. (ed.). *For Spirits and Kings: African Art from the Paul and Ruth Tishman Collection.* New York, 1981.

—. *African Aesthetics: The Carlo Monzino Collection.* Exh. cat. The Center for African Art, New York, 1986.

Völger, Gisela (ed.). *Kunst der Welt im Rautenstrauch-Joest-Museum für Völkerkunde Köln.* Munich, London and New York, 1999.

Wembah-Rashid, J. A. R. "Isinyago and Midimu: Masked Dancers of Tanzania and Mozambique." *African Arts* 4, no. 2 (1971): 38–44.

Weule, Karl. *Negerleben in Ostafrika.* Leipzig, 1909.

Willett, Frank. *Ife in the History of West African Sculpture.* London, 1967.

—. *Ife une civilisation Africaine.* Tallandier, 1971.

—. "L'archéologie de l'art nigérian." In Jean-Hubert Martin, Etienne Féau and Hélène Joubert, *Arts du Nigeria: Collection du musée des Arts d'Afrique et d'Océanie.* Exh. cat. Paris, 1997, 23–43.

Zahan, Dominique. *The Bambara.* Leiden, 1974.

—. "L'art des heaumes des tyiwara chez les Bambara." *Quaderni Poro,* Venice (July 1976): 137–51.

—. *Antilopes du soleil: Arts et Rites Agraires d'Afrique Noire.* Vienna, 1980.

Zarte Bande aus Marokko. Exh. cat. Textilmuseum, Krefeld, 2000.

Photo Credits